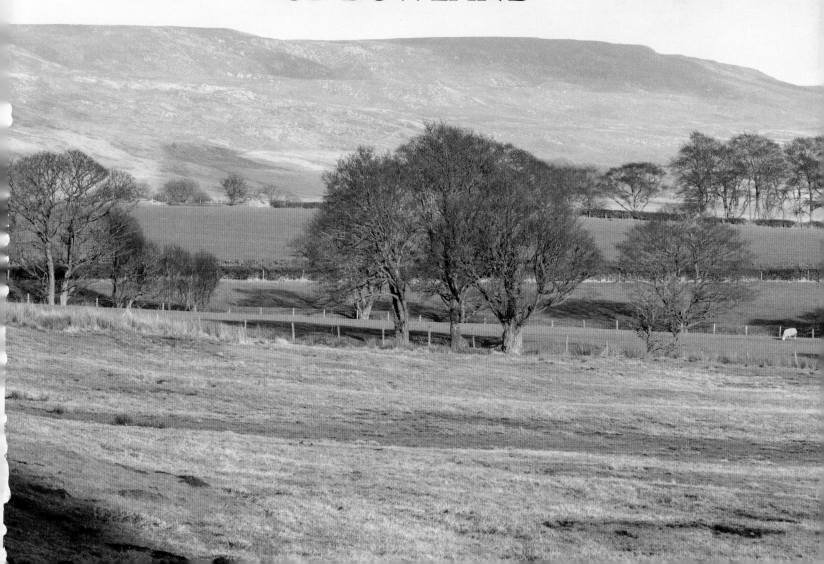

THE FOREST
OF BOWLAND

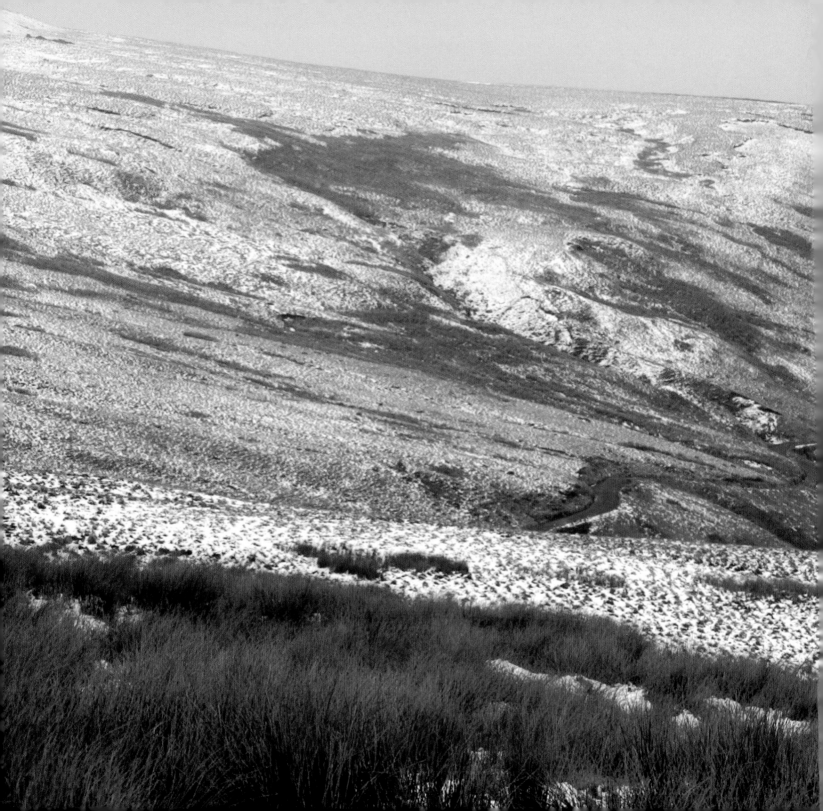

The Forest of Bowland

Helen Shaw & Andrew Stachulski

Merlin Unwin Books

First published in Great Britain by Merlin Unwin Books, 2015
Reprinted 2016, 2018

Photographs © Helen Shaw 2015
Text © Andrew Stachulski and Helen Shaw 2015

All enquiries should be addressed to:

Merlin Unwin Books Ltd
Palmers House, 7 Corve Street
Ludlow, Shropshire SY8 1DB, U.K.
www.merlinunwin.co.uk

The authors assert their moral rights to be identified with this work.
A CIP record of this book is available from the British Library.
Designed and set in Minion Pro 12pt by Merlin Unwin
Printed by Star Standard Industries (PTE) Ltd

ISBN 978-1-906122-99-7

CONTENTS

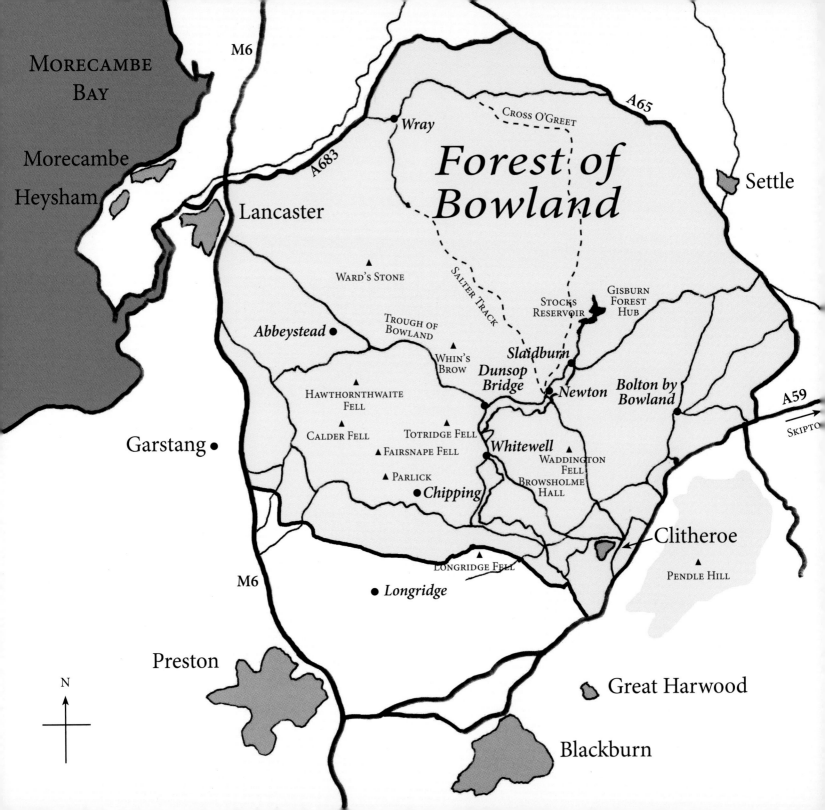

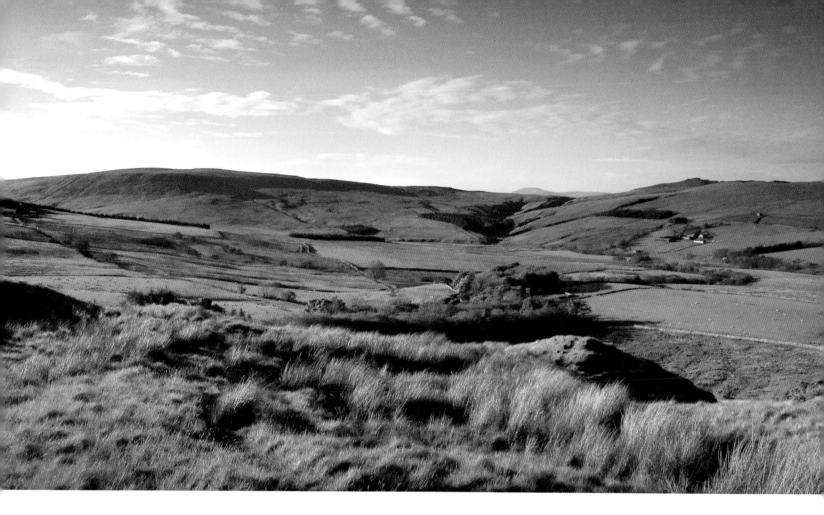

INTRODUCTION

The north of England is rich with areas of exceptionally beautiful countryside. Every year, the Lake District, Peak District and Yorkshire Dales attract hordes of visitors, and rightly so: their fame is well deserved. Yet there is a designated Area of Outstanding Natural Beauty (AONB) encompassing about three hundred square miles, which is barely known to many who frequent upland Britain. That area is the Forest of Bowland and it is the subject of our book.

Left: Fair Snape Fell from Parlick
Above: Catlow and Kearsden Holes from Merrybent Hill

The Forest of Bowland fully lives up to its AONB status, as its many admirers will testify. Yet it is an unobtrusive, retiring sort of beauty, of the kind appropriate to a sparsely populated area that is virtually devoid of A and even of B roads except at its periphery. There is nothing whatever touristy or brash about Bowland: thankfully, it has been allowed to evolve slowly in natural ways, and that is undoubtedly part of its great charm.

According to the area of the AONB, Bowland is defined approximately by a triangle with Lancaster, Preston and Skipton as the apices, with the northern side curving more sharply to the north. In truth, this is a modern definition of the Forest of Bowland's boundaries, because the AONB was established as recently as 1964. The heart of Bowland is clearly defined by its topography. The centre of the district is a compact mass of high hills, rising to 561m (1,839ft) at its summit, its streams draining into the Lune, Wyre and Ribble valleys: these are the Bowland Fells. The epithet 'forest' still puzzles many, as much of the district now consists mainly of open moorland. In fact the word 'forest' derives from the old French 'forès', Latin 'forestis silva': wooded lands outside the grounds of the medieval parks and halls, which were kept for hunting. Some consider that this aspect of the area can be traced back to the Saxon kings, and that Bowland was more properly regarded as a chase, rather than a forest, because much of the tree coverage was probably sparse. But certainly it was once a hunting ground.

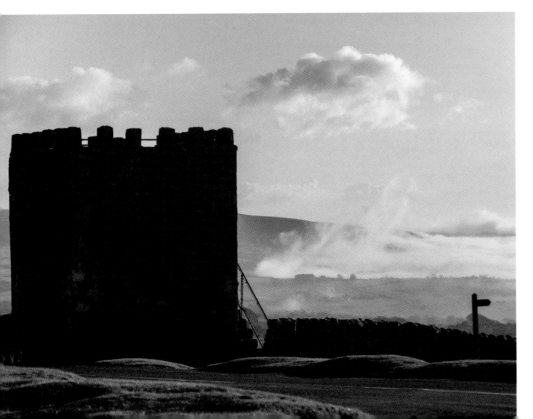

The origin of the name Bowland is still disputed, but it is known that the Parker family, ancestral occupants of Browsholme Hall *(see page 73)*, were the official 'bow-bearers' of the Forest, by royal appointment. Others consider that Bowland may mean the land of the cattle, or that the 'bow' may refer to a bend in a river, rather than the more obvious connotation of archery. The royal connection is very much alive today, for Her Majesty, who as Duke of Lancaster owns much land in this area, has declared her great admiration for the beauty of the Hodder valley. Certainly the view from Hall Hill

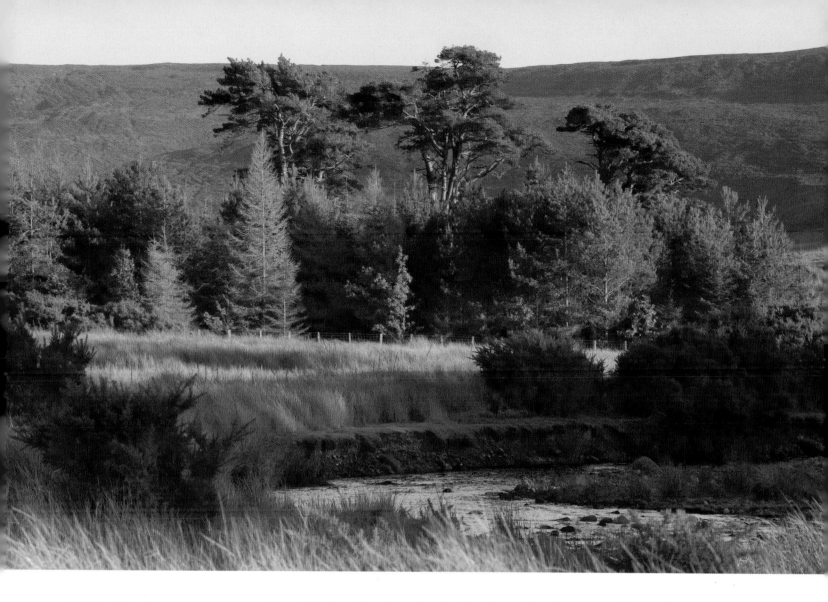

Left: Jubilee Tower, above Abbeystead

Above: The Marshaw Wyre looking towards Blaze Moss

above Whitewell, taking in the Hodder valley between Whitewell and Dunsop Bridge with a delightful backdrop of fells, could be considered one of the finest in the north.

This book is not an exhaustive account of the area. Our main aim is to communicate our love of Bowland to you through a series of vivid scenes, expressed in words and photography. The fells and high places of Bowland; its

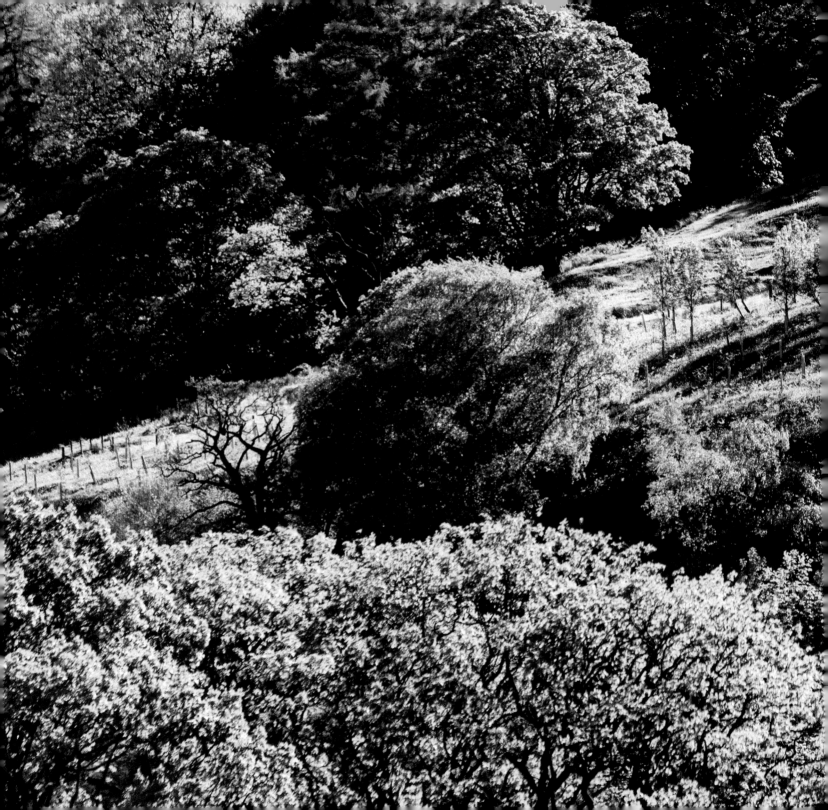

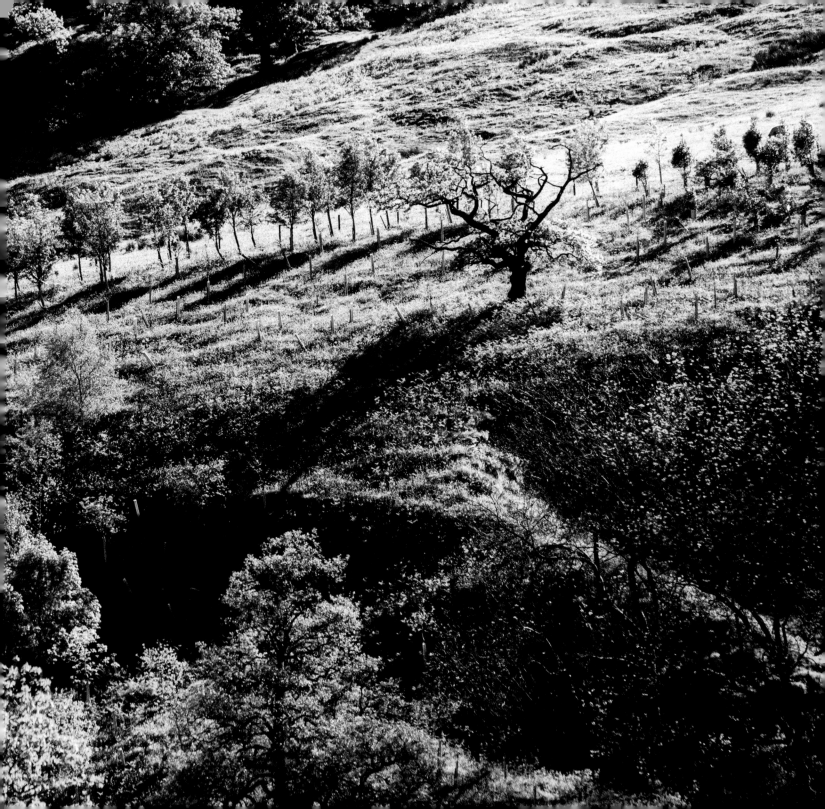

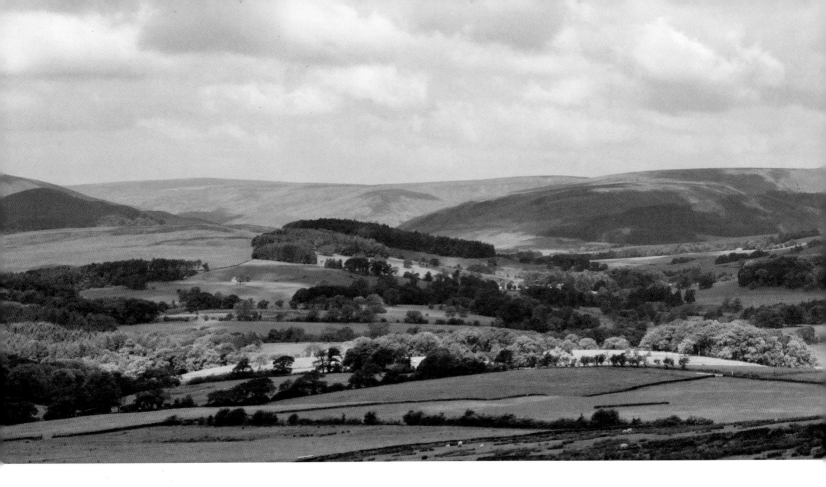

Above: The Hodder Valley and the Dunsop Fells from above Newton in Bowland
Previous page: Bluebells at Dunsop Bridge

roads, ancient and modern; its villages and other places of special character; Pendle Hill and its environs, steeped in turbulent history, and part of the AONB; Bowland's estates, and the ways its land is used today; and finally, a selection of the best walks the district has to offer. We hope to inspire the uninitiated to visit. The Forest of Bowland yields its secrets slowly; its haunting beauty draws visitors back, time and again, once they have seen it at its best – but Bowland's qualities are best appreciated in quietness.

To complete this introduction, we offer a brief tour listing the four principal compass-point aspects of Bowland: the first impressions offered to the visitor approaching from outside.

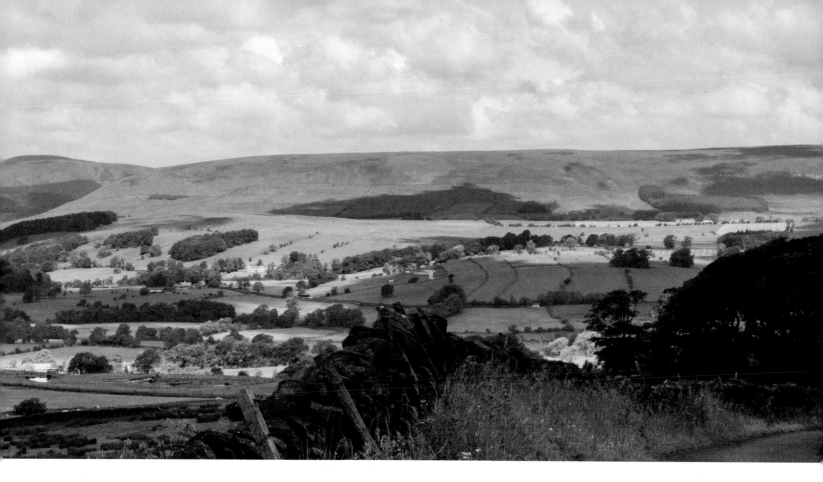

Western Bowland

The western aspect of the Forest of Bowland is probably the most familiar and is clearly seen from the main west-coast railway between Preston and Lancaster, or from the M6 motorway. From south to north, a fine sweep of fells is displayed: Beacon Fell, Parlick Pike, Fair Snape Fell, Hawthornthwaite Fell and finally the Ward's Stone massif where Bowland Fells reach their summit. These fells drain mostly into the Wyre, with the Ribble and Lune catchments claiming smaller areas in the north and south. A fine stretch of open country, contrasting with the hidden valleys and quiet recesses of Bowland which lie elsewhere. Western Bowland affords a good first introduction to the district, with straightforward access and some fine walking.

Northern Bowland

The northern aspect of Bowland is deservedly becoming more popular, but remains, thankfully, an area of quiet pastoral scenery, almost wholly unspoilt, with some charming villages. Here the hidden rivers and valleys of Bowland make an appearance, thanks to the rivers Roeburn and Hindburn, which combine to join the Wenning, thence the Lune. In addition to road access, the railway from Skipton to Lancaster offers a way in for the traveller on this side. Along this stretch, too, the minor roads, which cross the heart of the high fells, finally emerge and one of them opens up the Trough of Bowland, one of the district's most famous landmarks.

Eastern Bowland

The eastern part of Bowland is probably best known for the Hodder valley, and what a gem it is! Perhaps the best panoramic view of eastern Bowland can be seen from the B road crossing Waddington Fell. I am quite sure that many have fallen in love with Bowland on seeing this view. A more distant view can be had from the A59

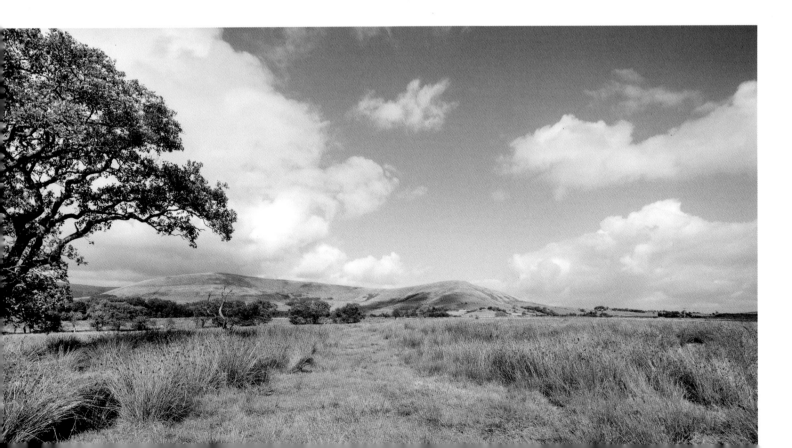

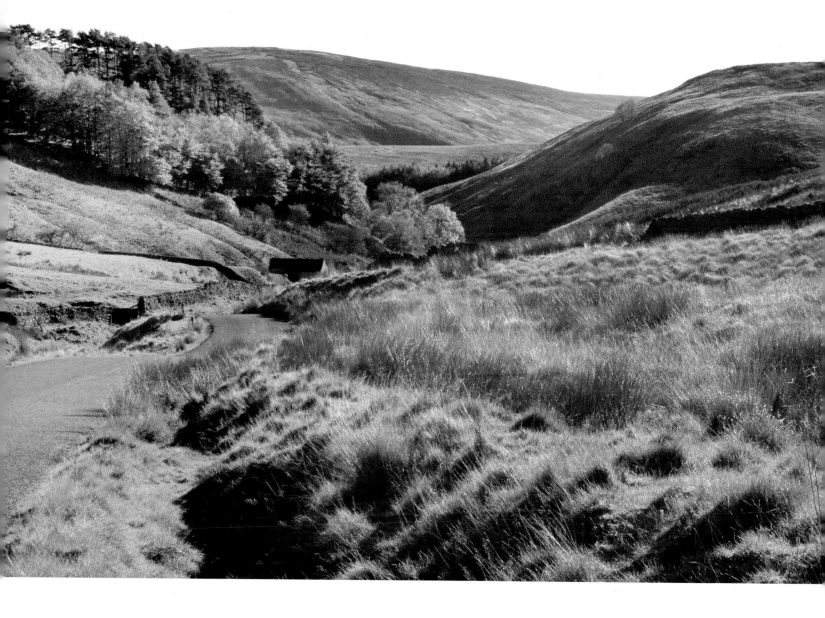

Left: Parlick and Fair Snape Fell from Bleasdale

Above: Trough of Bowland road near Sykes

Whalley-Clitheroe bypass, for several miles. Many of the fells show up quite well from here, but the beauty of the Hodder valley is unexpected. Gisburn Forest and the fells around Stocks Reservoir form the natural eastern boundary of Bowland, and the growing popularity of Gisburn Forest as a mountain biking centre has considerably increased the number of visitors here.

Langden Brook, near Hareden

Southern Bowland

The southern aspect of Bowland is arguably the least known of all, though it contains very attractive scenery and interesting history. The village of Chipping is the natural centre for exploring southern Bowland: it is a fascinating old settlement and deserving of more detailed coverage later. The Bleasdale pastures offer a pleasant, sheltered basin in the south, with fine wooded areas especially around Bleasdale Tower. Among the Bleasdale pastures lies one of Bowland's most interesting antiquities, the Bleasdale stone circle, which dates from the Bronze Age. North of Chipping, the land rises again to Parlick Pike, one of Bowland's most distinctive fells, then the huge mass of Fair Snape Fell.

The high places of Bowland occupy the heart of the district. It is these particularly dramatic Bowland fells that both define the framework of the area and contribute to the unique sense of mystery which sets Bowland apart from other tracts of upland Britain. As recently as the 1980s, authors including Wainwright, Mitchell and Freethy wrote of the Bowland fells as a near-primeval, wild terrain from which the walker and explorer were largely excluded. Today, with freedom to roam the fells access is available to all; yet even in high summer you may wander for hours among the hills and see hardly another soul along the way. We hope that this book will persuade readers to explore the distinctive character of Bowland and its soaring fells: one of the last true wilderness areas of England.

THE HIGH PLACES

At the heart of the Forest of Bowland are its high fells: sweeping, untamed, distinctive and lonely. In these high places are many inspiring viewpoints, unique habitats and rare birds of prey. Walkers can wander for hours in near-isolation on Bowland's fells, swept up in a landscape that is all its own. These high fells cover roughly half of the Forest of Bowland's total area of about 300 square miles. A considerable part of the fells is open moorland over 1,000ft in height, and much of that is over 1,500ft, reaching its summit at Ward's Stone (1,841ft, or 561m), seven miles south-east of Lancaster.

Superficially, the fells of Bowland appear similar in character to the Yorkshire Dales or the south Pennines. The main underlying rock is millstone grit, with a number of limestone intrusions, for example around Whitewell and east of Dunsop Bridge. Substantial beds of peat cover many summits, reminiscent of the Peak District. But there is a distinctly different character to Bowland's fells, especially in harsh weather, which is often more akin

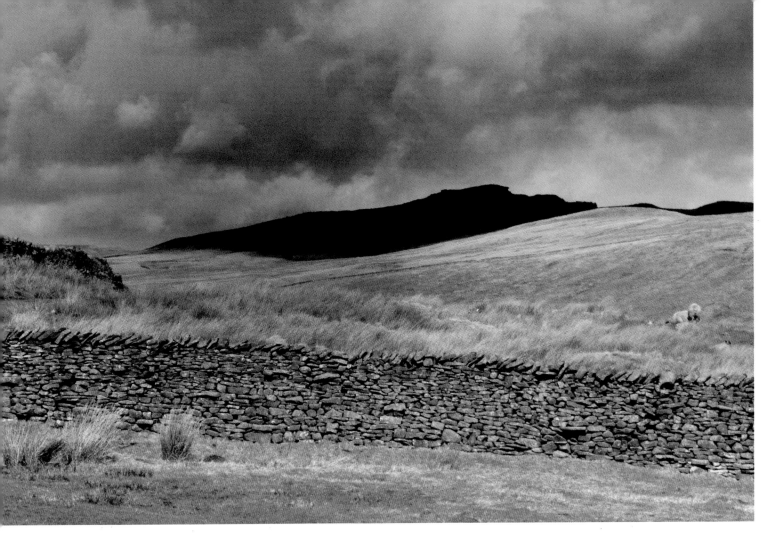

to that of the Lake District than the Pennines and should never be underestimated. The western side, especially, takes more of a battering from the prevailing westerly wind and rain, in contrast to relatively sheltered areas further east such as parts of the Dales. Anyone who climbs Pendle Hill regularly will have seen this contrast clearly enough.

Although this moorland heart of Bowland is still remarkably little known and little visited, the access has greatly improved for the walker over the last thirty years, especially as a result of the Countryside and Rights of Way Act 2000. For some time before this, many permissive paths had been opening up for the walker, and

Above: Bowland Knotts from Merrybent Hill

Right: Cold Stone, Catlow Fell

Previous page: Trough of Bowland from White Moor

18

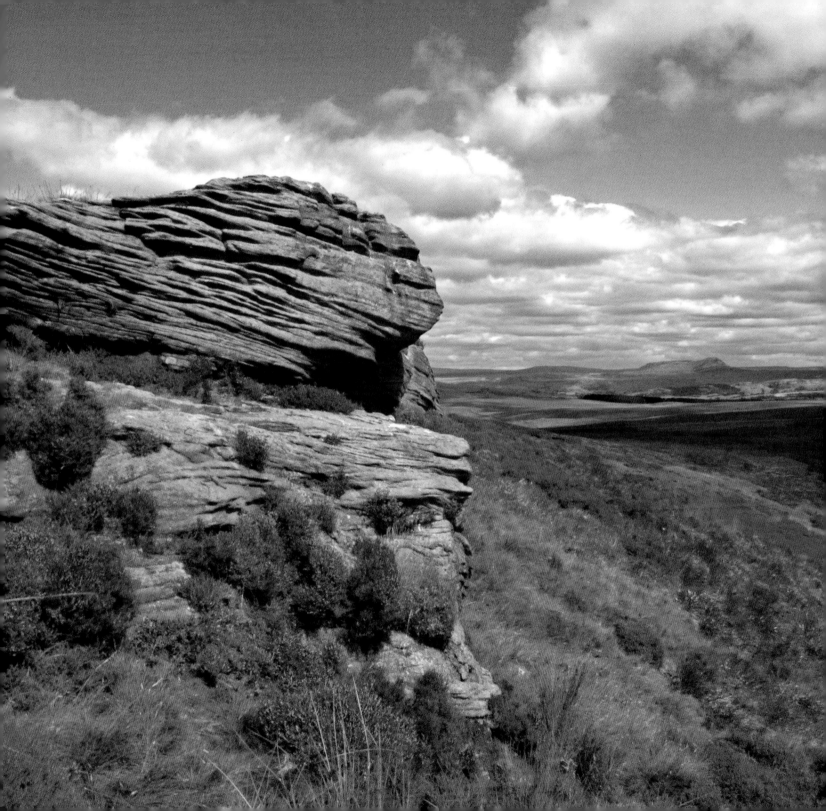

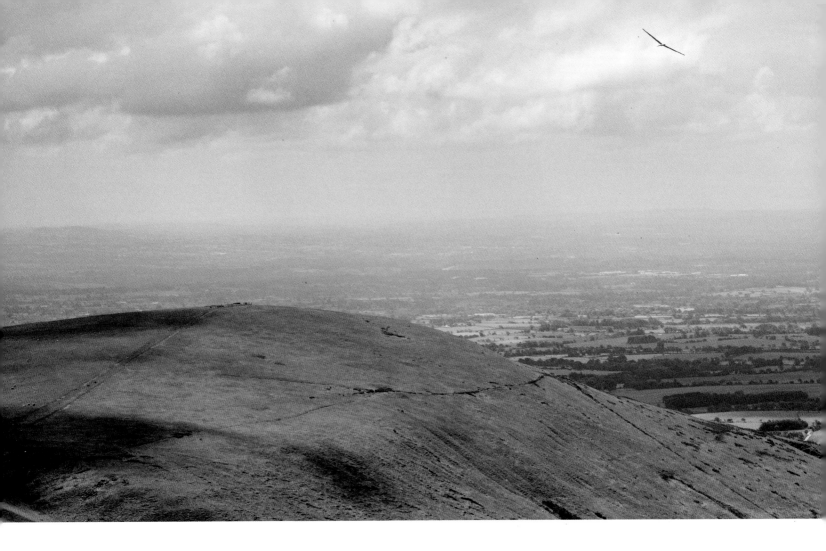

national bodies – the United Utilities and Forestry Commission – played a part in opening up their land. Landowners have maintained the right to close large areas of upland Bowland in response to weather conditions, such as prolonged dry spells which can create a fire hazard in the peat moors, and on certain designated shooting days. So, although the 'right to roam' laws marked a fundamental change in the culture of Bowland it has not yet greatly affected the numbers of visitors, walkers in particular.

On page 163 we describe three recommended walks – short, medium and long. This chapter focuses on one of the most important reasons for visiting Bowland, namely the high places and the views on offer from their uplands. Here, Bowland's strategic

Above: Glider over Parlick

Right: Dunkenshaw Fell and Ward's Stone Breast

Previous spread: Dunkenshaw Fell

position offers distant views – the Lake District and Yorkshire Dales, and the Three Peaks area in particular, can be seen from many of Bowland's high places. Bowland's fells offer many splendid panoramic views. From the western fells, you can see the coastal plain and Morecambe Bay which, when softened by afternoon or evening sun, can be seen at its best. Then there are the views of Bowland itself – the sweeping, lonely moorlands, fine ridges and quiet pastoral valleys.

Beginning in the south, Parlick Pike, though of no great height in itself at 1,416ft (432m) is a fine and distinctive fell rising two miles north-west of Chipping, conspicuous from a distance and a worthy starting point for exploration of the higher fells behind. The ascent of Parlick from Fell Foot is one of the most dauntingly steep climbs in the district. This is a favourite spot for hang gliders, too, taking advantage of the favourable thermals, their colourful wings making a lively splash on sunny days. Beyond its conical summit, the ridge from Parlick to the bulky Fair Snape Fell is a fine sight: a graceful arc, narrow at the col between the two fells. On a clear day, Fair Snape's western top has splendid views towards Morecambe Bay and the mountains of Lakeland. Fair Snape's true summit affords excellent views towards Pendle and the Dales. Generations of walkers have appreciated the stone shelter on Fair Snape, offering welcome respite from the elements.

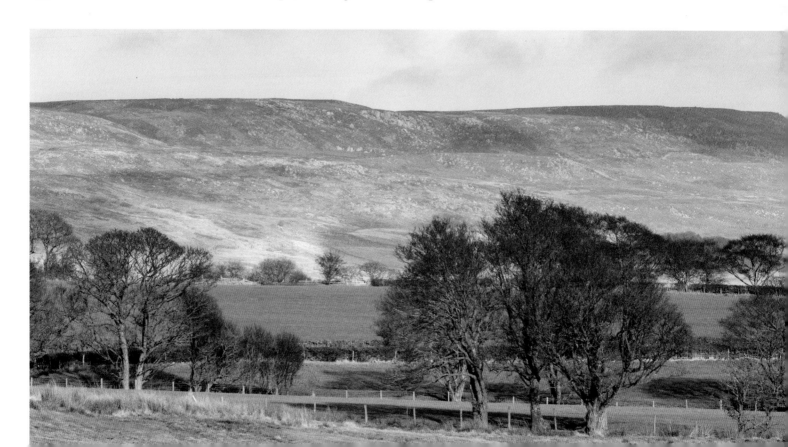

Moving some miles north, Ward's Stone, the highest point in Bowland, rises massively north of the Wyre valley and has two summits about a third of a mile apart. The fell takes its name from the large crag that forms the western summit, an impressive feature which requires a scramble to reach the top of it. All around the summit, the rock has been weathered into some remarkable shapes, given names by the mapmakers: Grey Mare and Foal, Cat and Kittens, the Queen's Chair. Though the summit plateau is unspectacular, Ward's Stone is a wonderful viewpoint, especially on a clear evening with mellow light bathing the coastal fringes and Morecambe Bay and many of the great mountains of Lakeland as a backdrop, leaving the spectator both soothed and stirred by the different aspects of this panorama.

Many people have heard of the Trough of Bowland but know little of the rest of Bowland. Certainly there is no doubt that the fells grouped around the narrow defile of the Trough offer some of the most spectacular views in the region. The Trough itself is so narrow and steep-sided that it is not easily viewed from other summits, but the nearby well-defined bridlepath over the shoulder of Whin Fell, the splendidly named Ouster Rake (a long-standing right of way) offers some wonderful views. To the west, Cockerham Sands can often be glimpsed,

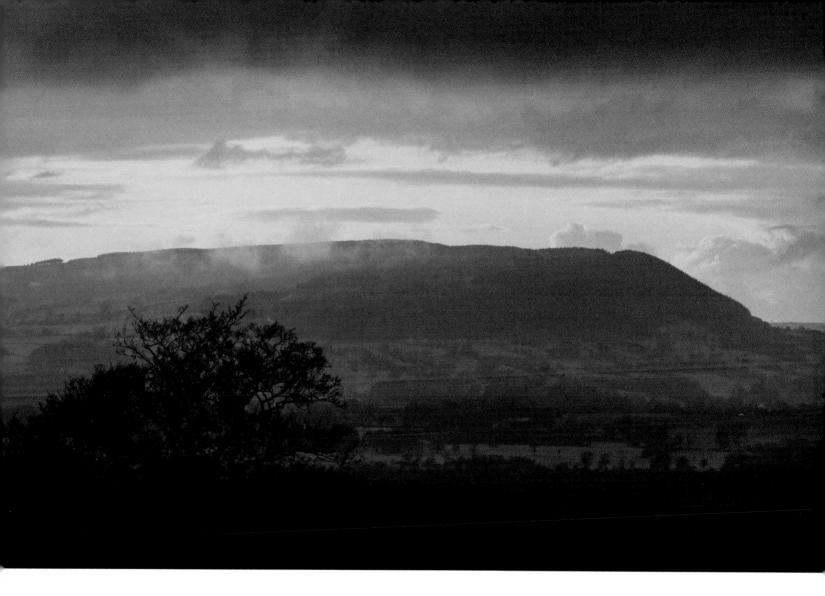

frequently bathed in golden light; while between south and west, a great sweep of fells dominates the scene, with distant Pendle peeping above intervening heights in the south-east. Looking north from Ouster Rake, where the path drops sharply away, there is a superb view of the great northern fells of Bowland, dominated by Ward's Stone and White Hill, with the green oasis of Brennand far below you.

To the south-west of the Trough at its narrow point, Blaze Moss is another fine viewpoint and often features on picture calendars. Further south, Totridge Fell is a lesser-known but splendid fell which juts out from the

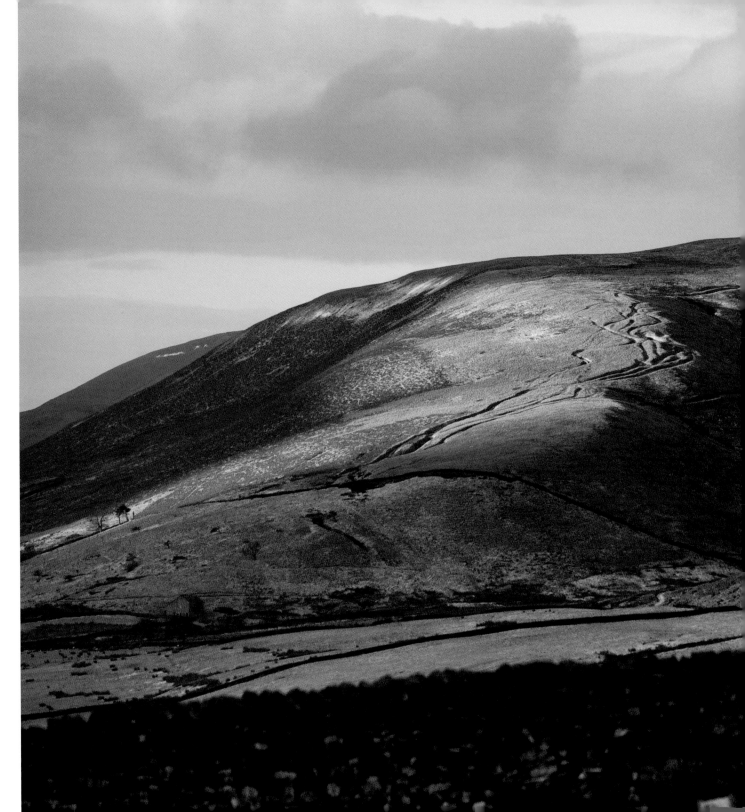

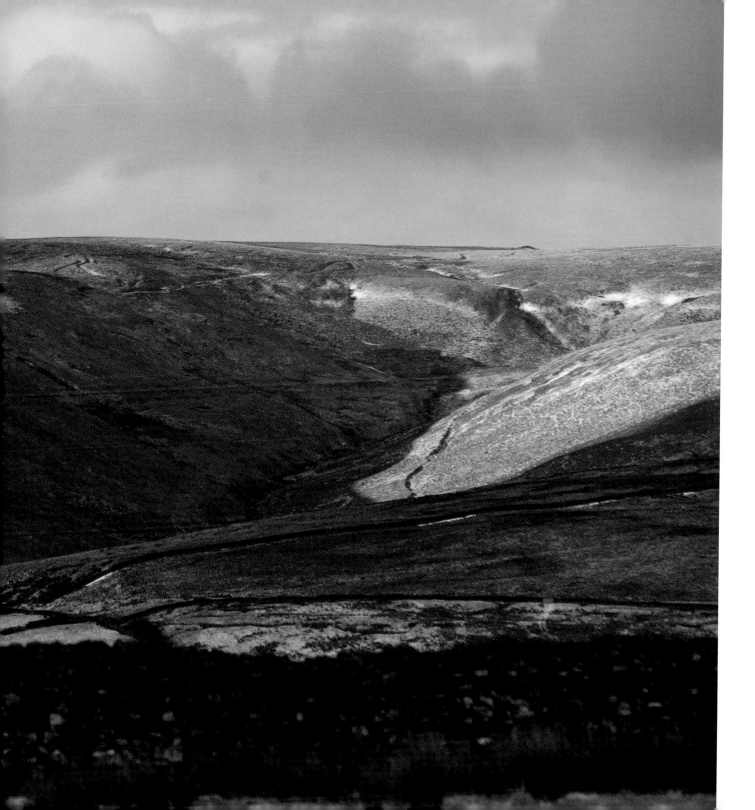

long ridge that starts at Fair Snape. From the summit of Totridge there is a splendid view to the east up the green Hodder valley, towards Newton, when conditions are right. To the north-west the Trough road can clearly be seen, climbing past Sykes and through Losterdale towards the narrow and often brooding defile. From the bridlepath lying east of Totridge's summit, passing through the Whitemore woods, there is a delightful terrace, enjoying a lovely prospect of the Hodder valley around Burholme Bridge.

Some miles east of Ward's Stone and north of Dunsop Bridge, the massive bulk of White Hill dominates the northern Bowland fells for many miles. At 1,784ft (544m), it is the second highest fell in Bowland. The seemingly mysterious towers, one lying close to the trig point, were used as observation posts for construction of the aqueduct taking water from the Lake District to Manchester. Though unspectacular in itself, with an extensive plateau summit, it is topographically important as it lies on the Lune-Hodder watershed, and

Left: Trough of Bowland

Right: Lamb Hill Fell and White Hill

Previous spread: Dunsop Fell

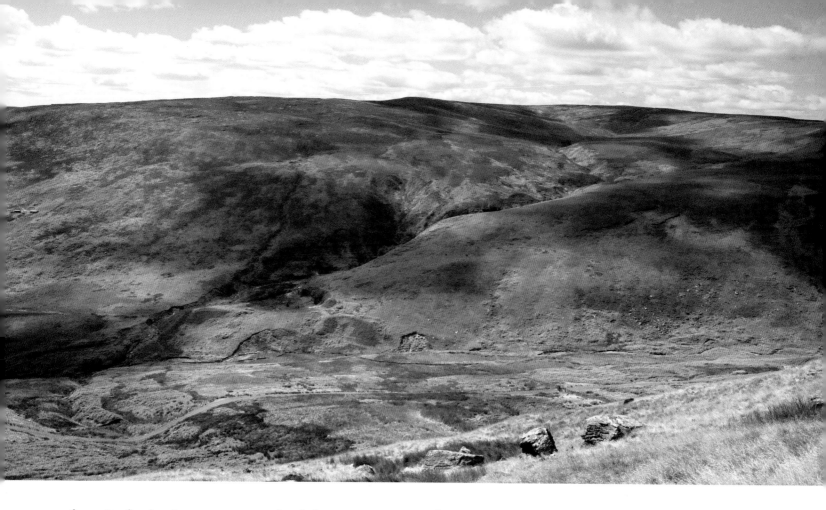

from its flanks there are some splendid viewpoints. Less than a mile from White Hill's summit, to the west, the old track of the Hornby Road or the Salter Fell track, runs south-east to north-west; at one point it offers a spectacular view. Here, as you round Alderstone Bank, the ground drops sharply in front of you – and what a prospect! A great sweep of the Dales, with the Three Peaks appearing as nearby giants, and Great Whernside and Buckden Pike also in view; Gragareth and Crag Hill and further north, the Howgills. Going further, on a clear day you can glimpse over intervening heights in the north-west towards Morecambe Bay and Lakeland, with Black Combe and the Coniston Fells prominent.

Further east we reach the spectacular minor road from Slaidburn to Bentham which passes the source of the River Hodder – the name is thought to mean 'beautiful river' and it is well deserved. Here, as you cross the summit of the road by Cross of Greet between White Hill and Catlow Fell, there is a wonderful view to the north and west. All that remains of the Cross is its base, clearly visible at the roadside. Further down the valley is Cross

of Greet Bridge, a delightful spot to stop the car and listen to the water rushing down from the fells. A few miles further north-east, in the Bowland Knotts area, another spectacular and lonely country road from Stocks Reservoir to Clapham crosses the watershed, which offers an even better view of the Three Peaks area. Car drivers and bikers often park here, with good reason, and there is a bench by one of the rocky

Below: Whitray Fell

Right: Whelpstone Crag and Gisburn Forest

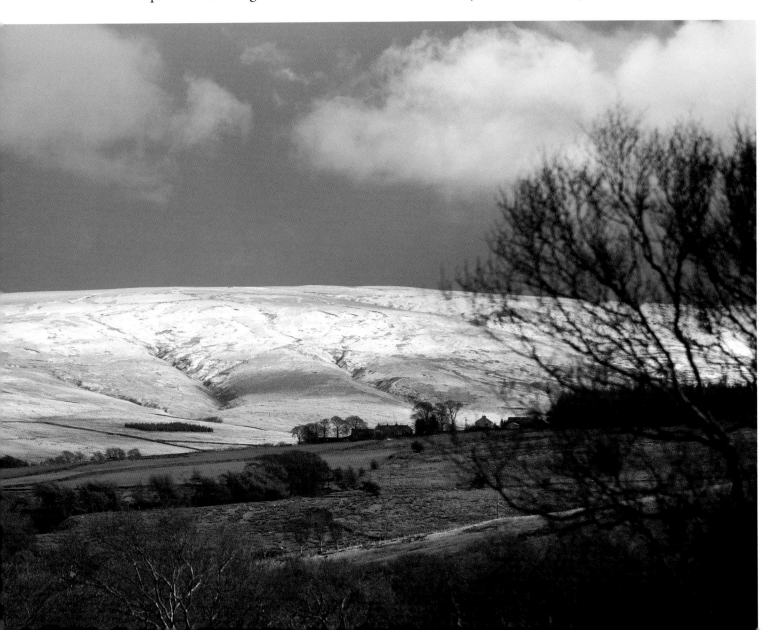

outcrops offering some shelter. The 'Knotts' are attractive rocky knolls, of no great height (rising to about 1,410ft, 430m) but conspicuous from a distance by virtue of their profile, and walkers can explore them.

Beyond the Knotts, the Bowland fells start to decline towards the eastern perimeter of the AONB and the upper Ribble valley, but there are still some notable viewpoints, and Whelpstone Crag certainly merits a mention. Though only 1,217 ft (371m) in height, it is isolated and offers one of the best of all Bowland's viewpoints towards the Dales, especially of Penyghent, Fountains Fell and the Malham Moor area. Between Stocks Reservoir and Whelpstone Crag, Gisburn Forest occupies many square miles, not all of it conifers. To the west of the Forest and Stocks, some of the hills, such as Merrybent Hill, looking south and east towards Pendle and Trawden, are well placed for spectacular dawns.

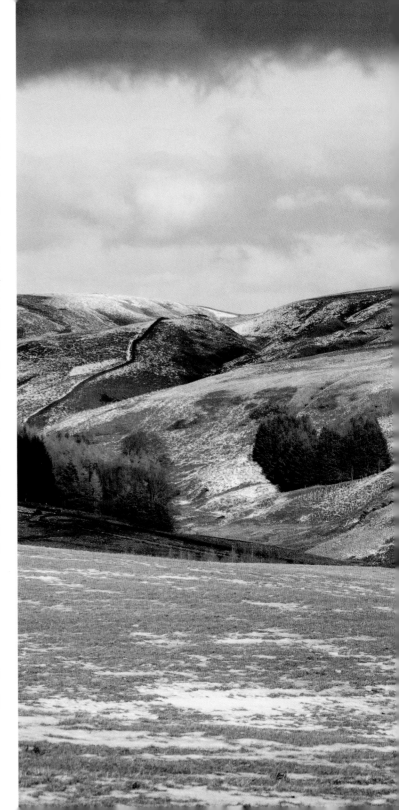

The Forest of Bowland

That was a brief bird's eye view, taken in a wide sweeping arc roughly from Bleasdale to Tosside, covering spectacular summits and viewpoints, which rival the best northern England has to offer. Yet this is not all of Bowland, not even all of the fells. There is also a short inner arc of less high ground, running south and east, offering beautiful views and much easier of access. This area is defined by Longridge Fell, Browsholme Heights, Waddington and Easington Fells: here there are some glorious viewpoints, less extensive but more intimate. The north side of Longridge Fell, especially its west ridge of Jeffrey Hill, offers superb views of the Chipping area and mid-Hodder valley with a backdrop of the higher fells behind – sometimes extending to the Three Peaks. It is a charming, very special, effect – a mini-district within the district, which was distinguished as 'Bowland Forest Low' on older OS maps.

These are, then, Bowland's high places; no longer forbidden territory but now accessible and full of beauty and grandeur. Among the fells there are many other beautiful features of Bowland's landscape to describe, notably its hidden valleys. Bowland's roads and tracks, the subject of the next chapter, have a rich history and have slowly, over many centuries, opened up to visitors this mysterious and, to some even fearful, area.

Right: The gritstone outcrop of Bowland Knotts

Overleaf: Cyclists in the Trough of Bowland

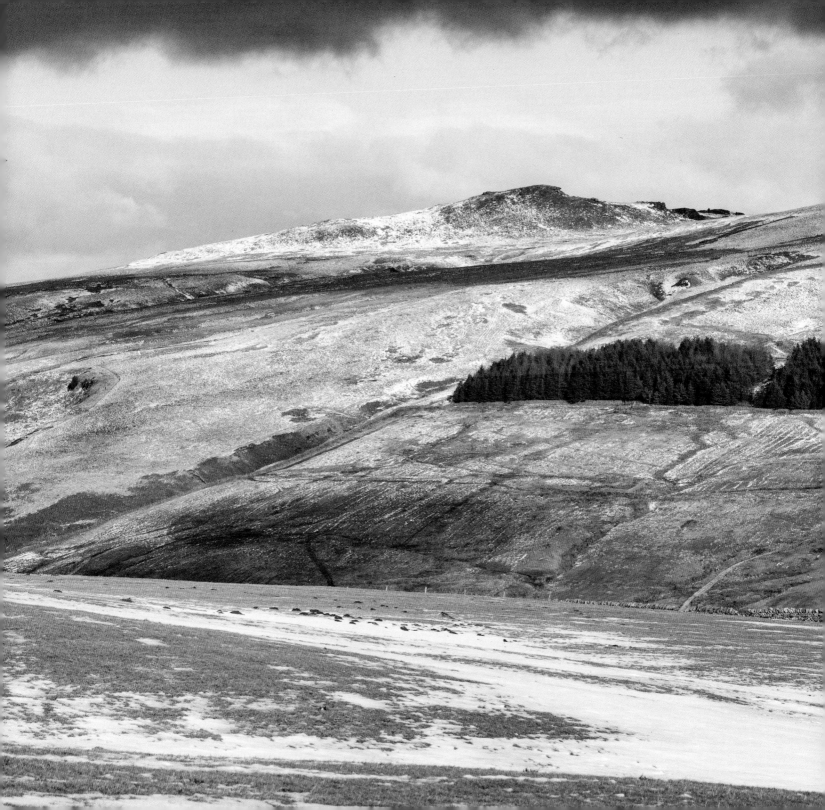

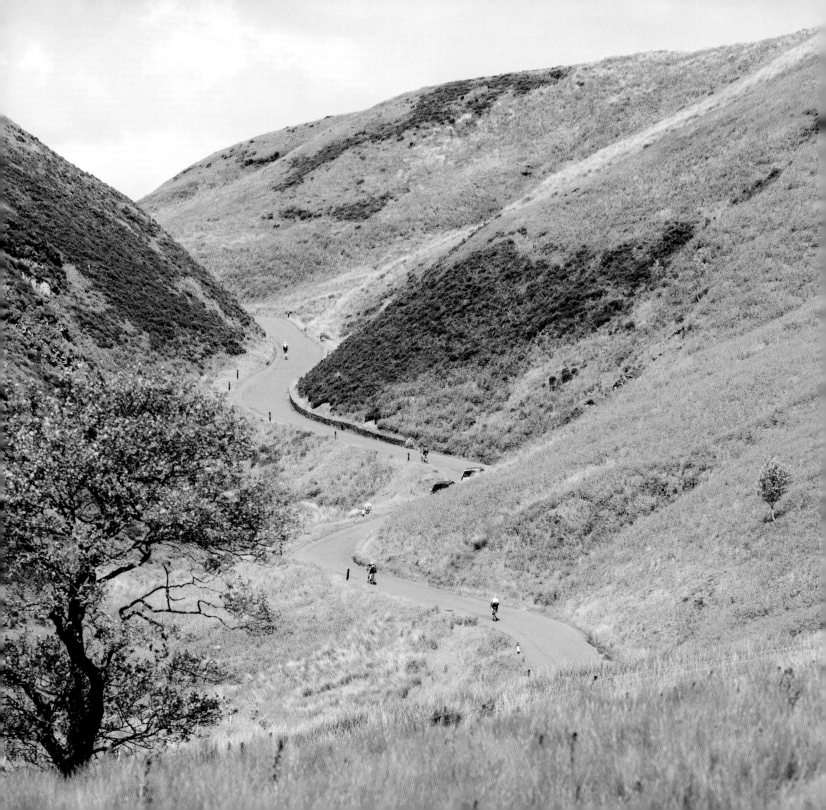

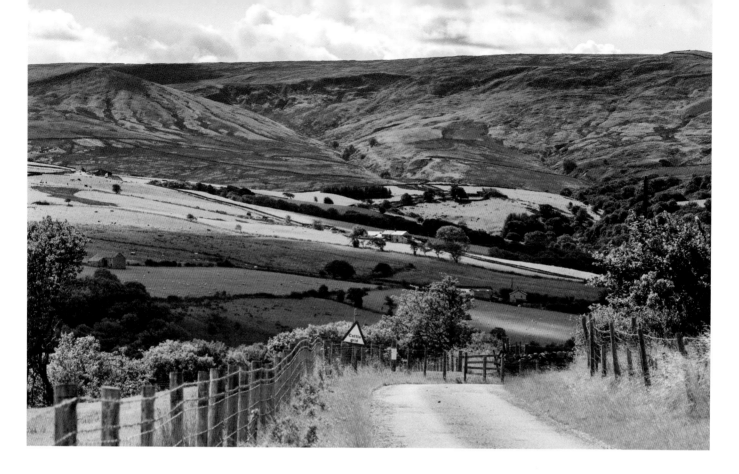

THE ROADS OF BOWLAND

Getting around the district

Without a doubt, one of Bowland's great assets is its quietness: most of its roads are minor roads. The A683, in its north-west corner, and the B6478 across Waddington Fell are the only classified roads making serious incursions into the AONB. Yet some of its roads, including one ancient track, have considerable history and traverse some of Bowland's most beautiful scenery. It says much about the character of Bowland that, of the four roads we describe in more detail, none is an A or B road, one has only been a through road since the 1950s and one is actually an ancient track incorporating several miles of Roman road. All of them cross important watersheds and pass through suddenly-reached, dramatic viewpoints which, when seen in the right conditions, will deeply impress themselves on the visitor's memory.

Inevitably we begin with the Trough of Bowland, perhaps Bowland's most iconic feature and the one best known outside the district. Frequently the term 'Trough Road' is applied to the whole journey from Clitheroe to Lancaster, or that part of it lying within the AONB. More properly, the Trough is the spectacular, narrow, twisting defile between Losterdale and the boundary with Over Wyresdale, where you enter Lancaster district. Here the road is narrow, steep and enclosed by soaring fells on both sides, demanding motoring precision, especially in winter.

In truth, though, the Trough Road is richly varied and offers many treasures along the way. The section from Dunsop Bridge passing Hareden, Langden and Sykes is a real gem with the fine river scenery of Langden Brook, tremendous in spate, beautifully set off by the light and shade of the high fells enclosing the valley. Beyond the narrow defile of the Trough proper, the road descends to the Marshaw Wyre, a lovely unfenced section with a fringe of Scots pine and other trees accompanying the river. Further on comes a more open section, reaching its

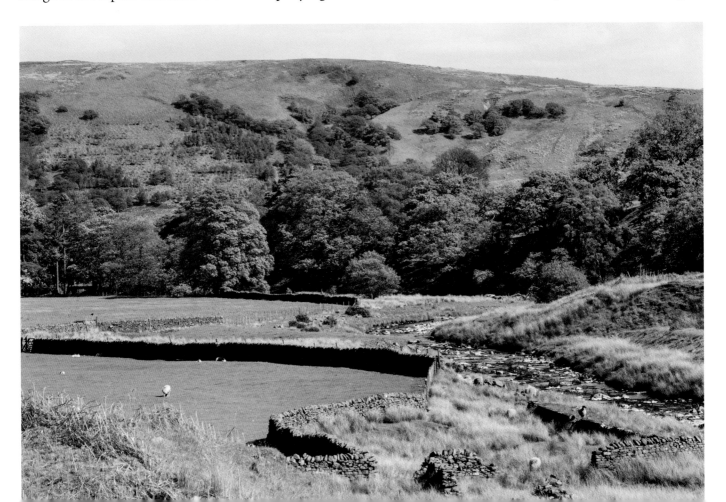

climax by the Jubilee Tower (1887) where a wonderful view across Morecambe Bay suddenly appears. Pause a moment at the adjacent car park, where you can read the fascinating story of the Quernmore Burial. A burial shroud dating from the seventh century was discovered here during excavations to prepare the car park: it's now exhibited at Lancaster museum. Beyond this point the road descends gradually, passes through the crossroads at Quernmore and soon leaves Bowland, running beneath the M6 to enter Lancaster.

At one time the Trough was a popular walk, and a major challenge too: a full 25 miles from Clitheroe to Lancaster. Nowadays the volume of traffic will deter most walkers, except perhaps for a weekday out of season. This author's favourite memory of the Trough Road, however, is probably the descent from the end of the Ouster Rake bridlepath, through Losterdale, down to Langden and on to Dunsop Bridge. On a quiet winter's afternoon, with only the occasional car intruding onto your thoughts, this is a lovely stretch of both solitude and grandeur that you will be truly reluctant to leave.

Left: The view from the Trough of Bowland road at Hareden

Right: The Lake District fells seen from the Cross of Greet road

Page 35: Roeburndale West looking to Mallowdale

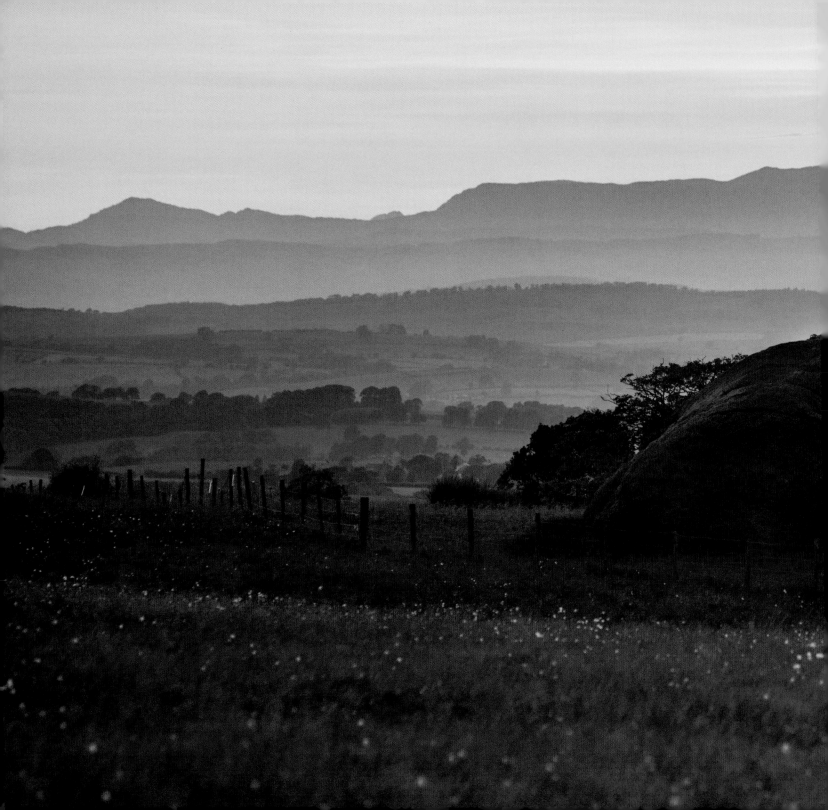

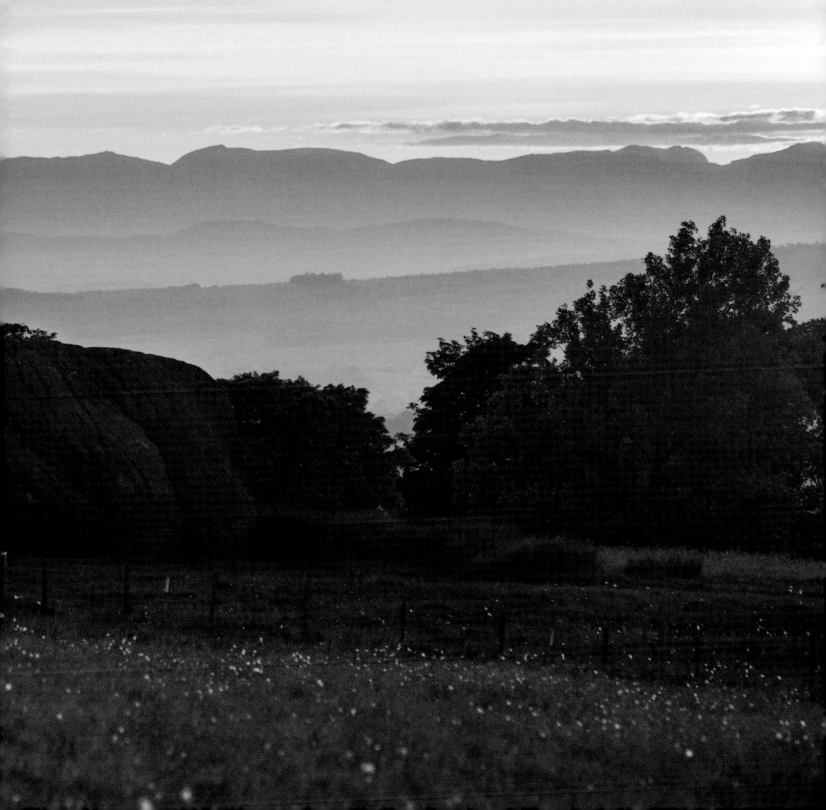

Passing further east we reach the Hornby Road, or Salter Fell track, a fascinating old route about which there is certainly more to discover. It is not a through road: the nine-mile section from just beyond Higher Wood House to High Salter is a track, whose exact status on current OS maps is 'other route with public access'. Suffice it to say that RSPB vehicles may be encountered here, but general vehicular access is not permitted. Whatever its exact status, it is a really fascinating way through the fells, and can be warmly recommended to walkers, who may enjoy taking on the whole distance of 15 miles from Slaidburn to Hornby.

Part of the Hornby Road is undoubtedly Roman, that section of about four miles passing the impressive amphitheatre of Croasdale Quarry and the head of Croasdale before diverging to the north beyond the Whitendale path. 'Salter Fell' is a later name, referring to the transport of salt between Morecambe Bay and the East Lancashire towns. It may well be that the Romans inherited a still earlier track and we await further discoveries with interest. At its highest point, the Hornby Road reaches a height of about 1400ft (430m); perhaps its greatest prize for the walker is attained, on a clear day, further north-west after you pass Alderstone Bank. A great arc of Northern England opens up: the Three Peaks area, the Howgills, a section of Morecambe Bay and some Lakeland fells. Not even the Trough Road can equal this. For birdwatchers, too, these are richly favoured miles. In spring especially you may see a number of unusual passerines, many different waders, seabirds – from the nearby Tarnbrook Fell colony – and birds of prey, including the hen harrier which has been adopted as Bowland's most iconic wildlife.

'Possibly the finest moorland walk in England': Mr Wainwright was quoting when he said that of Salter Fell – intriguingly, he does not give his source – but it is remarkable that he gives tacit agreement to the statement, considering his yardstick was the Lake District. Of course it is scenery of quite different character, but the solitude, rocky outcrops, wide sweeping fells and dramatic viewpoints of these miles, already hinted at, are truly special – and best appreciated in small numbers. To walk the whole way requires careful planning, with transport at both ends, if you intend it as a single day's outing – but the rewards are great. Come, taste and see!

Journeying further east again, we reach the Slaidburn to Bentham road, undoubtedly a motor road throughout its length but not one to venture on lightly. This has only become a through road since 1950, and was gated for many years. It begins in the centre of Slaidburn by the war memorial, heading resolutely north and soon passing close to Stocks Reservoir and the United Utilities plant. Beyond the shoulder of Merrybent Hill comes a steep, twisting descent into one of Bowland's characteristic hidden valleys as you approach Cross of Greet Bridge and the upper Hodder, where the infant river tumbles down from the high fells.

The rough but welcome car park by the bridge is a lovely spot for a break: just enjoy the Hodder, already a fine vigorous stream, and its environs in this truly away-from-it-all location. Nearby you can spot clear signs

of an old trackway that was used to transport materials for the construction of Stocks Reservoir, unseen from here, about two miles south-east. The Cross of Greet no longer exists, but you can see its base quite clearly by the roadside at the watershed, some two miles uphill. This section of road is demanding, steep and narrow with sharp bends and likely impassable in snow. The reward, as you cross the Ribble-Lune watershed at the summit, is a splendid view into the north, the Three Peaks prominent and remaining

Previous spread: Big Stone and the Lake District from Cross of Greet road above Bentham

Below: The turn-off to Whitendale from the Salter Track

so for some miles as you descend. A most unusual feature, enhancing the later miles, is a great erratic boulder, the Great Stone of Fourstones ('Big Stone' to the locals), which you can climb by steps cut into one face. As the name implies, there were initially four stones but the others have long disappeared, broken into fragments for local farms.

Strictly speaking, both Low and High Bentham – the latter being the road's final destination – lie outside Bowland as now defined. Visitors should not be pedantic: Bentham is a worthy objective, an interesting old market town with some good shops. Sadly its grammar school no longer exists, but true to the town's origins it retains an important livestock auction market covering a wide area.

Finally, there is another minor road crossing the fells which is becoming better known – not least owing to the growing recreational popularity of Stocks Reservoir and Gisburn Forest. This is the minor road which leaves the B6478 about three miles north-east of Slaidburn, heading ultimately for Keasden and Clapham. Scenically, its finest features lie in the miles beyond Stocks Reservoir. You pass through the quiet north-west corner of Gisburn Forest, in one of the likeliest stretches of Bowland to spot deer, and after crossing Coat Rakes bridge climb steeply past the remote, superbly situated Dale House. The best moment of all comes just over a mile further on, when after climbing out of the Hodder basin you reach the attractive serrated skyline of Bowland Knotts. Quite suddenly, on passing the watershed, you reach another of Bowland's great viewpoints, with space to park and even a strategic bench to enjoy the prospect. The Three Peaks, with other Dales summits such as Great Whernside, look real giants from here and contrast most pleasingly with the greenery of the Wenning valley in the middle ground. Bowland Knotts can readily be explored on foot: although there are no natural paths, walkers had begun to forge unofficial routes here even before the Countryside Act of 2000. Beyond the Knotts, the road descends more sedately, passing Keasden crossroads and emerging at Clapham near its railway station, whence a number of good homeward routes can be used to complete a circular tour.

Four fine and contrasting routes, then, all with their own individual beauty but united by their possession of outstanding vantage points. For walkers, too, sections of each have much to offer and we shall revisit them later in our selected walks.

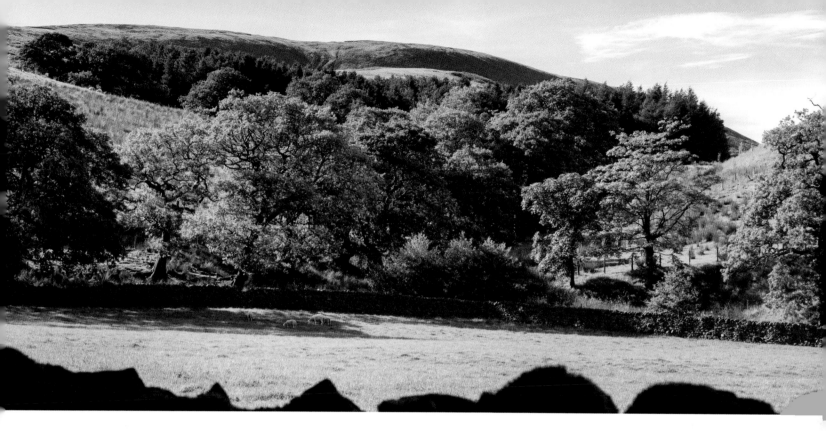

THE ESTATES OF BOWLAND

The Forest of Bowland is largely split between four major estates: the Forestry Commission, United Utilities, the Abbeystead Estate (part of the Grosvenor Estate) and the Duchy of Lancaster Estate. There are several other smaller estates, such as Bleasdale in the south-east of Bowland, which are of note, and two 'estate villages' (Downham and Slaidburn) which have remained largely unspoilt as a result of being owned and development-controlled by just one family.

To the north-east of Stocks Reservoir, Gisburn Forest is managed by the Forestry Commission both as a working forest and as a leisure facility. As the largest forest in Lancashire, the majority of the area is still forested with conifers, although work is underway to recreate 'native woods' to supplement the existing pockets of ancient native woodland in the forest. Despite first appearances, this is a diverse environment, with farmland occupying

Above: Langden

some open areas, some areas of bog and rough moorland, some heath, and several becks running down through the forest from the surrounding high places.

At Gisburn Forest Hub, in the centre of the forest at Stephen Park, the Forestry Commission has developed a centre for mountain biking, with a number of marked trails graded for difficulty, as well as numerous footpaths through the forest and a café and information area. The Forestry Commission also manages 187 hectares of woodland in the Dunsop Valley.

Stocks Reservoir is neighbour to Gisburn Forest and is the centre of the United Utilities Estate in Bowland, covering 10,000 hectares (24,000 acres), and apart from supplying water to major towns such as Preston, Lancaster, Blackburn and Burnley, the UU Bowland Estate is also the most important breeding site for Hen Harriers in England. There are a number of Sites of Special Scientific Interest across the area, which the company are keen to conserve and protect.

The company also has sites at Hareden and Langden in the Trough of Bowland area, as well as important water catchment areas at Ogden and Black Moss above Barley in the Pendle section of the AONB. Additionally the huge Haweswater Aqueduct, taking water from the Lakes to Manchester, runs through Croadsale.

In the western section of the AONB, covering the valleys of the River Wyre, and encompassing Ward's Stone, at over 561 metres (1839 feet) Bowland's highest point, is the Abbeystead Estate, owned by the Grosvenor Estate, and one of England's premier sporting moorlands. There are over 7,000 hectares (18,000 acres) of remote upland, woodland, upland grazing for hill farms, and river valleys.

Right: Winter landscape near Kenibus

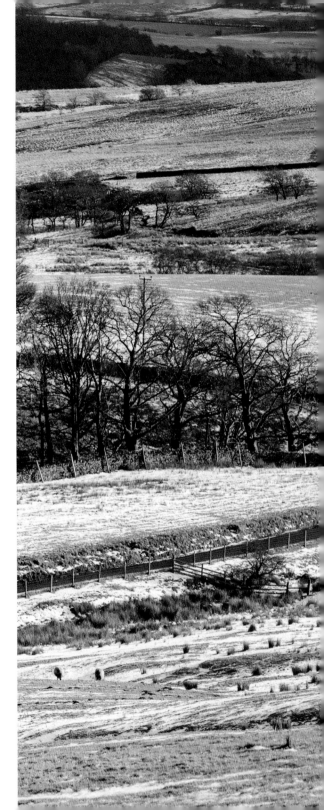

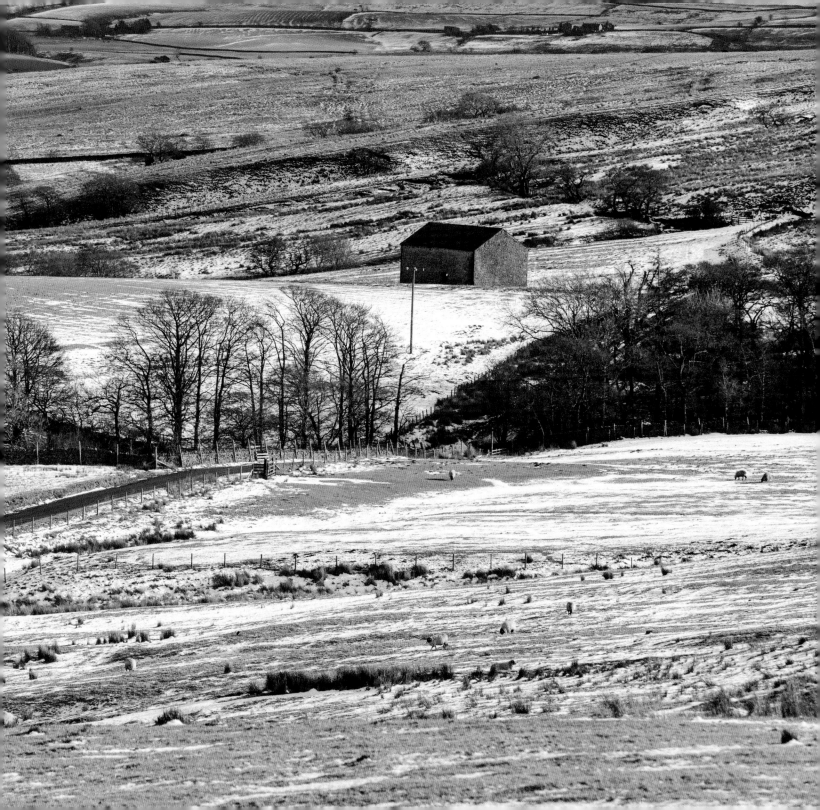

The other great estate in the Forest of Bowland is the Duchy of Lancaster Estate, owned by Her Majesty the Queen, and which is concentrated around the Whitewell and Cow Ark areas of Bowland, and comprises 2,400 hectares, mainly of livestock farms and uplands, as well as the ancient and famous *Inn at Whitewell*.

On the slopes of Pendle Hill, the Assheton family run the Downham Estate and manage the estate village of Downham, carefully controlling its appearance and development.

Slaidburn is another estate village, almost entirely owned by the lady squire, Anthea Hodson, and her two daughters.

In the south-east of the area, between Beacon Fell and the Abbeystead holdings, is the Bleasdale Estate, covering nearly 1200 hectares (3,000 acres) of wooded and moorland ground, over which there are shooting rights as well as the Leagram and Wolfen Hall Estates near Chipping.

To the north are the estates of Mallowdale and Fourstones, both in the Tatham Fells area, whilst to the south near Pendle there is the Huntroyde Estate.

Below: The top section of the Cross of Greet road from Lamb Hill Fell
Opposite: The view from Ouster Rake

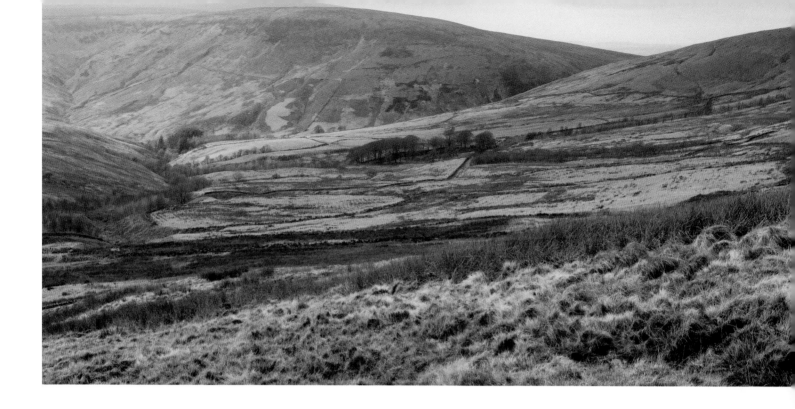

UNITED UTILITIES ESTATE

As the Land Agent for United Utilities, who are one of the largest landowners within the Forest of Bowland AONB, Mark Riches is fortunate enough to work in the Bowland landscape on a daily basis.

It is a common misconception that the uplands are a 'natural' or 'wild' habitat. In reality this is far from the truth. The 'Natural Beauty' referred to in the 'Area of Outstanding Natural Beauty' designation and the appearance that people associate with the uplands is largely as a result of human activity over many generations. Modern environmental stewardship schemes are an important part of enabling upland farms to continue to manage the landscape in a way that maximises the protection and enhancement of the environment and the biodiversity that relies upon it. A prime example of this is of course the hen harrier that is now synonymous with the Forest of Bowland, and for which the United Utilities' estate is the breeding stronghold, but there is also a plethora of other species that inhabit the area. These include breeding waders such as curlew, oyster catcher and golden plover; birds of prey such as peregrine, merlin and short eared owl; reptiles such as adders and of course the rich and diverse flora of the area.

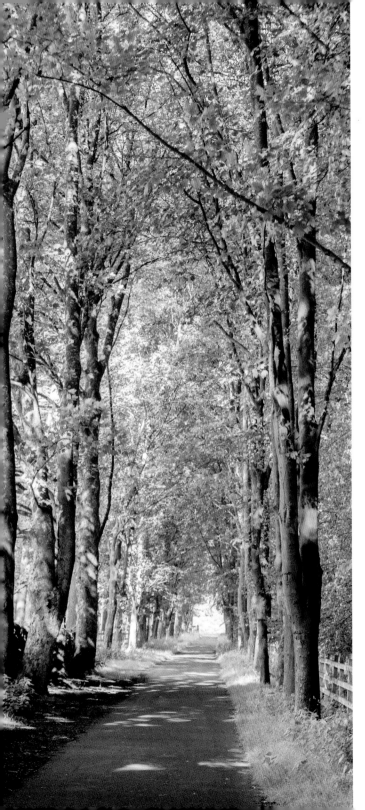

Many people are puzzled as to why a water company should own such large areas of land. These areas are water catchment land and the rain that falls here feeds into the drinking water reservoirs and intakes. By controlling the activities on catchment land United Utilities (UU) can ensure the water entering the reservoirs and intakes, and therefore the water treatment works, is of the highest quality. This reduces the requirement for water treatment intervention which can be an energy and chemically intensive process. UU works closely with

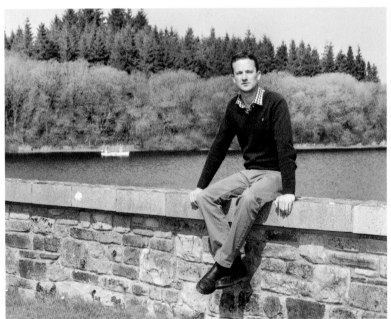

Above: Mark Riches, Land Agent for United Utilities, on the dam at Stocks Reservoir

Left: An avenue of beeches and sycamores at Langden

the farmers and land users to protect water quality and undertake cooperative works and schemes with them: for example the Sustainable Catchment Management Programme (SCaMP) involved large scale works to restore and re-wet moorlands and blanket bog, reduce stocking densities, protect water courses and erect new buildings to allow some activities to take place under-cover and reduce the burden on the land and the risk of pollution or disease. The protections put in place to improve water quality have also had the beneficial effect of both protecting and enhancing the environment.

Many of the people in the surrounding conurbations may not be aware or perhaps even interested in the existence of the Forest of Bowland. However, they all have a far closer link with the area and its environment than they realise, since the water that comes out of their taps has fallen onto and percolated through the ground and soil of Bowland. Leonardo da Vinci stated that 'Water is the driving force of all nature'. Here it is the forces of nature that have helped to ensure the water provided to us is of the highest quality.

A great deal of Mark's time is spent in the office dealing with tenancy agreements, rent reviews, legal issues and compliance. When he does get out from behind a desk, undertaking boundary inspections is one of the jobs he particularly enjoys. Mark smiles and says that it is lovely to be out of the office and getting paid to walk over some of the country's most beautiful scenery inspecting boundary walls and fences. Strangely enough, he comments, it is an activity which always seems to fall on a sunny day (pure coincidence of course!). It was on one of these days that Mark

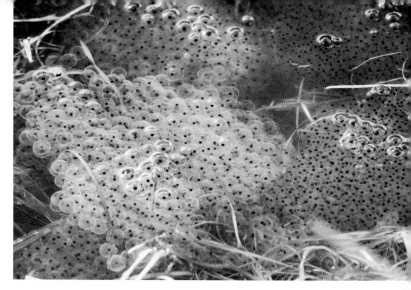

Frog spawn near Stocks reservoir

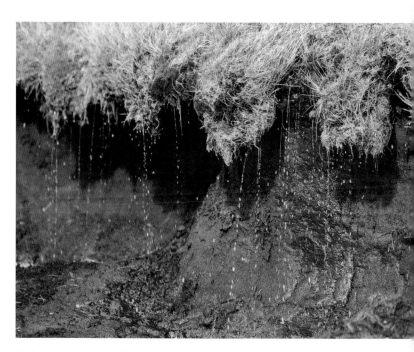

Sphagnum moss dripping onto peat, all preserved by United Utilities as part of their Sustainable Catchment Management Programme

discovered his favourite place in Bowland (so far). Standing on the top of Catlow Fell looking down over Stocks Reservoir and onto Pendle Hill in the distance is just a breath-taking view.

Having studied Rural Enterprise and Land Management at Harper Adams, and Historic Environment Conservation at the University of Birmingham, Mark has always worked in land, property and business management in some form or another. He previously worked on a United Utilities Estate in the Peak District National Park and came to the Forest of Bowland as the result of a job promotion. For him, it has been very noticeable that these two areas have very similar landscapes but very different atmospheres. To Mark it appears that Bowland has a much more relaxed and friendly feeling, the pubs are inhabited by locals, village shops and services still survive and the significant urban fringe pressures suffered by the Peak District are far less prevalent. Local people outnumber the tourists and as a result the area feels more real. Visitors can come to see a working countryside rather than a manufactured pastiche. An increase in tourism to the area would undoubtedly boost the economy but he hopes that any increase can be done in a balanced way and that the Forest of Bowland can prosper whilst still remaining a quiet, unspoilt and forgotten land for many generations to come.

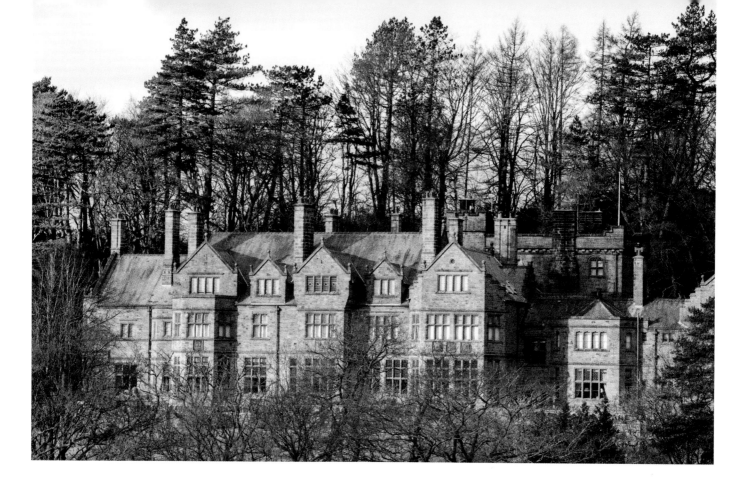

ABBEYSTEAD AND THE WYRE VALLEY

The River Wyre drains a significant part of western Bowland. The green enclave of the Wyre Valley, surrounded by some of Bowland's highest fells, is a most attractive feature of this part of the district. Compared to the Ribble and Hodder valleys, it is relatively little known: nevertheless, motor access to this sector is remarkably easy from the M6. A number of pleasant short circular drives can be devised, returning for example via the Trough Road north through Lancaster or south via the Hodder valley. Although not as narrow as some of the Yorkshire dales, Wyresdale is well defined, lying between the Hawthornthwaite Fell and Ward's Stone massifs from south to north, and between the M6 and the Trough Road from west to east. It deserves to be better known.

Above: Abbeystead House, a country retreat belonging to the Grosvenor Estate

Left: Hawthornthwaite Fell

Above: The Tarnbrook Wyre at Abbeystead

There is often something arbitrary about boundaries, but it does nevertheless seem surprising that Dolphinholme, lying on both the Wyre and the Wyre Way, lies outside the official AONB; as does the popular Grizedale, locally known as 'Nicky Nook'. A few miles further east lies Abbeystead, unquestionably within the AONB and in some ways the natural centre of Wyresdale, though not part of the old Bowland estate. This small but attractive village is part of the Grosvenor Estate, and includes Abbeystead House, bought by the Duke of Westminster in 1980. This splendid 19th century building was originally a shooting lodge built for the 4th Earl of Sefton in 1886. The 'abbey' implied by the name refers to a short-lived Cistercian foundation from the time of Henry II; it was sited near the present-day Abbeystead reservoir. The tranquility of Abbeystead and its surrounds was broken within recent memory by a major tragedy, when an explosion in 1984 at a plant by the

reservoir on the Wyre, caused by a build-up of methane gas, led to the loss of many lives. A plaque by the spot recollects the disaster.

The Wyre is a fine though relatively short river, which divides upstream of the green lanes around Abbeystead. The major branch is the Tarnbrook Wyre, flowing down from the heights of Ward's Stone, the

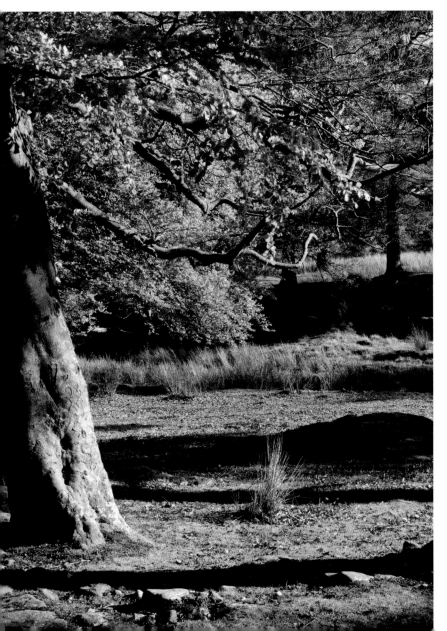

summit of Bowland. The other significant branch is the Marshaw Wyre, rising further south and flowing for some distance adjacent to the Trough Road. Wainwright considered the Wyre to be Bowland's most important river and while this is a debatable point, no-one can deny the beauty of the Scots pine-fringed roadside section of the Marshaw Wyre.

The Wyre Way, a long-distance footpath of 41 miles, offers walkers the opportunity to trace the river's course from its youthful beginnings among the fells to the Irish Sea at Fleetwood. The walk might appeal especially to those who feel a little daunted at first by Bowland's higher summits, and the riverside scenery is charming. East of Abbeystead, the walk makes a loop to visit both the Marshaw and Tarnbrook branches. There is a connecting section between Tower Lodge, an old shooting lodge, and the secluded hamlet of Tarnbrook, which is thought to have Quaker origins. The walk therefore does not take in the birth of the Wyre, high on Ward's Stone, but more adventurous walkers will have their appetites whetted, for the summit of any national park or AONB is a natural goal for the walker.

Left: Woodlands beside the Marshaw Wyre

Opposite: Stocks Reservoir with Dunsop Fell in the background

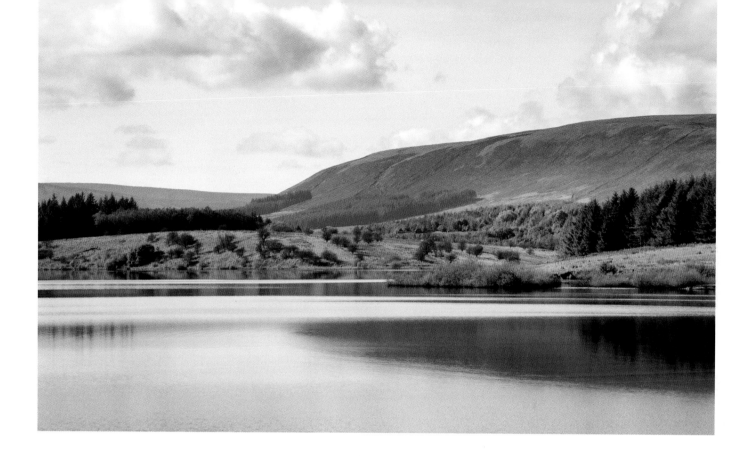

STOCKS RESERVOIR

Stocks Reservoir, completed in 1933 and about two miles north of Slaidburn, is Bowland's largest infrastructure and an impressive piece of civil engineering. Today, some eighty years on, it has blended in well with its surroundings: its many inlets and wooded bays softening its lines. The reservoir supplies the needs of the Fylde, and in recent years, after ample rainfall, its 'tide-mark' of a shoreline has usually been inconspicuous. It was a different story in 1995 when, after a long dry spell, the water level plummeted to just 10% of its capacity.

The inter-war years saw a number of important reservoir developments, and in many ways Stocks is Bowland's parallel to Lakeland's Haweswater: in both cases, a valley was flooded, a former village was lost and the remains lie many fathoms down. The building of the reservoir began in 1926, and for some years there was a substantial shanty town housing the construction workers, complete with amenities including a cinema. The

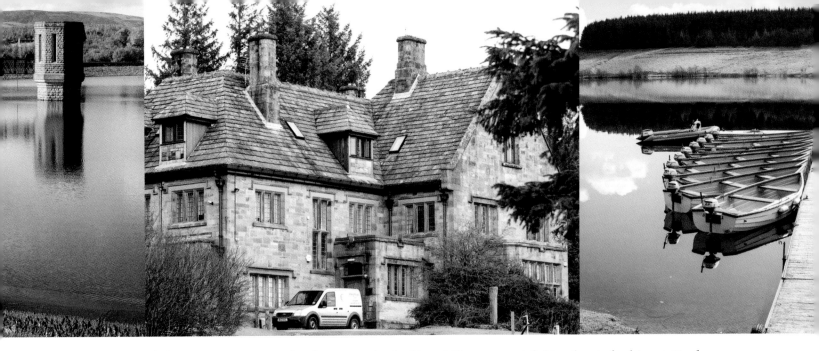

Above, from left: Aeration tower at Stocks reservoir; the Board House; trout fishing boats for hire at Stocks

official opening took place in 1932, conducted by the Duke of York (later King George VI). In truth, the former village of Stocks in Bowland was a small affair although it did have its own church and rectory. The Church of St James, Dalehead – formerly of Stocks in Bowland – has been preserved. It was translocated to its present spot, about a mile from the original site, and is a little gem: a beautifully-kept building.

In true Bowland fashion, Stocks reservoir is unobtrusive and rarely shows to advantage from a distance: it peeps out suddenly, at the last minute of your approach. One of the rare views of Stocks from afar is at (OS 723593), a wall junction on the path climbing to Bowland Knotts. Yet its immediate surroundings are enchanting and the circuit of the reservoir is a very popular walk, of about eight miles, well waymarked. Although barely ten miles from Clitheroe as the crow flies, the area feels very remote, especially at quiet times of the year: tucked away in that deep bowl, you could be anywhere. Beware the slopes of Eak Hill in wet weather, however, which become very heavy and will test any walker's boots. As well as a number of remains of old buildings, you can spot, on the west side, tell-tale signs of an old railway. By the south-west corner near the reservoir dam stands the Bowland headquarters of the United Utilities enterprise, and a little to the north, on an attractive, sheltered bay, a fishing lodge where boats can be hired and refreshments bought in season.

As a natural wildlife haven, especially for birds, Stocks excels and United Utilities have worked hard to encourage this. Recently a second bird hide has been added, close to the earlier one on the north inlet near the main car park. Unsurprisingly, it is in water birds that Stocks excels, with many sightings of rare ducks and

geese, but there is great variety. A number of osprey sightings are recorded, with other birds of prey including the Bowland hen harriers. All kinds of passerines may be seen too: alongside the more common finches and tits, you may see siskins near the hides, and crossbills, normally regarded as a Scottish species, may be a prize sighting if you are fortunate. The mixed woodland plantings have assisted in generating a splendid diverse environment.

What began as a necessity, through the growing demand for clean and reliable supplies of water, has turned into one of the district's most attractive features. Stocks Reservoir is a model of how urban need, countryside planning, varied recreational activities and wildlife can happily co-exist.

Below: A bank flyfisher changing flies at Stocks Reservoir

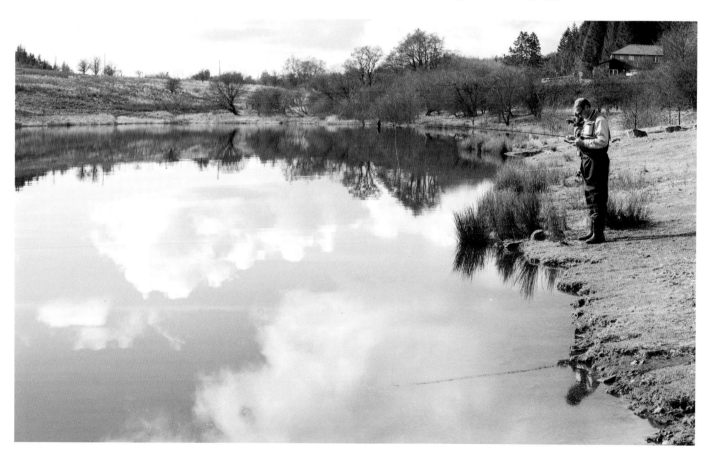

GISBURN FOREST

Gisburn Forest, on the eastern edge of Bowland, has become another model of good understanding between a public body and the general public seeking recreation. Formerly this was a very quiet corner of Bowland, but today Gisburn Forest has become a centre par excellence for mountain bikers and, with the public interest in cycling at an all-time high, the timing has proved perfect.

The bikers' centre is Gisburn Forest Hub, easily accessed from the narrow road which leaves the B road about three miles north-east of Slaidburn. The 15th century farmhouse of Stephen Park lies adjacent to the Hub and has been turned into B&B accommodation suitable for families, with a café that opens at weekends. Another good access point is Tosside, further along the B road, from where you can enter the network of forest tracks via a lane leading past a sawmill.

Above: Whelpstone Crag
Right: One of the many paths through Gisburn Forest

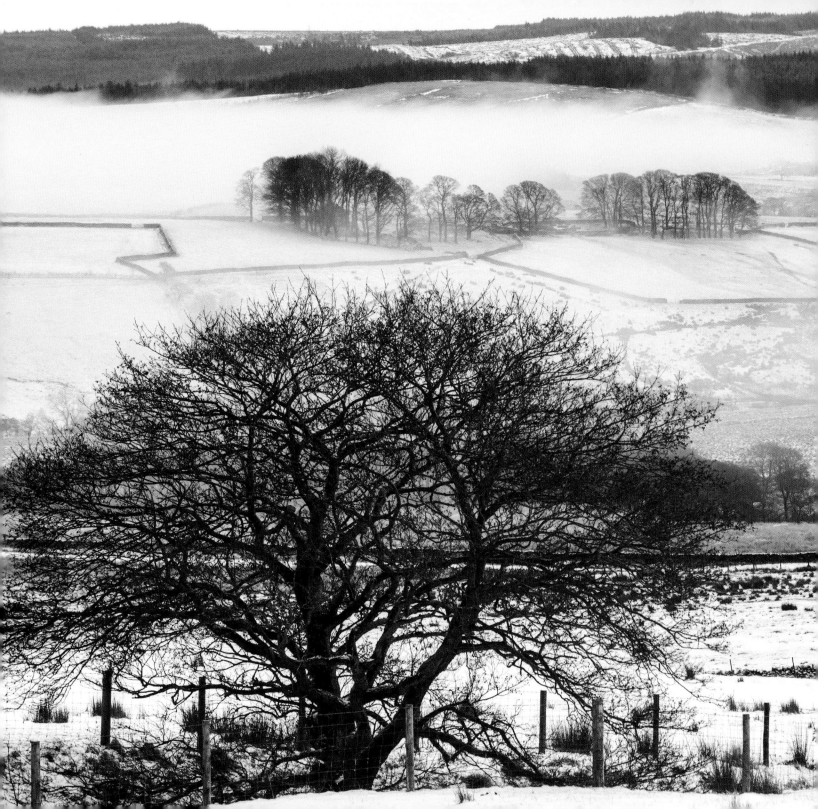

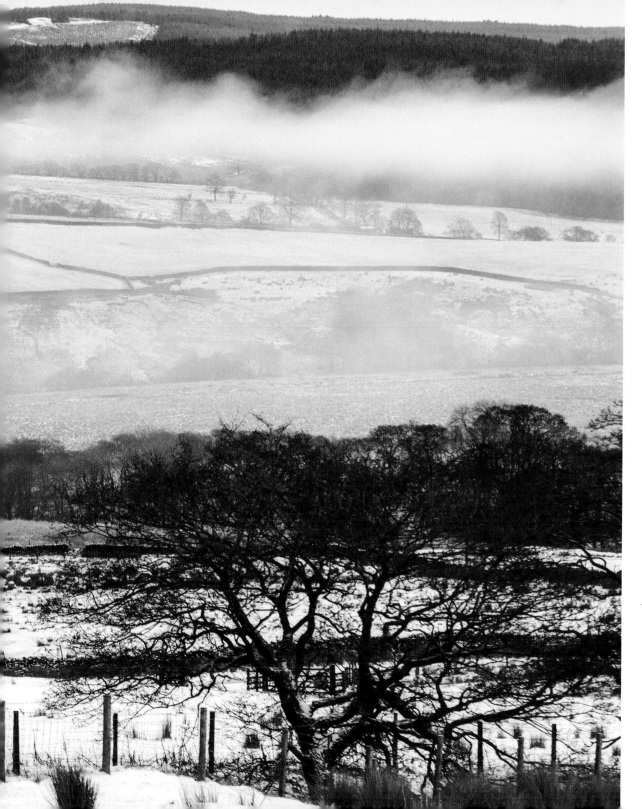

Gisburn Forest in winter. The view from Kenibus looking towards the forest

The bikers' trails are clearly graded and, with the backing of the Forestry Commission, new ones are still being developed. Beginners can start here with confidence on some of the wide forest roads, while at the opposite extreme are advanced sections – restricted to cyclists only and clearly signed – with sharp descents and tricky jumps.

Quite often walkers are chary of forestry areas, and with good reason – twisting paths through dense woodland can lead to loss of sense of direction, and views are generally restricted. Yet Gisburn Forest offers some excellent walkers' routes which can be used to link up with other walks adjacent to the forested area: around Stocks Reservoir, up to Whelpstone Crag or to the wonderful viewpoint of Bowland Knotts. There are a number of clearings providing a contrast with the denser forest, offering remarkably good distant views, such as that just above Hesbert Hall on one of the main through routes. The main Stocks Reservoir car park on School Lane is a linking point and, with transport arranged at both ends, walkers can enjoy a through walk to Slaidburn, taking many different woodland routes.

Gisburn Forest offers interesting wildlife, especially birds. A noticeboard by Hesbert Hall illustrates a number of unusual species that may be spotted, including the crossbill, the redstart (most likely on the fringe of the more densely forested areas) while among birds of prey, sparrowhawks and buzzards are likely to be seen – since both species enjoy tree cover – but there are kestrels around too, in the more open stretches.

Left: Mountain bikers on a trail near the Gisburn Forest Hub in Stephen Park

Above: Stocks Reservoir from Gisburn Forest Hub, Stephen Park

Gisburn Forest is a good option for recreation in all seasons. When the high fells may be ruled out on grounds of poor weather, visibility or short daylight, walkers can resort to the forestry tracks with confidence and, as a bonus, this part of Bowland, in the lee of the higher fells, has lower average rainfall than the western sector. Finally, for the sightseer, Gisburn Forest sunrises and sunsets can give spectacular local lighting effects. In the right conditions, the view east from Merrybent Hill over Stocks Reservoir, towards Gisburn Forest, can be a vision of tranquility.

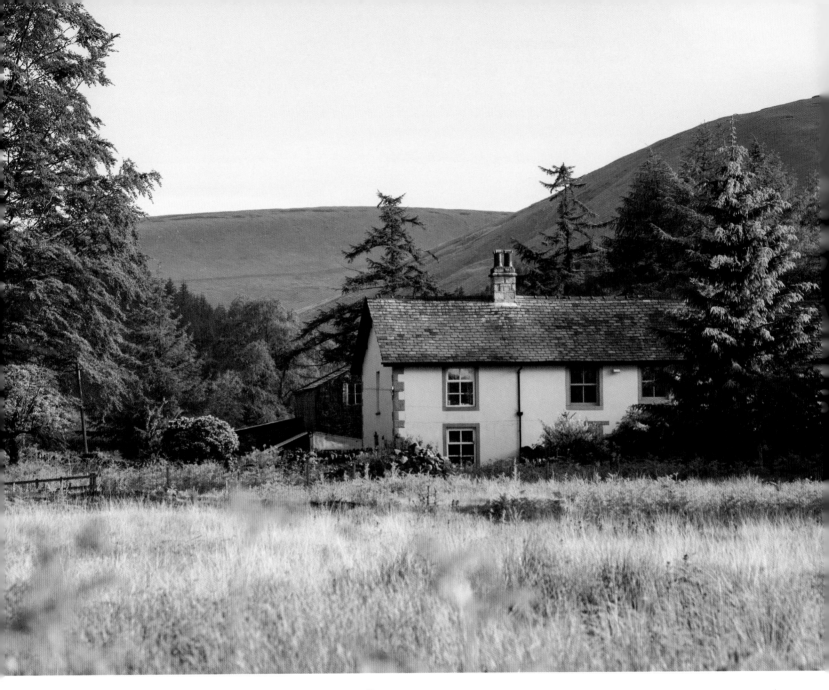

Above: One of the secluded houses in Dunsop valley

Opposite: Dunsop Valley from New Laund Hill

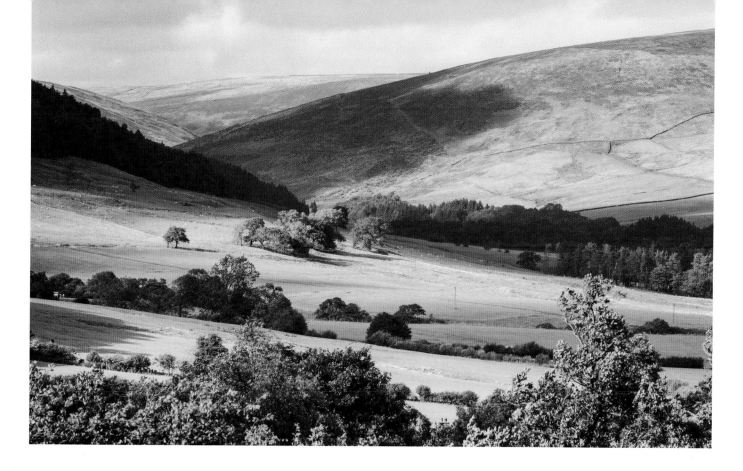

THE QUEEN'S FAVOURITE VALLEY

A story first told me by a friend and most likely apocryphal, will serve to introduce this section. Somewhere in the fields by the Hodder near Whitewell a local was watching a lady with a headscarf shooting unsuccessfully at some game.

> 'Eh, that were a poor shot!'
> The lady turned to address the speaker:
> 'One does one's best.'
> Enough said!

The Hodder valley and the Langden valley are both within the Duchy of Lancaster and United Utilities estates and the famous *Inn at Whitewell* is the natural focal point of this tract of Bowland. The area is actually

one of the medieval deer parks of the Forest, and the Duchy crest is a common sight hereabouts. The Royal connection, therefore, is certainly not a new one, but in the past twenty years the secret has gradually crept out that Hodder is the Queen's favourite valley.

Few would deny the beauty of this stretch of the Hodder valley, from Doeford Bridge through the delightful wooded gorge to Whitewell, followed by the more open section to Dunsop Bridge. The popular *Inn at Whitewell* might yield a possible glimpse of members of the Royal Family but it is also a thriving wedding venue. It is set on the bank of the Hodder with a splendid

Above: The wooded gorge of Whitewell

Below: The river Hodder at Whitewell

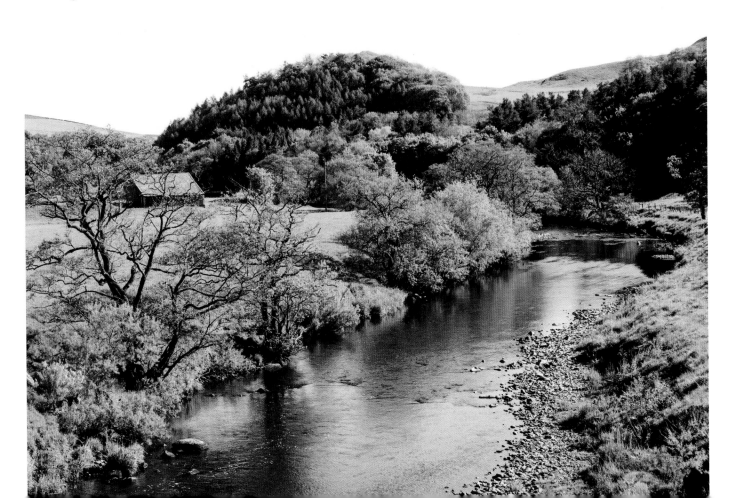

view of the valley winding north. Don't omit a visit to the adjoining St. Michael's church. Arrangements can be made through the churchwardens for interior viewings, and the inn will give you contact details.

An easy short stroll up the Dunsop Bridge road leads you to the fine two-arched Burholme Bridge. During the spring, the river and adjoining pastures may seem alive with waders and other water birds including the attractive common sandpiper and redshanks together with the more common species. From the bridge a minor road leads westward eventually returning to Doeford Bridge or on to Chipping after passing Bowland's wild boar park.

Back at the inn, when the river is low, it is possible to cross via stepping-stones, leading to some very pleasant short circular walks. Downstream from here lies the Hodder gorge, and though there is no public footpath by the river, there is a good view from the road above. Seen on a bright spring day, with sparkling water amid the fresh greenery, it is an enchanting stretch of the Hodder.

The east-bound road leaving Whitewell is a complete contrast, climbing steeply, initially through an attractive wooded area then entering one of the limestone intrusions which are a feature of this part of Bowland. You eventually reach the crest of Hall Hill, the famous viewpoint. The combination of fine woodland, briskly flowing river and the backdrop of some of Bowland's shapeliest fells – including Totridge and Mellor Knoll – is exceptionally fine, and justifies the title 'Little Switzerland' bestowed on the Whitewell area. Time to retrace your steps, or the car, back downhill to Whitewell for a brief drink, afternoon tea or a fine sit-down meal.

Below: The Hodder valley near Whitewell looking towards the Dunsop valley

Following page: The River Dunsop. The village of Dunsop stands at the very centre of the United Kingdom

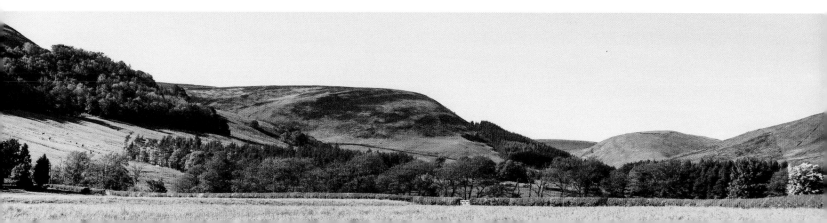

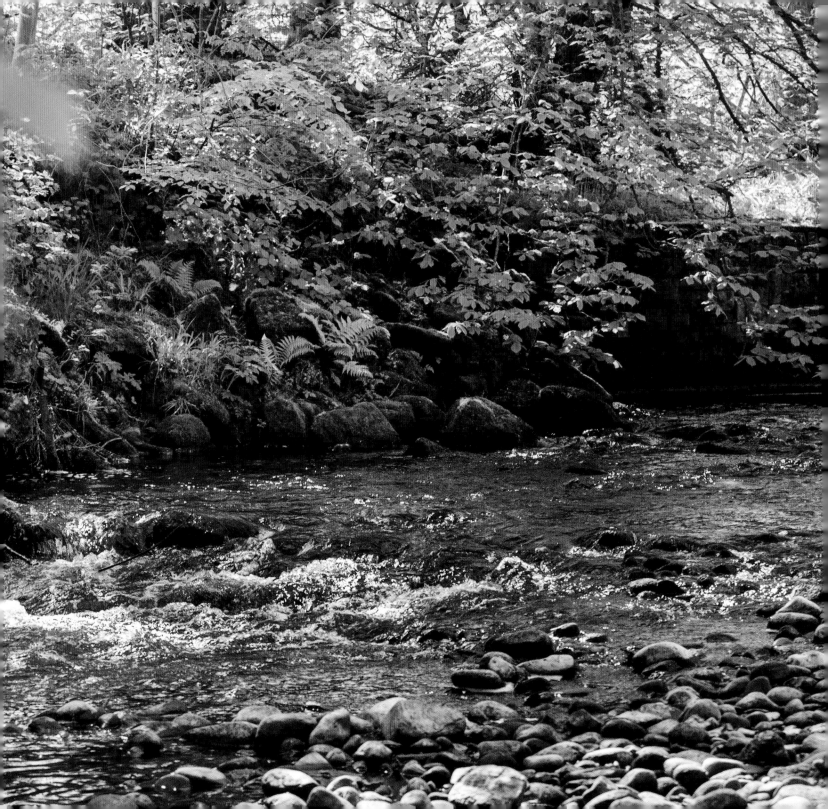

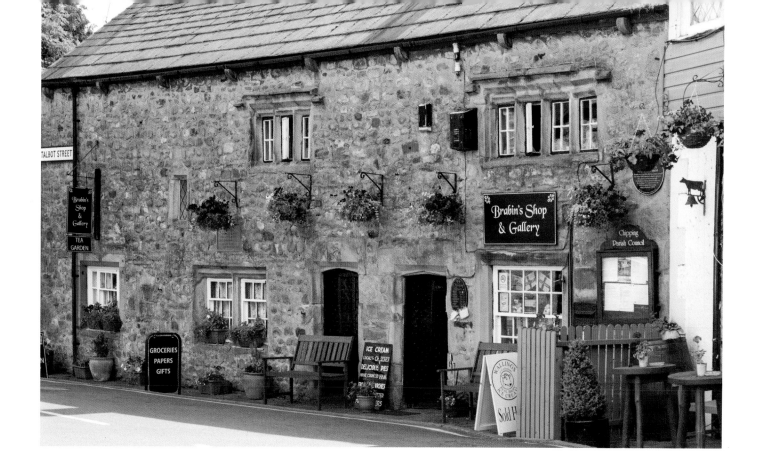

CHIPPING

Chipping is a common English place name, derived from the Anglo-Saxon *ceapan*, the market. Bowland's Chipping was within the Danelaw and was later referred to as *Chipenden* in the Domesday Book, but according to Chipping's enthusiastic history society, it may have been founded as early as 620 AD. Its ancient parish church, St. Bartholomew's, is probably over one thousand years old. Although Chipping stands within the Forest of Bowland, it was not part of the old Bowland estate. That ended at Leagram Hall, barely half a mile north of the village, which had historical links with the Shireburnes of Hurst Green and Stonyhurst College. This strategic position on the edge of Bowland doubtless made Chipping a favourable trading centre.

Chipping has a strong independent character, which is apparent even on a brief visit. It has some fine old buildings, narrow winding streets, and a rich history including some famous old citizens. Lying to the west

69

of the Ribble and Hodder valleys, it is only a short journey from the M6 and is especially popular with residents of Preston and the Fylde.

Perhaps Chipping's most famous son was John Brabin, a 17th century cotton trader whose old shop on Talbot Street is still a post office and general store today. The lintel bears his initials and is dated 1668 AD. Brabin was a generous philanthropist who founded a local school (1684) and almshouses, in Windy Street. The modern school, along the street, bears his name: the old school, with its descriptive lintel, is remarkably well preserved and used today as a parish room.

St Bartholomew's church breaks into view as you emerge from the narrow exit of Windy Street. Its history is not wholly clear: the terraced ground supporting the present building is characteristically Anglo-Saxon, but the church was not mentioned in Domesday. Its first rector was recorded in 1230, and the present building is largely 15th century. Across the street is the *Sun Inn*, considerably older than the 1758 given on its door lintel, and associated with the tragic story of Lizzie Dean whose ghost is said to haunt the inn. The Roman Catholic church of St Mary's lies on a lane behind Windy Street, provided by a former owner of Leagram Hall; there is also a Congregational Chapel, of similar age, on Garstang Road.

Above: St Bartholomew's church, Chipping

Below: The old wheel, a surviving remnant of the corn mill

Chipping is not merely a pastoral idyll: it flourished during the industrial revolution. By 1850 there were seven mills in the village, powered by Chipping Brook, which can be torrential in spate. The corn mill (formerly a restaurant and now a private house) has an old waterwheel which has been preserved, visible from the bridge on Talbot Street. Walk past St. Bartholomew's, down Church Raike and Malt Kiln Brow, and you come to the former industrial heart of the village.

Here were Berry's chair works, which sadly closed in 2010, and Wolfen Mill, Kirk Mill (a genuine Arkwright spinning mill) and Tweedy's Foundry, which formerly made parts for the shipbuilding industry but closed in 1973. A little further up the hill lies the mill lodge, peaceful now and home of many waterbirds. Are they just asleep, these places – awaiting a financial angel to revive them in new ways for the 21st century?

Right: Chipping Brook

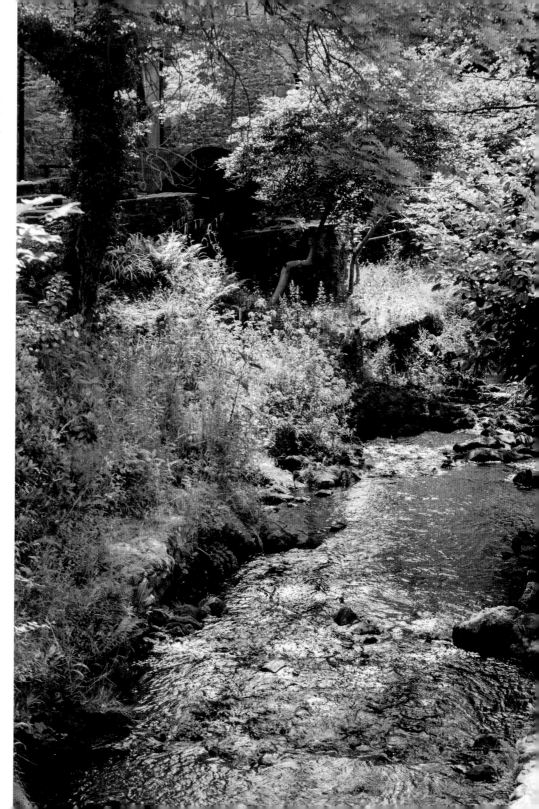

Walkers have long recognised Chipping as an excellent starting point. There are walks for all tastes here, from short strolls around the village to vigorous climbs onto the high fells. The short walk through the grounds of Leagram Hall is a delightful short stroll at any time of year. Here you pass into the old Bowland estate: Leagram was one of its ancient deer parks. The rolling grass slopes and fine trees are a delight, and views to the east are splendid: the valley of the river Loud, joining the Hodder further down, with Longridge Fell and Pendle as a backdrop. By circling round through outlying farms, you return to the village via Malt House Lane.

The old heart of the village, down Windy Street, right at the T-junction and along Talbot Street is best appreciated at quiet times of year if possible. Be sure to visit Brabin's old shop or the village shops and don't miss the local history society's excellent publication, *Longer Sen*, which tells more of the fascinating story of this charming village.

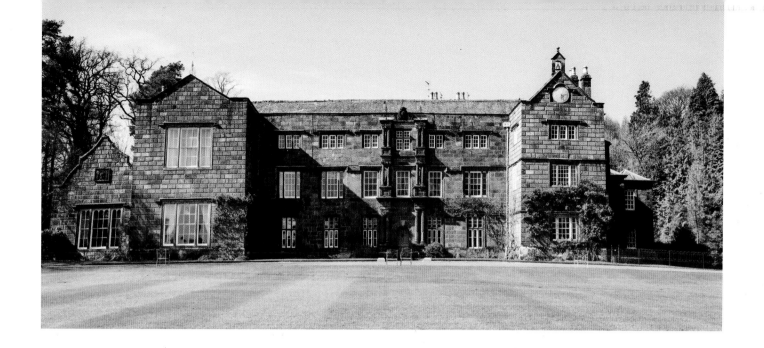

BROWSHOLME HALL

Browsholme (pronounced 'Brusom') Hall is the ancient home of the Parker family who were park-keepers of the Forest of Bowland. It is probably Bowland's finest large building, standing in a beautifully wooded tract of Bowland, about five miles from Clitheroe. The present building, built by Edmund Parker in 1507 after he had obtained a new lease, has since been restored at intervals during a remarkable, uninterrupted occupation of the Hall by the Parker family for over 500 years. By the fourteenth century, the Parker family had moved to the Forest of Bowland as deputy parkers of Radholme Laund, a major deer park whose name survives today at a farm near Whitewell. The lease of Browsholme, a Royal appointment, dates from 1380 and is described as a 'vaccary' or cow-pasture – so the name 'Bowland' is possibly derived from the old word for cow pasture, 'Bolland'.

The original hall was 'H' shaped, a characteristic Tudor design. Its original red sandstone façade was significantly re-faced in 1603 by Thomas Parker, who also added a fourth storey with the gables and the portico we see today, containing samples of the three classical Greek architectural orders. Major additions were made in the eighteenth century, notably a new East wing, and in 1805 the West wing was pulled down and reconstructed by Thomas Lister Parker. Two years later a new dining room was added, and the bell and clock we see today were added about a decade after that. Apart from alterations to the lower windows, the façade has changed little since then.

No exploration of Bowland would be complete without a visit to Browsholme. The hall was first opened to the public in 1957 by Robert G. Parker, who personally conducted tours of the building; today there are many open days each year, and parties of sufficient size can make their own booking. Recently, the large tithe barn there has provided a venue for regular markets, and wedding receptions (*see* www.browsholme.co.uk).

Browsholme Hall

The entrance hall of the main building evokes some turbulent history: a greatcoat here belonged to Capt. Thomas Whittingham, husband of Anne Parker. He was killed in the Civil War (Newbury, 1648). The wonderful panelling in the library, with its distinctive diagonal pattern, dates from 1620 and has only two known equivalents in England. A number of Jacobite relics in the library are from Robert Parker of Alkincoats, a supporter of Bonnie Prince Charlie.

The drawing room is the hall's chief state room, dating from the rebuilding of the West wing in 1805 and created as an Elizabethan revival.

Below: Browsholme's knot garden

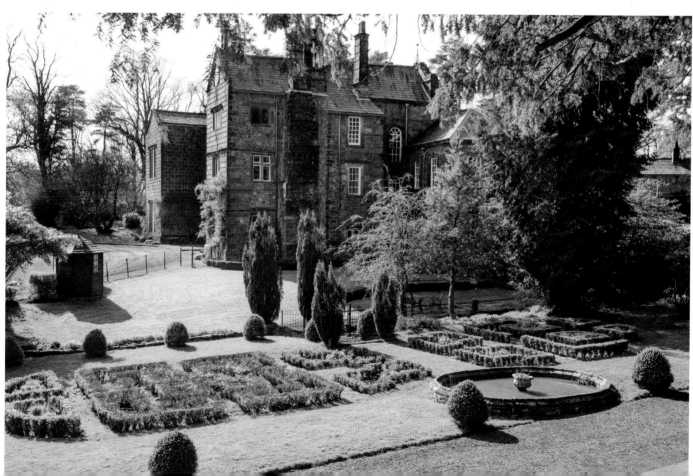

Here are a number of family portraits, dating mostly from the eighteenth and nineteenth centuries. The building has a link with J. M. W. Turner, who stayed here around 1807 and left a painting of the Hall. The dining room is of the same period and originally used as a gallery: today it features a number of fine portraits, a very fine gilt table, a highly ornate sideboard and an Elizabethan ornamental fireplace. Yet Browsholme today is very much a living, welcoming family home, rather than a museum.

The main entrance to the Hall is via the Bashall Eaves-Whitewell road, past a prominent lodge. Perhaps the finest view of the Hall, however, is from a quarter of a mile further south, looking through an old arch. This viewpoint reveals the splendid grounds, the driveway winding through trees past a pond, leading the eye to the southern aspect of the Hall. A fitting memory of a visit there.

Below: Decorative triglyphs on columns (top left) and coats of arms at Browsholme

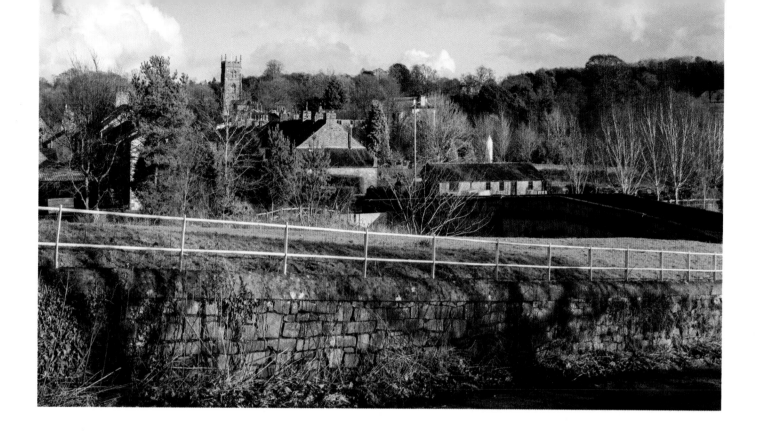

BOLTON BY BOWLAND

Lying unobtrusively six miles north of Clitheroe and barely two miles, as the crow flies, from the busy A59, the village of Bolton by Bowland is an understated and peaceful delight. Generations of visitors have been beguiled by its peace and charm: within the last century, coachloads of visitors used to come and enjoy a stroll round the village followed by afternoon tea. Unlike Downham and Slaidburn, Bolton is only in part an estate village, but the centuries of influence of the old Bolton Hall (demolished in 1959) have left a unique village character.

There may have been a Bolton Hall from as early as 1229, and the old hall dated from at least the time of Edward III. It was the family seat of the Pudsays, who were lords of the manor for over 400 years. Later it was owned by various families, arguably reaching its heyday after 1866 when it was bought by a wealthy mine owner, Charles Wright, who kept a staff of over one hundred. He lived and entertained in style, encouraging visitors to both hall and grounds. After 1918, the hall became prohibitively expensive to keep: the Wrights moved to Foxghyll and, though the hall was briefly occupied again from 1939-1945, it gradually fell into disrepair.

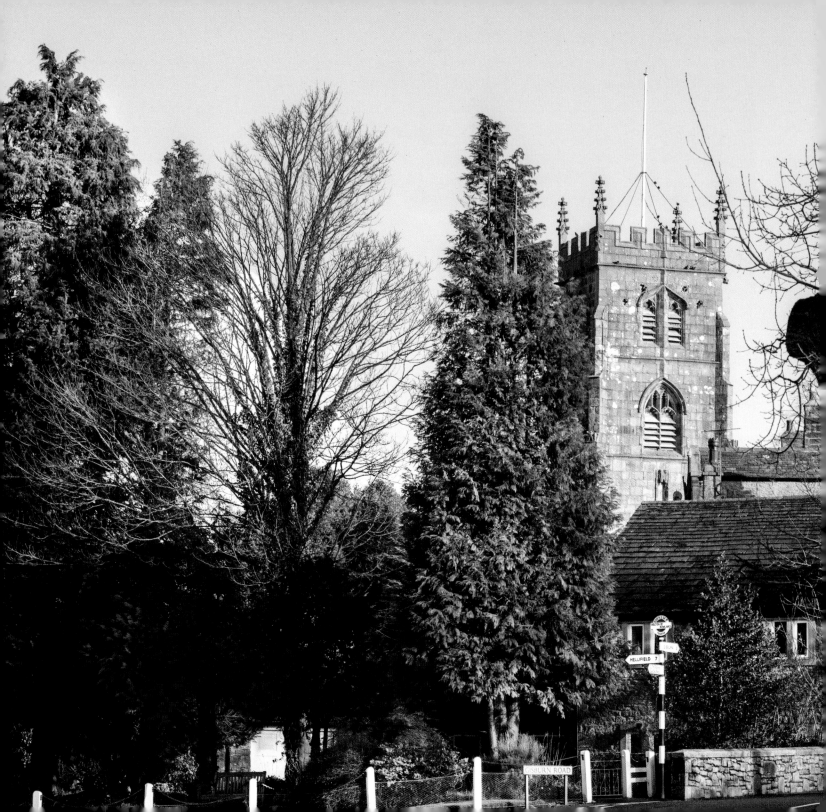

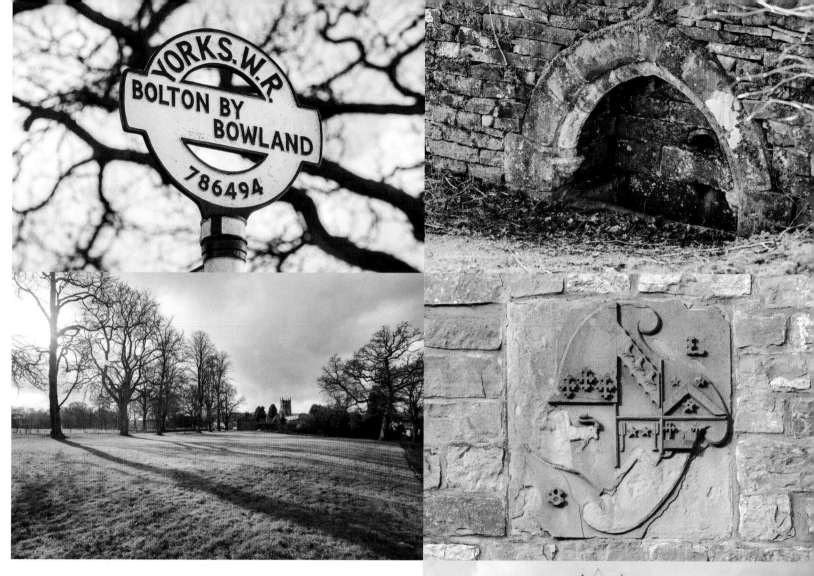

Left: St Peter & St Paul's church

Above, clockwise from top left: old West Riding Yorkshire signpost; old well; coat of arms on a cottage wall; the villages' rooftops; view of the village from across Bolton by Bowland's large village green.

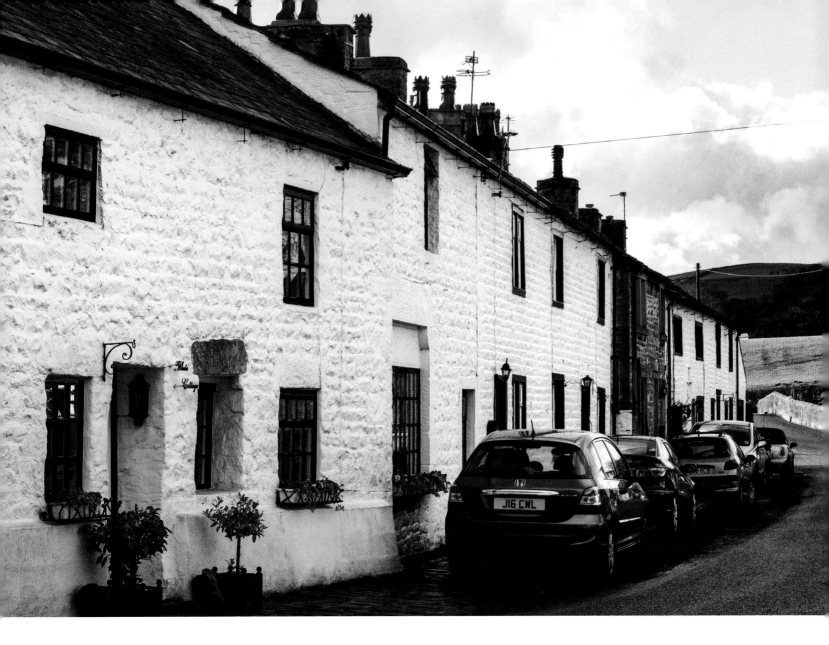

Sir Ralph Pudsay, in the fifteenth century, sheltered the fugitive Henry VI at the Hall for one year after his defeat at the battle of Hexham (1464). Sir Ralph was a staunch Lancastrian; Henry later moved to nearby Waddington, where he was betrayed to the Yorkists.

Ralph's influence is also seen in the fine local parish church of St. Peter and St. Paul. Nothing remains

Left: Cottages, Main Street, Bolton by Bowland

Below: Village green with the remains of a thirteenth century cross and old stocks

of the original Norman church. Apart from a few traces of thirteenth century masonry, the church we see today is largely due to Sir Ralph's rebuilding of the 1460s: the distinctive high tower is said to have been designed by Henry VI during his stay at the Hall. The Pudsay Chapel, on the south side of the nave, features a remarkable family tomb carved in limestone, depicting Sir Ralph, his three wives and twenty-five children. Opposite the church, still distinctively park-like, is the driveway to the old hall.

The geographical heart of the village is the village green. A charming collection of old houses, the village inn (the *Coach & Horses*), the green itself with its cross and stocks, a briskly flowing stream running through it, all add to Bolton

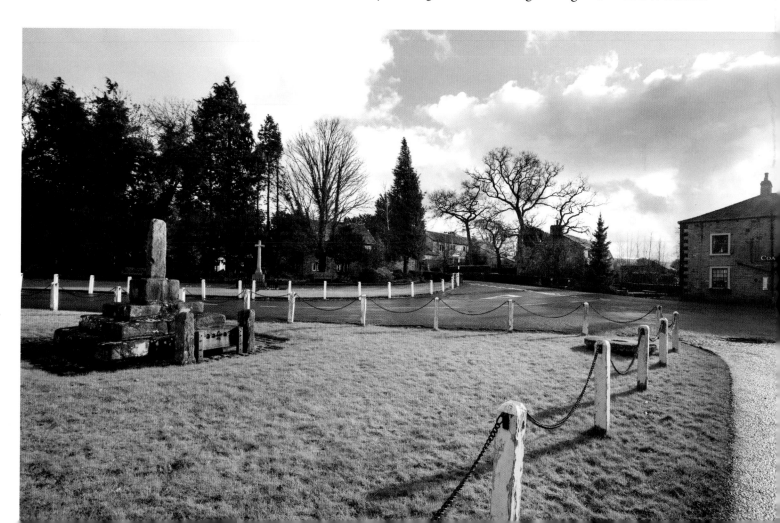

by Bowland's appeal. Along the main village street are a number of well-kept properties, mainly of the eighteenth century. Beyond the church, by the village school, stands the old courthouse where local magistrates sat and there were cells for petty criminals: it was built in 1859 by the Littledales, owners of Bolton Hall at that time.

The first section of Hellifield road from the village centre often features on calendar and postcard views. During the Second World War, this idyllic road was under strictly controlled access: not far beyond the village were two major storage areas for bombs – a closely-guarded secret then. These munitions were transported via the railway at Gisburn, about three miles away.

Bolton by Bowland, picturesque but not pretentious, packs a great deal of interest and history into a small space and continues to enchant today's visitors.

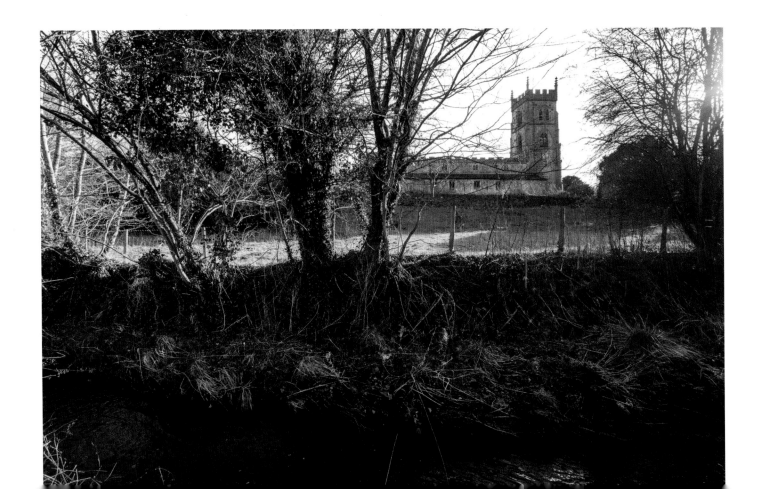

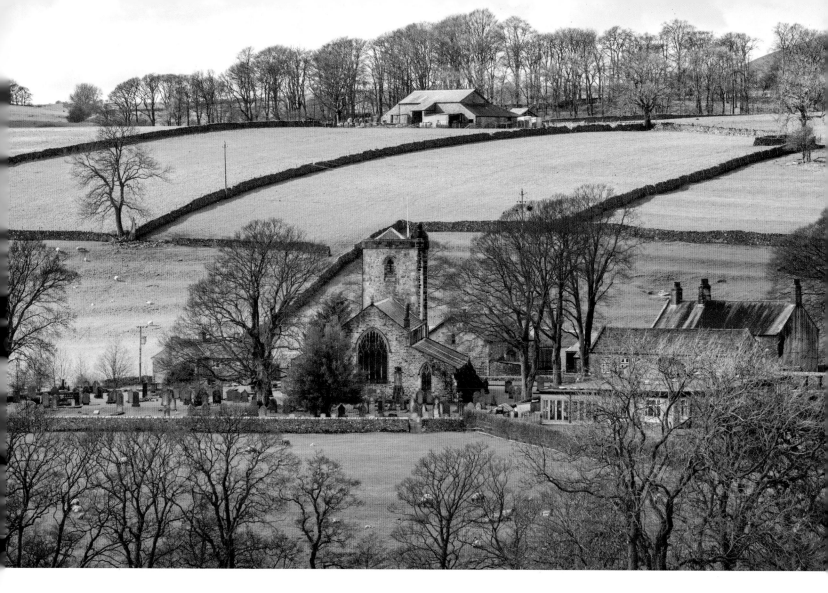

SLAIDBURN

Slaidburn, lying in a fold of hills by the Hodder and its confluence with Croasdale Brook, is one of the most interesting settlements in north-west England. Its long and varied history, witnessed by the mixture of Anglo-Saxon, Norse and Norman place names, makes Slaidburn a magnet for any visitor to Bowland. The name itself is Norse, meaning *'sheep pasture by the stream'*. It was in Norman times, however, that the village enjoyed its

heyday: for centuries it was the administrative centre of the district, under the De Lacys of Clitheroe Castle. The *Hark to Bounty* inn, in the village centre, includes an old courtroom dating from 1590.

The parish church, St. Andrew's, makes an excellent start for a tour of Slaidburn. The present building is largely 15th century, rebuilt by the Hammerton family, but there was almost certainly a Saxon church on the site. The raised graveyard is characteristic of the Saxon pattern, and excavations have uncovered a Bronze Age burial site adjacent to the present church.

Perhaps the most striking feature within the church, is the unusual three-deck pulpit – for verger, parson and preacher! The font is Norman, restored after being thrown out by Puritan zealots. Outside the church wall are stone steps, formerly used by riders on horseback to dismount. Until recently, the village had a flourishing Methodist church too, by the green near the river. Dwindling attendance led to its closure in 1999, but the old building has now been given a new lease of life as a village hall.

The village reached its highest population, of around 800, in the 18th century, and it was at this time that its school, endowed by John Brennand, was built near the church. The foundation stone dates from 1717.

Perhaps Slaidburn's most famous building, however, is the *Hark to Bounty* inn, at the T-junction in the village

Right: Slaidburn from The Skaithe ('Skaithe' means racecourse in Old Norse)

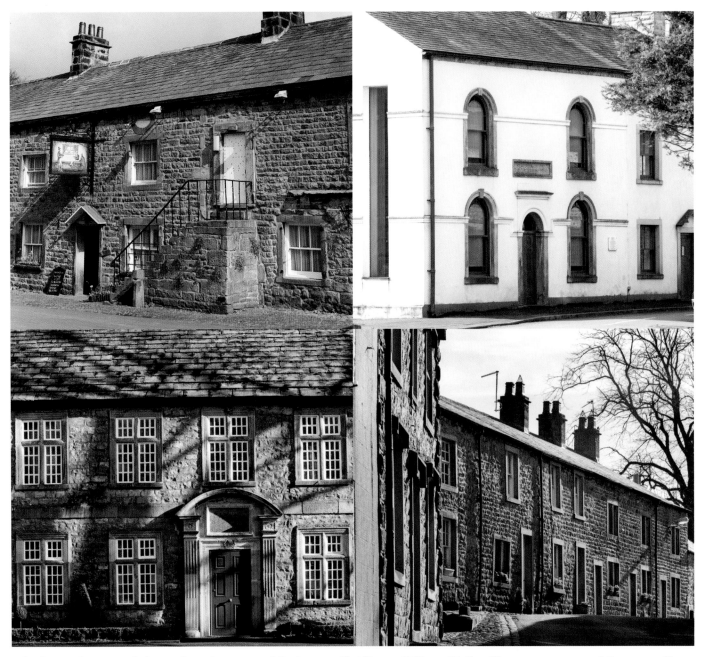

Clockwise from top left: Hark to Bounty public house; Slaidburn Village Hall; village cottages; and Brennand's Endowed Primary School

centre. Originally *The Dog Inn*, dating at least from 1700, it was a favourite haunt of Henry Wigglesworth, the squire of his day, whose favourite dog was called Bounty. Wigglesworth was both squire and vicar and no doubt used to sit in the courtroom too, which is still a part of the inn and entered by stone steps. Across the square was another inn, *The Black Bull*, which became a youth hostel in the 1930s, and a little further down the road is a fine war memorial.

Across the road here is a well built to commemorate Queen Victoria's Golden Jubilee in 1887; here, and in many places in the village, you will see the legend 'W.K.W.', namely William King-Wilkinson, a former squire. The squires of Slaidburn have lived in many houses in the village over the centuries; Henry Wigglesworth himself lived at Townhead, a large detached building north of Croasdale Beck. The King-Wilkinson family has been associated particularly with Rock House, a fine Georgian building with a characteristic portico, on Shay Lane: the estate was inherited jointly a few years ago by Anthea Hodson and her two daughters Kate Berchem and Bridget Woollard.

Slaidburn remains a true estate village: most of its buildings have changed remarkably little since the 19th century. Out of season, it is a place of delightful quiet and repose; in high summer, bustling with life – children playing, motor-bikers congregating, walkers coming and going. All Slaidburn's visitors seem to agree, however, that there is nowhere else quite like this.

Below: Hodder Bridge, Slaidburn

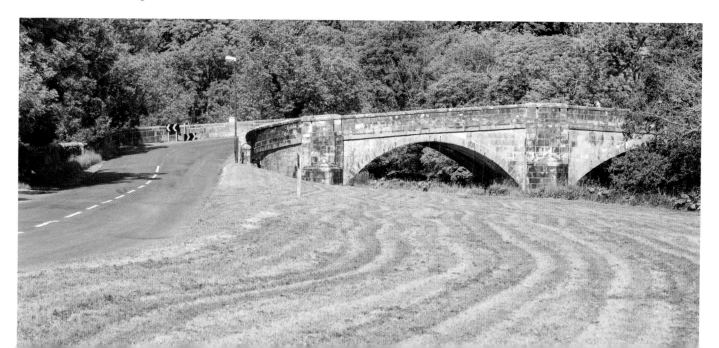

Around Slaidburn

Hammerton Hall lies about a mile north-east of Slaidburn, on what is clearly an ancient trackway. Standing on the site of an older hall, its old mullions immediately attract the walker's attention. Manorial rights were granted by Henry II to Richard de Hammerton in 1170; by 1500, after a succession of strategic marriages, the family owned a vast swathe of country, stretching as far north as Ingleton. The Reformation led to the Hammerton's downfall, however: Sir Stephen Hammerton joined in the Pilgrimage of Grace (1536), losing his life as a result, and the Crown confiscated the lands.

In the opposite direction, Easington lies about one mile south of Slaidburn, beyond the Hodder.

The suffix '*ton*' is a clear indicator of its Anglo-Saxon origin and Easington had its own record in the Domesday Book, quite separate from Slaidburn. Today it is a delightful quiet hamlet of a few stone cottages, and a fine old manor house.

A number of charming short walks link Slaidburn and Easington, ideal for a summer evening stroll; in particular, the section alongside Easington Beck is a real delight.

Left: St Andrew's Church, Slaidburn

Right: Hammerton Hall can be seen in the distance

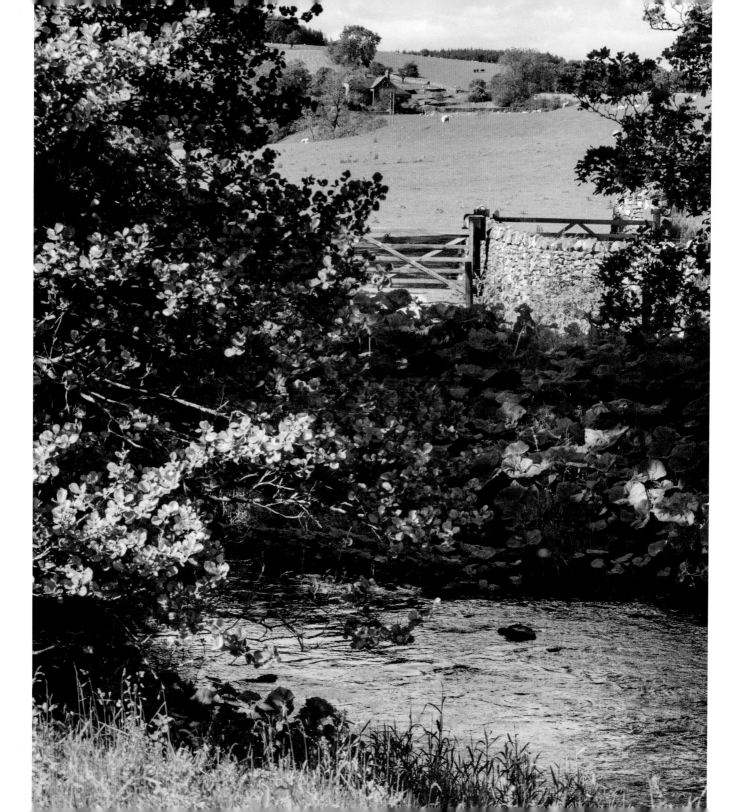

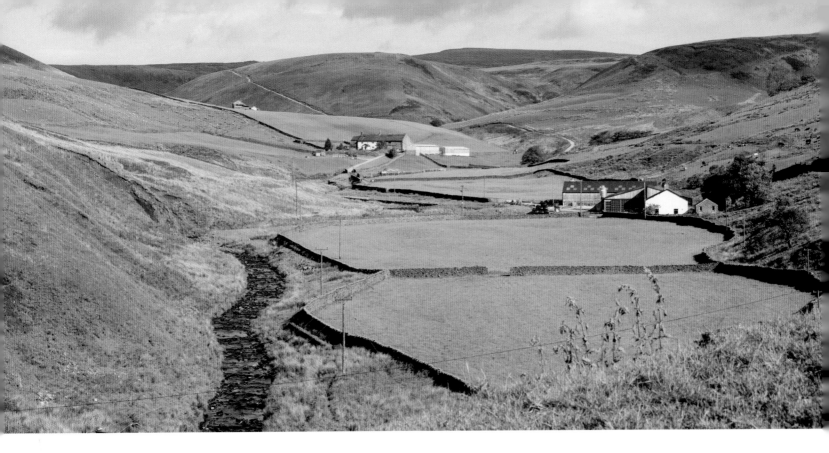

THE HIDDEN VALLEYS

Far from any public roads, quiet and attractively green, are Bowland's numerous hidden valleys. One or two of these are rewards for the walker alone; others can be visited via access roads which serve remote farms. Even the less active walkers should not lose heart, for some of these valleys can at least be glimpsed without having to tramp rough moorland, giving a sight of the best of remote Bowland.

Brennand and Whitendale are upper branches of the Dunsop valley, and are accessible by a popular family walk from Dunsop Bridge, turning north immediately before the steeply-arched bridge in the village centre and following the river upstream. This is a tarmac road, but no through public way, serving only outlying houses and farms. About two miles on, following an attractive wooded valley with steep fells on both sides, you pass the waterworks and a concrete runway where the river divides. Here, after turning left up a sharp little rise, the Brennand valley suddenly opens up and what a haunting spot, especially in soft evening light! The two farm

buildings, linked by a narrow green sward, are completely encircled by sombre high fells: walkers' paths emanate both north-east and south-west from upper Brennand. The Y-shaped pattern of the valleys here leads to distinctive air currents: I remember watching several kestrels here one breezy summer afternoon, exploiting the thermals with their masterly hovering.

To go to Whitendale, you can take the vehicular track left of the stream or the footpath to the right. Soon you emerge from a very narrow pass into a more open stretch, before reaching a farm next to a vigorous stream with a backdrop of trees. From Whitendale farm, three walkers' paths diverge, all demanding but rewarding, with steep climbs and much rough going ahead. One of these rises steeply to circle the back of Middle Knoll, emerging at Brennand, while the other two both link with the Salter Fell track after traversing some lonely, open miles.

Two miles along the Trough road west of Dunsop Bridge, just before Sykes farm, the Langden valley makes an abrupt turn, where the brook emerges from the high fells and runs by the road. Many have parked here, but few will have explored upper Langden by taking the track which leads west and soon passes by the water bailiff's house. Here a rough vehicular track continues, winding gently uphill. Then comes a wonderful moment where the track dips, suddenly revealing the small patch of green surrounding Langden Castle in one of Bowland's most remarkable settings, about

Left: the pastoral Brennand valley and river

Right: The Waterworks Tower at Langden

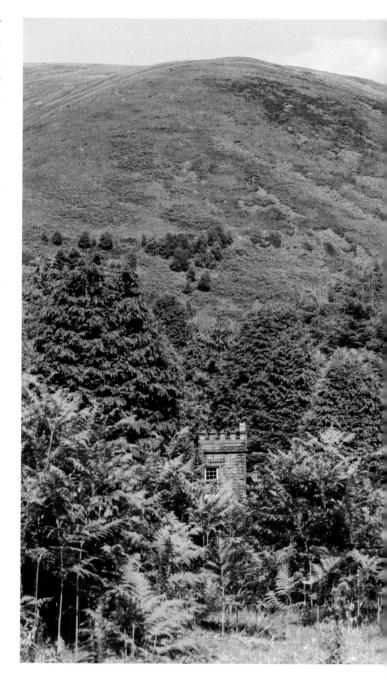

two miles beyond the road. The track now descends, leading you to the 'castle' – actually a modest hut for shooting parties – probably 19th century, but its Gothic arched windows are a surprise.

Many visitors will go no further, but two excellent strenuous walks are possible from this point. The main route proceeds south-west, soon climbing the spectacular narrow valley of Fiendsdale and reaching the old county boundary fence. From here, continuing in the same direction, you can drop into Bleasdale then follow the lanes to Chipping or visit the Beacon Fell visitors' centre. Alternatively, from Langden Castle you may ford the streams – potentially dangerous in spate! – and take a faint path leading south up Bleadale Water. This is another dramatic, narrow, steep-sided valley that eventually climbs onto the plateau and comes to a fence which to the west leads to Fair Snape Fell and offers a difficult, but most satisfying circular walk when combined with the other branch.

Croasdale deserves mention as one of Bowland's lovely valleys: not so dramatic perhaps, but a hauntingly secluded stretch of the Hornby Road several miles from Slaidburn, reached after passing the old quarry. When you climb the steep rise and curve with the road, the distant views quickly disappear and you enter upper Croasdale, the home of many birds, a few naturalists (especially birdwatchers) and just an occasional pedestrian. A simple shooting hut stands near the

Left: Langden Brook

track, emphasising the isolation of the place. Recently a post has been erected at the roadside near the quarry, bearing a grim reminder of the Lancashire witches' trial of 1612. Apparently it is now thought that the party was escorted to Lancaster this way, rather than by the Trough road. Birdwatchers can be rewarded in the Croasdale valley with sightings of birds of prey and rare whinchats and ring ouzels in summer.

Finally, the northern valleys are also worth a mention though perhaps in a different category because of their proximity to motorable roads. The main valleys draining the fells on this side are of the rivers Roeburn and Hindburn, and Lowgill is a particularly attractive hamlet just east of the Hindburn. Here, investigations have revealed traces of the Roman road which, further south, forms a section of the Hornby road. The road ends a

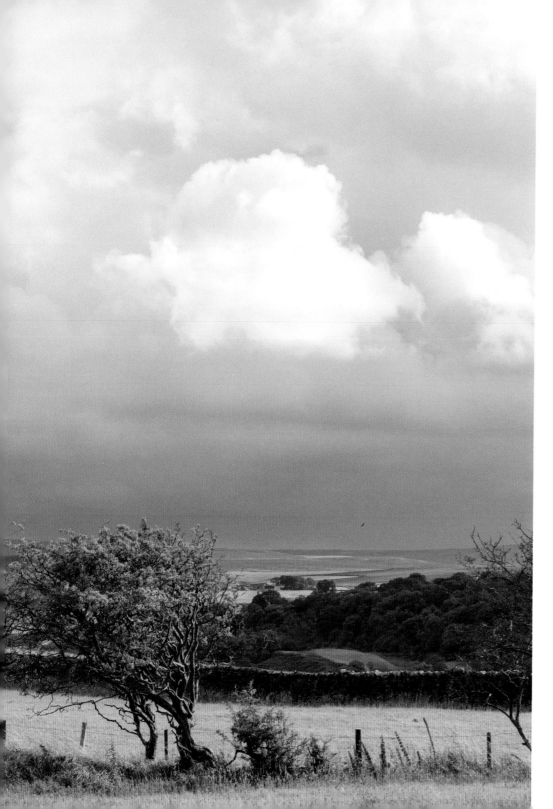

little further on at Thrushgill; to the south of Lowgill stands the Church of the Good Shepherd in a tranquil setting. Finally, Littledale is a lovely, densely-wooded valley among streams that join the Lune more directly, below Caton. The fine Littledale Bridge is crossed by the road from Quernmore to Caton, and there are footpaths that can be used to explore the upper valley near Littledale Hall.

From this part of Bowland, though the valleys seem remarkably remote in themselves, the A683 offers a quick return via the M6 or by joining the A65 eastbound for the Dales.

Left: Tatham Fells and valley

Opposite page: Roeburndale

WRAY

Among the sequence of villages stretched out along the Lune and Wenning valleys to the east of Lancaster, Wray holds a special place. The visitor's first impression will probably be one of tranquility, although Wray has an impressive and varied industrial past and arguably had its heyday in the mid-19th century. Although it is now a part of the Bowland AONB, Wray's origins lie with the Hornby Castle estate; the village of Hornby is about two miles from Wray, and it is the natural terminus of the Hornby Road (Salter Fell track), one of the great roads of the district.

Today, Wray is a charming and unspoilt village, with many well-kept old stone cottages, neat gardens, its own primary school and village hall. It has many parallels with Chipping in south-west Bowland. Here

Left: Cottages at Wray

Above: Bridge over the river Roeburn at Wray

too is a strong industrial past, including coal mining and nail-making and a number of mills. The main one – Wray Mill itself – was a significant site of silk manufacture in its day. Like Chipping, Wray also has an endowed school, dating from 1684 and founded by Capt. Richard Pooley with an initial bequest of £20 towards the building and £200 to fund a schoolmaster. The school is still thriving today.

There was formerly a strong Quaker tradition in the village, and the Friends Meeting House on Hornby Road (1704) was Wray's first place of worship. In 1849 the old building, then disused, was taken over by Wesleyan Methodists for a time until they were able to construct and move into a dedicated building. The old Quaker meeting building reopened briefly, following repairs, as a Friends' Meeting House but closed again in 1900. Eventually it was readopted by the Methodists and, following major refurbishment, it is now used as a Sunday school and for other religious gatherings. In Roeburndale, some miles south of the village, is a beautifully situated Methodist chapel which will be known to walkers who have taken the Hornby Road from Slaidburn. Wray's Anglican church, Holy Trinity on Main Street, is a relative newcomer, consecrated in 1841 and steadily developed during the 20th century.

Wray has held a fair since the 19th century, and from 1992 has organised a more distinctive event, namely the Wray scarecrow festival. This has become a very popular pageant, backed up by other events such as road and fell races, car boot sales and a market.

In August 1967 parts of Wray were devastated by a flash flood originating in Roeburndale, an event still graphically etched in the memories of many villagers. Houses, bridges, livestock and vehicles were swept away and

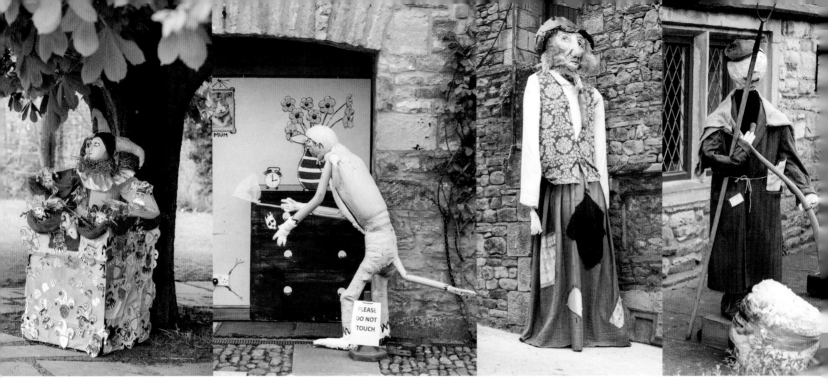

Above: Four of the entries for the Wray scarecrow festival

it is amazing that there was no loss of life, or even serious personal injury. Many local people can still recall that day and a number of written records with photographs were collated. In his *Wray and District Remembered*, published in 2008, David Kenyon, a Wray resident all his life, has collected some remarkable images from that day. A Millennium Mosaic was constructed at the spot where a number of houses were devastated, and another Wray resident, Emmeline Garnett, has published a detailed account of the flood with assistance from the University of Lancaster's Regional Heritage centre.

Wray has shown great resilience and adaptability throughout its varied past, and its strong sense of identity and community must have been a major factor in surviving the difficult times. More recently, Wray can boast a significant first: it was the first wireless hotspot village in Lancashire. Wray is certainly worth a visit for any visitor if you are in the Forest of Bowland, a contrast to the villages further south within the old Bowland estate. You will find a special friendliness and strength of character here.

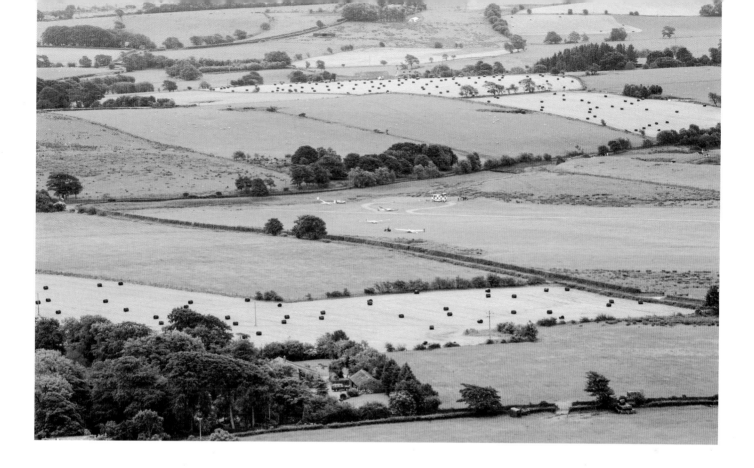

INDUSTRY AND LAND USE

Farming is the primary occupation in Bowland. Across the fells, the hill farms dominate the farming scene, with their beef cattle and their hardy hill sheep, prone to wandering casually in front of cars and causing the visitor some anxiety as to how to bypass them on the narrow fell roads.

It is these farms which maintain the characteristic dry stone walls, and whose 'inbye' meadows and pastures are increasingly being developed under Environmental Stewardship schemes for biodiversity and to retain and protect important wildlife. The field barns dotted across the upland pastures are scenic in their own right, but often they are home to the increasingly rare, ghostlike barn owls. What a joy it is to walk the fells

Above: The Bowland Forest Gliding Club

on a breezy spring morning and hear the incessant bleating of young lambs or the haunting, wild call of the returning curlews, to see the dancing, twisting, flight of lapwings, or to catch a glimpse of hares in the lowland fields. It is often thanks to the farmers that these sights and sounds remain.

In the lower parts of the valleys, hedgerows are repaired, maintained, and replanted by the farmers, providing a boon for wildlife and shelter and safe 'corridors' for animals and birds to travel from one habitat to another. Here in the more sheltered valleys, the farms are often dairy, although the scandal of the low prices paid to dairy farmers for their milk in the past few years means that there are fewer such farms nowadays. This price pressure has led to local farmers often banding together to produce high quality local milk and dairy products, some organic, which are sold locally with a guarantee of freshness and quality. Increasingly Bowland farmers are focusing on heritage breeds reared in traditional ways, so that the Forest of Bowland area has begun to develop a reputation for great-tasting, locally produced food.

There are some less conventional and more surprising farms in Bowland, a result of the need to diversify and adapt to survive. For example, Bowland Wild Boar Park rears and sells wild boar meat, amongst many other things, and at Dolphinholme a farmer who switched from dairy

Right: Fieldfares flying past Merrybent Hill with Gisburn Forest in the distance

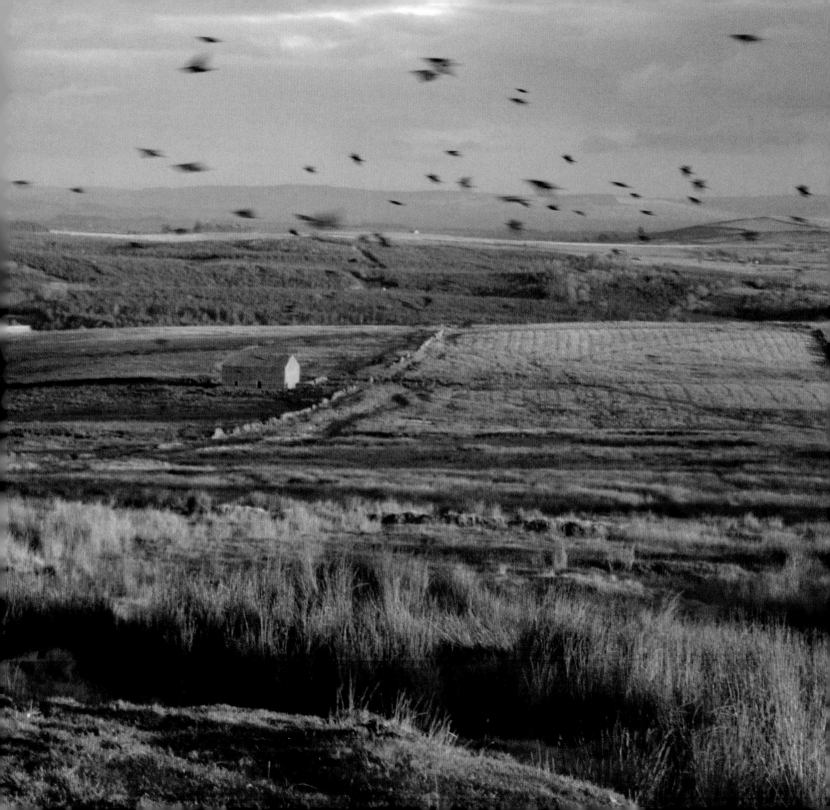

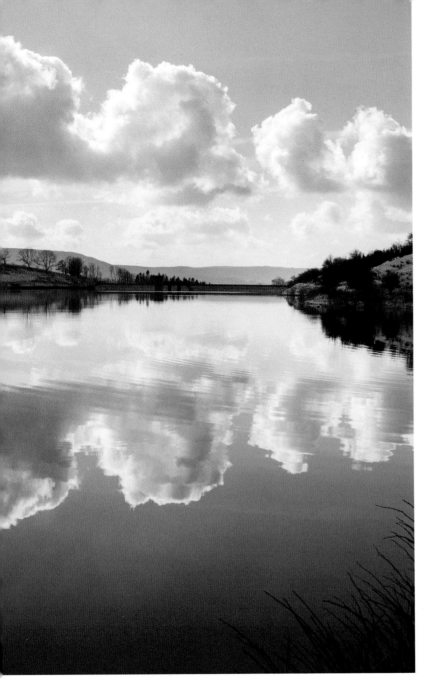

Above: Stocks Reservoir

to goats has 1000 'nannies' producing milk for a local cheese company.

Many of the farms and, of course, a multitude of other businesses in Bowland, cater to the thriving tourist industry in the area. Latest figures show that nearly four milllion people came to the area in one year, but this is a fraction of the numbers visiting the Lake District and the Yorkshire Dales, Bowland's more famous neighbours. The AONB is determined to promote tourism in the Bowland area, but on a sustainable basis, managing and balancing the demands of tourists with the need to protect and conserve the special environment and wildlife of the area, since in many cases it is this very thing that attracts the visitors. The reasons people come to Bowland are many and various; most obviously the walkers and cyclists, the birdwatchers, the daytrippers who come for a drive out in the country, those who come to fish and shoot, gourmets, those interested in local arts and crafts, and many more.

For walkers, the 'Right to Roam' legislation has allowed access to previously closed areas of the high fells, and some of Bowland's most spectacular landscapes are now available to them. There may still be days when parts of the fells are closed for shooting but on the whole, the land is open to all and for those looking to find utter peace and solitude, this is the place to come.

Cycling is becoming a more popular pastime across the UK, and Bowland has played a part in that with Sir Bradley Wiggins announcing

that he trains in the area and leading an annual 'Ride with Brad' event over Bowland's fell roads. At Gisburn Forest, adjacent to Stocks Reservoir in the north east of the AONB, the Forestry Commission have developed mountain biking tracks suitable for all levels, whilst the Lancashire Cycleway and the Way of the Roses cycling routes both pass through the area. Many Land's End to John O' Groats cyclists pass across the fells, crossing the watershed at the Cross of Greet pass high above Slaidburn.

Many of these visitors do not merely pass through and the many country hotels and inns in the area cater for this need. The visitor can stay, and eat, in great gastro pubs such as the *Red Pump Inn* at Bashall Eaves, or in the rather grander luxury hotels like *The Inn at Whitewell* or the *Gibbon Bridge Hotel* near Chipping. Many of the towns on the periphery of the AONB, such as Clitheroe, Whalley, Lancaster, Settle and Kirkby Lonsdale also have great places to stay and eat. Within the area there are many B&Bs, farmhouses offering accommodation, delightful little cafés in the small villages, and farm shops selling wonderful local produce.

Below: A public footpath at Roeburndale East

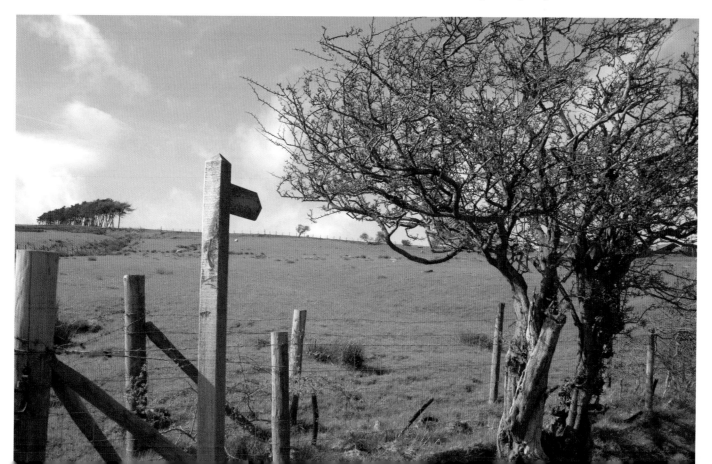

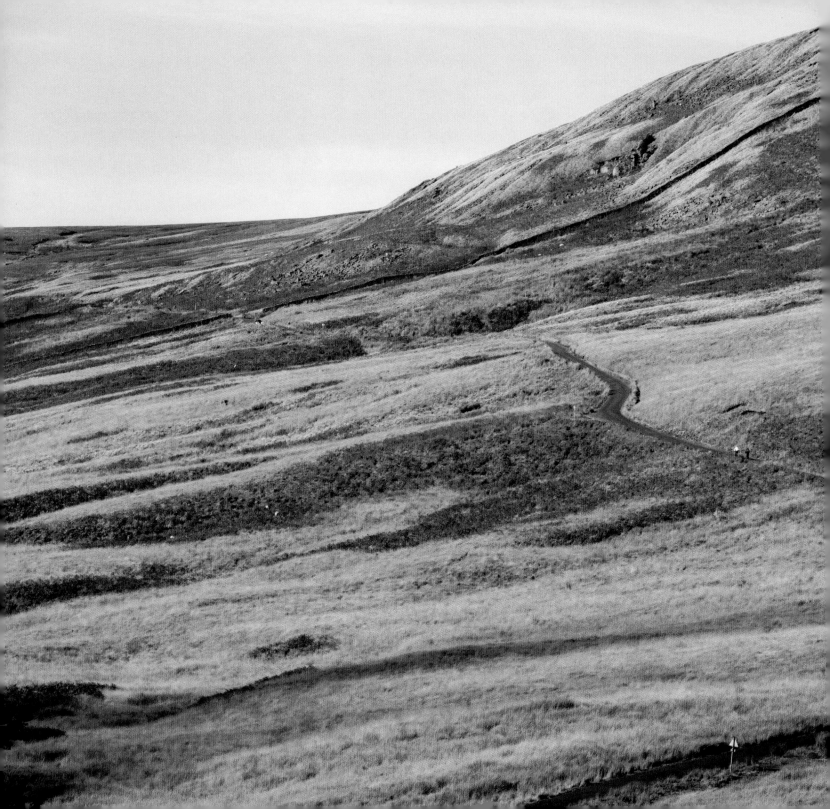

Industry and Land Use

With several large estates in the AONB, most noticeably the Duke of Westminster's Abbeystead Estate covering 23,000 acres, the Duchy of Lancaster Estates and the 25,000 acres owned by United Utilities, shooting is a popular pastime in the area. The estates provide jobs for many local people and bring visitors to the area.

United Utilities has a number of roles to play, its principal one being water catchment, but it also supports tourism and recreational activity in Bowland, including game fishing on Stocks Reservoir, as well as providing birdwatching. Much of United Utilities' land in Bowland is SSSI (Sites of Special Scientific Interest) and the company works with the RSPB to manage its water catchment areas accordingly, aiming to ensure that the peat moor habitats and natural

Left: Cross of Greet road, Catlow Fell

environment are protected and enhanced. There are opportunities for fishing across Bowland, not simply on reservoirs, but also in the major rivers of the area which support fairly healthy populations of salmon, trout and sea trout.

Some of the land usage of the area is actually not 'usage' at all but conservation and restoration. There is work going on across the area to reintroduce natural woodland where appropriate, around cloughs and on some of the lower fellsides, whilst any conifer plantations (and fortunately there are not many) are being reconfigured to have broadleaved woodland around their perimeter. Gisburn Forest is one of the largest areas of conifer woodland in Lancashire but even so, is interspersed with broadleaved trees and has attractive rocky outcrops which rise above the tree tops. Bowland has an internationally important area of blanket bog and work is ongoing to repair erosion and re-wet areas of bog. Blanket bogs are not only important for biodiversity, but the wet peat

acts as a carbon reservoir. The modification of bogs through drainage, burning and grazing may release large quantities of carbon into water courses and subsequently carbon dioxide into the atmosphere. It is often the farmers who are taking on the conservation role, by changing grazing patterns and densities on the high fells, managing pastures to encourage and feed birds such as lapwing, snipe and curlew who feed on wet grassland, and maintaining the traditional field boundaries of hedgerows and dry stone walls.

Finally, one of its most important functions is what Bowland supplies to people in terms of solitude, solace, clean air, peace, and a sense of expansive freedom which cannot be quantified.

Below: Sheep dog trials at the Hodder Show

THE PEOPLE OF BOWLAND

THE HILL FARMER

There are hill farms scattered across the Bowland uplands, the majority of them farming land from valley bottom to high moorland. Lamb Hill is one of these, with 2000 acres of mixed fell and pasture. The farm is neat, a traditional white farmhouse surrounded by old stone barns and more modern cattle sheds. Protected from the prevailing westerlies by the fell from which the farm *(facing page)* takes its name, it sits at an altitude of over 1000 feet on the sides of Lamb Hill Fell, north of Slaidburn. Christine Scott *(above)* and her daughter Liz farm some 800 sheep and 25 beef cattle here.

It's hard. The land is beautiful but rough, with bog and heather moorland on the tops of the fells and wet grassland on the inbye pastures closer to the farm. In the winter the weather can be wild and wet for days on end, and snow can drift across the fells and block the single-track road below the farm. The milder spring and summer weather is welcome but even so it can be very wet, high on these fells. The financial rewards for hill farming are poor, and Lamb Hill, like many other such farms, would probably not survive without government

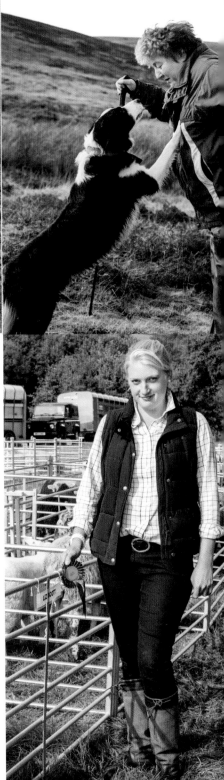

Above: A new-born lamb takes a stretch. Christine takes this as a sign of a healthy animal. Right: Christine Scott with Paddy the sheepdog; and daughter Liz

subsidies in return for management of the land and environmental stewardship. It costs on average £15 to produce a lamb for market, and it sells for perhaps £35. Not much profit when the work involved is taken into account! And there is even less profit when 80 of your sheep are rustled just as you are about to send them for sale, as happened to Christine in the autumn of 2013.

The farming year starts in early autumn when the sheep are sorted and rams selected, with tupping (when the rams are put to the ewes) following in late October and throughout November. In early spring there is dosing, then lambing; dipping and shearing in the summer and selling at auction market in the autumn, before the whole cycle begins again. Besides these key events there are walls and fences to maintain, cattle to feed and put out to pasture once the grass starts to grow, haymaking, cutting the rushes and sedges and bracken on the poorer pastures, maintaining tractors and other machinery, and constantly completing paperwork required by DEFRA (Dept for Environment, Food & Rural Affairs).

Christine and Liz have eight sheepdogs: Flash, Jock, Paddy, Jet, Nell and Millie, plus two of Millie's pups: Boo and Frankie. These are working dogs, not pets, yet there is not only respect between farmer and dog, but affection, even love, too. The understanding that exists between Christine and her dog, Paddy, is remarkable, so much so that it almost appears at times that Paddy is talking to her. The dogs are all business when there is work to be done. Fast, intent, eyes fixed on the sheep, they work the fields and fells with amazing skill, gathering and then driving the sheep to the shouted or whistled commands of Christine or Liz.

Christine knows secret places on her farm, hidden folds high in the fells, where rare mosses and sedges grow, and which she protects as part of her connection with the land. The land is her responsibility, taken seriously, and it is also her joy. For both Christine and Liz, there can be no other life. It is what they want to do, what they were born to do, and they do it without fuss or complaint, loving their animals, enjoying the freedom and the quality of their lives, high in the Bowland fells.

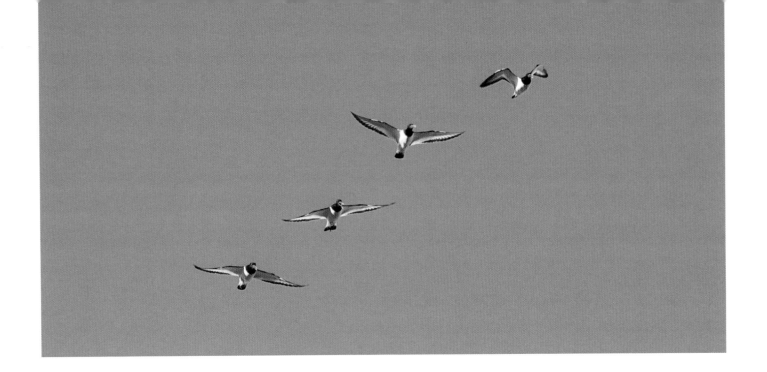

RSPB BOWLAND WADER PROJECT OFFICER

Since 1960 the number of lapwings in England and Wales has dropped by 60%, skylarks have declined by a massive 75%, whilst there has been a 42% decline in curlews since 1995. Skylarks and lapwings are on the RSPB's 'Red List' of Conservation Concern, whilst curlews, snipe, redshank and oystercatchers are all on the 'Amber' list. Whilst these are UK figures, the Forest of Bowland, an important habitat for these birds, has also seen a substantial decline in numbers, mainly due to the draining of fields that were once boggy, and the replacement of diverse hay meadows with monocultures of rye grass for silage. It is these fields that RSPB officer Gavin Thomas calls, with some despair in his voice, 'green concrete'; and it is his job to try to reduce and reverse the decline in Bowland's waders and other wildlife. An RSPB colleague is working on the similarly disastrous decline in hen harriers and other raptors on Bowland's moors.

One of the ways in which Gavin is hoping to reverse the decline is through taxpayer-funded agri-environment schemes which provide incentives for farmers to better manage areas of their land for wildlife. These schemes aim to reduce overgrazing; protect the moorland peat beds and blanket bog; plant native woodland; wetland management; and restore wildflower-rich hay meadows. There has been considerable support from United Utilities, a major landowner in Bowland, particularly through their Sustainable Catchment Management

Programme, as well as from Natural England, yet it is also the local communities on the ground, the farmers in particular, who can make a difference. Gavin regularly visits farmers in the area to support and advise them on how best to manage their land for conservation and protection of the environment and its wildlife. Many farmers are in the Government's Higher Level Stewardship Scheme (HLS), and Gavin and his colleagues offer a free service to farmers to complete the applications on their behalf. A new Countryside Stewardship scheme introduced in late 2015 will provide the latest incentive.

The farmers 'top' the rushes in their pastures, as lapwings in particular like short grass and scattered low tussocks of rushes. Some farms have made small muddy pools and scrapes which encourage invertebrate food sources for curlews, lapwings, snipe and redshank. And this cooperation is working, with good results being achieved on farms in the area. On one farm lapwings rose from one pair to 16 pairs in just five years following RSPB advice, whilst on another farm there are now 30 pairs of lapwings nesting annually. A brand new nature

Opposite: A flight of oystercatchers
Below: A curlew takes off from a fence post

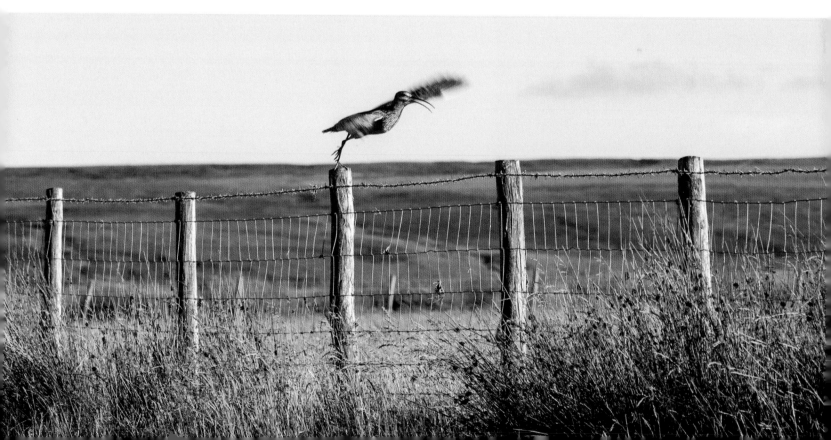

reserve has been created at Alston Wetland on the edge of Bowland on the site of one of United Utilities' decommissioned reservoir sites. Up to 30 pairs of wading birds nest there each year and Gavin has recorded over 160 species of birds there since its creation in 2005.

Gavin also organises an annual wader survey in the spring, using volunteers, to go onto farmland to record numbers, breeding activity, whether there are chicks, and the overall effect of habitat management. He stresses that anyone can become involved in local conservation work; as a volunteer, or by growing wildflowers, putting up nest boxes, creating wildlife habitats in private gardens, by campaigning, or giving whatever support they can.

To ensure that the work being done is publicised as widely as possible, and to encourage involvement of people from young to old, a large portion of Gavin's job involves education and raising awareness. All of the Primary schools in Bowland have been involved, with guided visits to livestock farms to enable the children to see farming for conservation in action. Guided walks on particular farms are arranged for members of the public during 'Festival Bowland' each summer, and Gavin runs farm-based training and demonstration events for advisers and land managers. Bowland is also one of the RSPB's 36 'Futurescapes' – targeted areas where the RSPB is working to safeguard and improve special places for nature and wildlife on a landscape scale.

The rewards of his work to Gavin personally are clear to see. Having always been interested in birds since a child, he took a degree in Geography and then completed a Masters in Wetland Archaeological Science and Management, before coming to Bowland more than 10 years ago to work with the RSPB. Now he enjoys Bowland's wonderful diversity and range

of habitats. An area he loves, which Gavin describes as Bowland in microcosm, is upper Roeburndale, an area of traditional farming, bluebell woods, fells behind; isolated and undiscovered. But it is the walk from Croasdale up and along the Salter Fell Track that is Gavin's favourite place. From redstarts in the approaching lanes, to lapwings and curlews in the meadows, to ring ouzels, whinchats and golden plover higher up on the fells, to hen harriers, short-eared owls, merlins and peregrines on the fell tops, this is Bowland at its very best, and he hopes, with his help, that Bowland's special birds, wildlife and habitats will thrive and flourish here for future generations to enjoy.

Opposite page, from top: lapwing, curlew (© Peter Guy), RSPB officer Gavin Thomas.
Below: Brennand Tarn

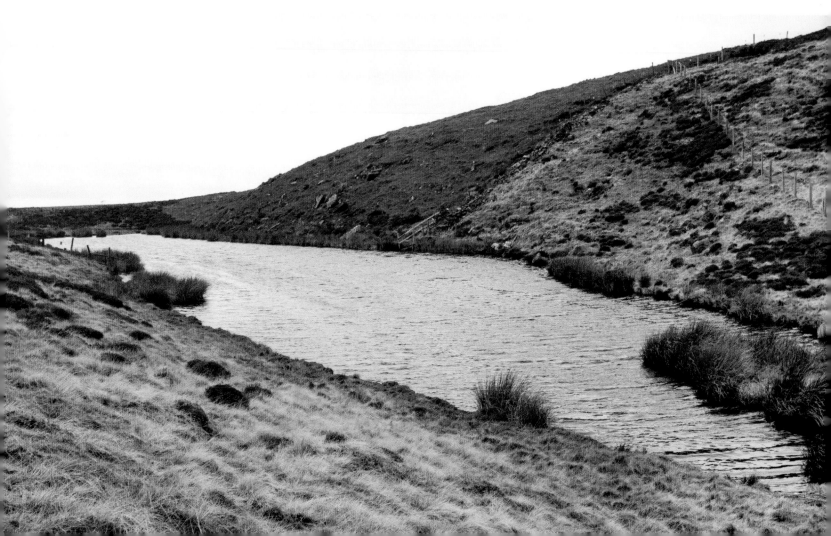

BOWLAND PENNINE MOUNTAIN RESCUE

Phil O'Brien has seen most things in his 29 years with Bowland Pennine Mountain Rescue Team, from finding lost persons, evacuating injured walkers, to tragic death on the Bowland Fells and he remains committed to the service he and his colleagues provide, to help people in need, whatever the circumstances.

Phil grew up in South Wales, and it was a local Scout Leader there who first introduced him to the mountains and fostered in him a life-long love of wild places. He lived in Cumbria after university where he joined the Penrith Mountain Rescue Team, but has been with the Bowland Pennine team since 1986 when he moved to the area for work.

In all there are some 58 men and women in the team, composed of 42 full team members, 10 trainees and 6 reserves, with approximately another 30 people involved with the charity in various other ways such as fund raising. Becoming a full team member is no easy process. Individuals

Left: Winter reaches Kenibus
Following page: View towards Cold Stone and Kearsden Holes

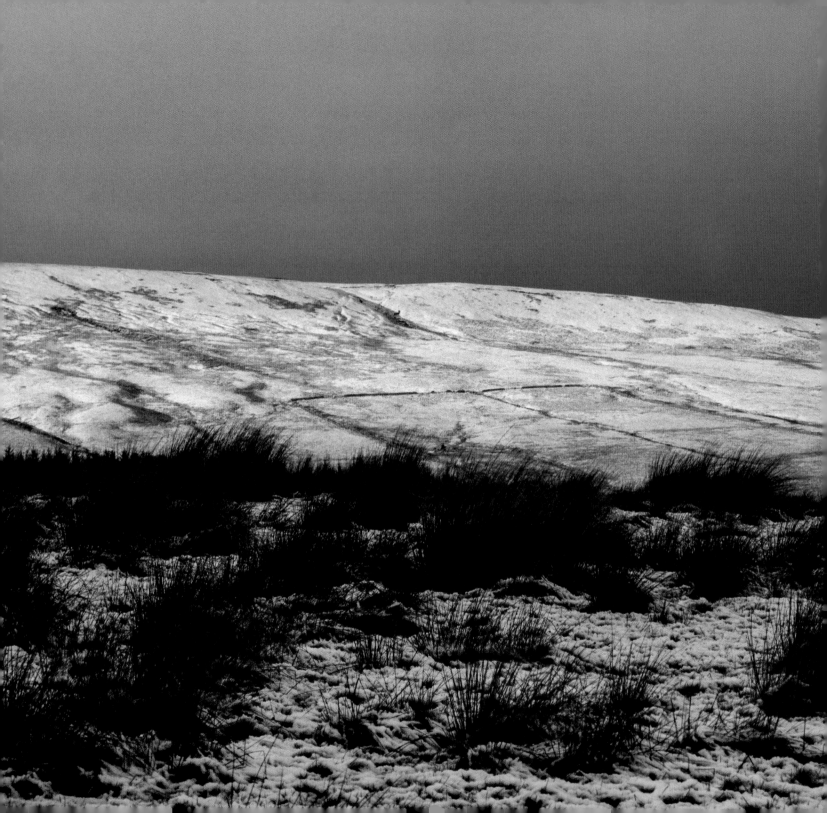

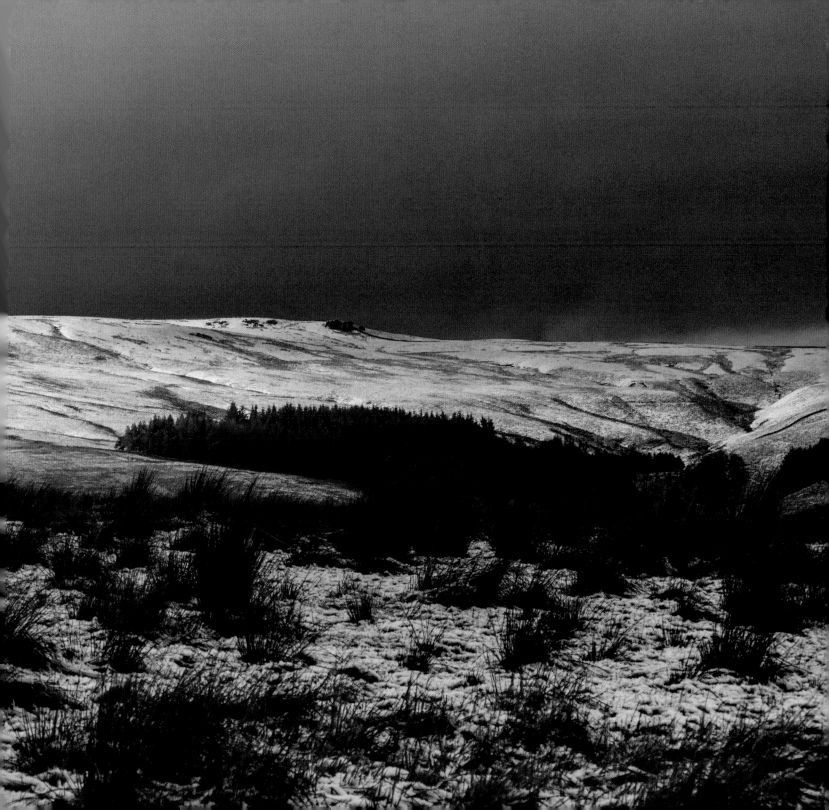

generally approach the team asking to join and an application form is sent out to them, which is designed to help them 'self select' and usually means that only about 6 people actually return the form each year. Those individuals are then invited to spend a day with the team, following which they become a probationary member, with 10 weeks of training ahead of them. If they are successful at the training, they become a trainee for 12 months and only at the end of that time are they considered for full membership of the Mountain Rescue Team. It may sound like an unnecessarily long process, until you remember that the team can have people's lives in their hands; then the selection process makes sense.

There are three main bases for the team – at Smelt Mill Cottages outside Dunsop Bridge, a training and vehicle base at Garstang, and a vehicle garage in Penwortham. Vehicles include the trusty go-anywhere Land Rover Defenders, and there is also a minibus. Thanks to these vehicles and their distribution around the area, the team can usually get to within 800 metres of a casualty; the Land Rovers have stretcher-bearing capability so that a casualty can be taken safely down to a road. Two Land Rovers are sent out on every one of the approximately 60 annual calls, as insurance, in case one of the vehicles cannot get to the incident.

The process of call-out is remarkably efficient and works well. All team members have pagers and mobile phones, and either the Police

or Ambulance service call the team out by contacting all full team members; usually 15 or 20 people are available at any one time and will come out. The types of incident vary, from an injury on a hillside, to lost walkers, helping with a search for a vulnerable individual, getting an ambulance crew through snow to someone needing help, or even working with the Coastguard on a marine search and rescue operation. If necessary, search dogs are also used. The team has mapping software which shows the exact location and status of Mountain Rescue teams across the country.

Interestingly, there are different search patterns and methodologies employed according to the type of person. There are 'lost person characteristics' which determine the type of search – for example when searching for a fisherman the first rule is to look downstream first, which obviously makes a lot of sense! Individuals with dementia often wander in a completely straight line until an obstacle diverts them, so in this case the search is carried out in a straight line from the last sighting.

No charge is ever made for a call out or rescue, even if the call is spurious or unnecessary. In one incident an individual complained of being lost with a head injury, occasioning 18 people and 6 vehicles being used in a search, only to discover the person had in fact gone home. At the other end of the scale, the team on occasion have to recover a body, surely one of the most difficult and disheartening of calls. But mostly, there is the reward of knowing that someone in need has been rescued or helped, serious injury treated as quickly and safely as possible, and individuals sent on their way to hospital, or home.

For Phil, the satisfaction of helping people in need is combined with the pleasure he gets from simply being out and about in the wilds of Bowland. It is Bowland's remoteness, its secrecy, that appeals to him; as he says, people bypass it, unaware of the beauty that can be found here. Phil's own secret place is Brennand Tarn, high up on the fells above the Trough of Bowland. It is, literally, in the middle of nowhere, very hard to reach, and with very few visitors except birds. It is the only tarn in Bowland, a bleak, lonely stretch of water, surrounded by rushes and peat groughs, but it is in places like this, in the remote heart of Bowland, that the very essence of this area can be discovered.

Right: Mountain Rescuer Phil O'Brien at Smelt Mill
Left: Catlow Fell near Cross of Greet

BOWLAND HAY TIME
& NETWORKS FOR NECTAR OFFICER

'It's brilliant, it's just a joy,' is how Sarah Robinson describes her job as Project Officer working to conserve and restore traditional hay meadows and to develop nectar corridors for pollinating insects in the Forest of Bowland.

'There is so much diversity here, with woodland, meadows, people, and wilderness, all making Bowland really special.' And it is species-rich diversity that Sarah is working to achieve across Bowland. In the past half century it is estimated that more than 97% of meadows have disappeared from the UK, due mainly to changes in farming practice such as the production of silage rather than hay, extensive use of inorganic fertiliser, and more modern intensive farming methods. Yet in Bowland some 50 hectares of traditional hay meadows survived, and were designated Sites of Special Scientific Interest (SSSI). Other grasslands, whilst still being managed as meadows, were lacking the huge range of native species, and part of Sarah's role has been to work with farmers to restore botanical diversity to these sites.

The main method of restoring meadows is by transferring seed from existing species-rich sites to a new (receptor) site. To begin with, possible receptor sites have to be identified, and having done so, farmers need to agree to their fields being restored in such a way. It is a complex matter to ensure that the receptor meadow

Left: Wild meadow near Dalehead

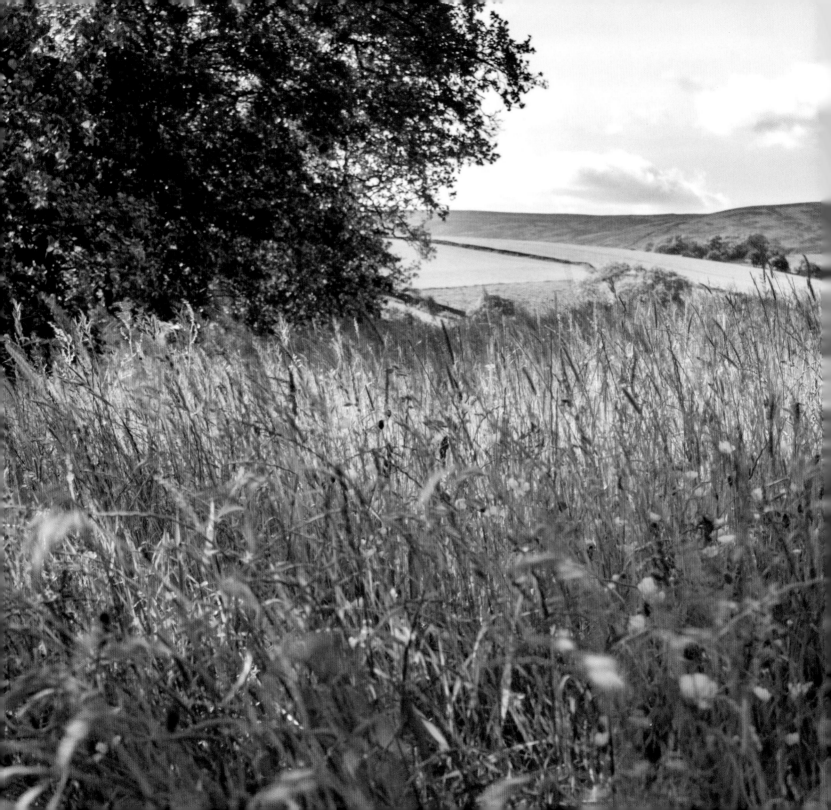

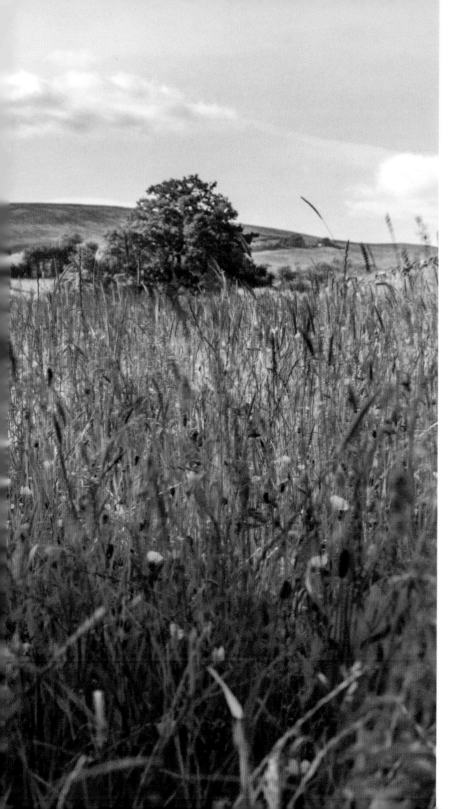

is suitable. Native wild flowers will not grow in areas where intensive fertilisation has produced nutrient-rich soil, so it is important to sample the soil to ensure that there is not too much nitrogen, phosphorus or potassium. In addition, the aspect, altitude, drainage and micro-climate of the receptor site all need to be similar to the location of the donor seeds, whilst the land must be managed correctly, usually under a Higher Level Stewardship environmental scheme.

Having achieved all of this, then the work to transfer the seed can actually begin! Seeds need about 50% of bare ground to be successfully grown, so the receptor site must be cut or grazed and then prepared with a chain harrow. Obtaining the seed from the donor meadow is done by one of three methods: green hay is cut and collected with a forage harvester but must be spread onto the new meadow within an hour of being cut to keep the seed from overheating in the hay; vacuum harvesting collects seed which is then dried and spread by hand; and hand collection of seed is used for those plants with hard outer seed cases. Once spread, seeds need frost in order to germinate so it can be six months or more before Sarah knows whether a seeded meadow has been successful.

The rewards for this work are immense. Not only is Bowland's natural beauty being enhanced by meadows full of native wildflowers,

Left: Coronation Meadows, Bell Sykes Farm, Slaidburn

but many of these flowers are rare or endangered and are being conserved and propagated through this work. One of these rare flowers, the stunning Globeflower, exists in just one location at the moment; but a local farmer remembers a time when women from Slaidburn would go out into the fields and cut armfuls of Globeflowers for their vases. How wonderful it would be to see that level of profusion again. Even more rare is the Greater Butterfly Orchid, with currently just 14 individual plants in Bowland. The fragility of these plant species is frightening.

The meadows are also all about people. In the past, hay time was an important social occasion in Bowland, when people came together to help with the cutting of the hay; it was a time when farmers' sons and daughters could meet their opposites when helping out on neighbouring farms, leading on to marriages later; when the farmers and their wives could chat to neighbours and pass on the latest news. Sarah is trying to record many of these memories, to preserve the traditions as well as the plants.

Left: The Common Spotted Orchid

Slaidburn also has the honour of being host to Lancashire's Coronation Meadow, at Bell Sykes Farm. This initiative was championed by HRH The Prince of Wales to celebrate the 60th anniversary of the Coronation, and the delightful flower-filled meadows at Bell Sykes are a joy to behold. What is more, they have acted as the donor for at least three receptor meadows in the area, at Newton in Bowland, *The Inn at Whitewell*, and Ellel near Lancaster. And it is at Bell Sykes that Sarah would choose to spend a sunny summer day in Bowland, completely surrounded by the wonderful wild flowers she is helping to conserve.

THE GAMEKEEPER

For Ben Scott *(above)*, being a Gamekeeper is all about working in, and caring for, the wild place that is the Forest of Bowland. He sees his job as an integral and essential part of maintaining the land and achieving a successful balance of wildlife across the area. He emphasises that while many people think of Gamekeepers as people who go out and shoot anything that moves, that is by no means the case! Apart from the fact that there are strictly controlled shooting seasons, a great deal of Ben's job, and pleasure, is about being out in the wild, watching the wildlife and the deer, and appreciating the beauty of the land that surrounds him.

There is always work for a Gamekeeper to do, however large or small the estate he works in. For a large part of the year, outside the main autumn and winter shooting seasons, there are a number of main tasks to do, from rearing pheasants and partridge, controlling vermin, stalking and controlling the movement of deer, and maintaining the land and woodlands. Whilst some estates rear pheasants from breeding onwards, most buy

127

their pheasants as poults at about 7-9 weeks old. They are then raised in pens, fed on pellets and later wheat, before being released into the woodlands where they will feed at first from wheat feeders. Grouse and deer are totally wild and are not reared in any sense, but it is important that the Gamekeeper maintains the correct environment to ensure a good distribution of wildlife. The deer need to be controlled in where they wander so that they do not destroy woodland or newly-planted trees, and gamekeepers undertake diversionary feeding of raptors like the hen harrier and peregrine falcon, by placing mice, rats, or rabbits on posts for the birds to feed on, which means that there is no need for the raptors to target the grouse. Should the proportion of raptors to other wildlife become unbalanced, there is a danger that the moors will become less, not more, species-rich. As with all nature, maintaining a healthy equilibrium is essential for the good of all, but under no circumstances is it legal to kill raptors as they are protected and rare species; and, as Ben points out, it is possible to use other tactics and good environmental management to achieve balance without harming any protected birds.

Below: Fly, Ben Scott's Springer Spaniel

Right: Heather burning on the Abbeystead Estate, part of the grouse moor conservation effort

The control of vermin is also an important part of Ben's role. He will trap crows for farmers as these birds will take out the eyes of lambs as they are being born, whilst humane traps and snares are used for mink, stoats, and foxes, all of which will kill ground-nesting birds. It is said that a stoat will rise onto its hind legs and do a strange, manic dance to hypnotise a rabbit before pouncing!

In the shooting seasons (mainly through late summer and autumn to February – specific dates vary according to the species), much of Ben's work is planning for and organising the shoots. Before a shoot day he will plan which way a shoot will be walked or driven; this decision depends on the wind direction, land condition, where the birds are, and a great deal of previous experience! If the birds have wandered from the woodland then he may 'dog them in'; that is, use his dogs to shepherd the birds back towards the shooting ground. If that is required, then any traps and snares in the wood must be removed so that the dogs do not get caught in them. Beaters must also be recruited and organised; for a woodland shoot there will be 8 or 9 beaters, perhaps double that number for a grouse shoot up on the open fells.

On the day of the shoot, the guns draw lots to be allocated their station – either a peg on the ground in the wood or a shooting butt if up

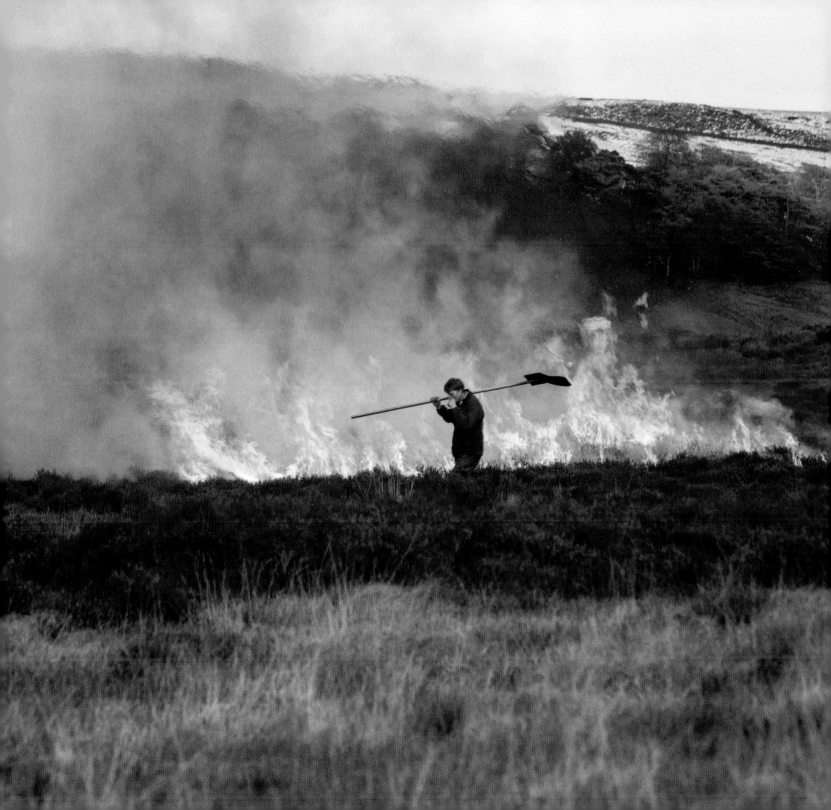

on the moor. Ben describes vividly how low and fast the grouse fly, requiring a greater level of skill from the guns when shooting grouse rather than pheasant or partridge, though those are not easy targets either! There will be 'pickers up' behind the guns for the fallen birds, and gun dogs are often used to retrieve; mainly Labradors and Springer Spaniels, but recently also Hungarian Vizsla, as these dogs can also be used to track deer.

There may be two or three drives on the morning of a shoot, followed by another session after lunch, until the brass horn, or occasionally a loud whistle, is blown by the Gamekeeper to signal the end. The birds are then divided between the guns and any excess may be sent to a game dealer for sale.

It is clear that Ben loves his job and the wild places. For him Bowland has a secret nature, tranquil, hidden away from the hustle and bustle of the towns; the views, the wildlife, the fells and the woodlands are where he belongs and are what make Bowland his special place.

Below: Stoat with rabbit

THE DRY STONE WALLER

Reuben Parsons chuckles when I ask him why he became a dry stone waller. 'Job of last resort', he laughs with self-deprecation, yet to see the miles of dry stone walls that sweep across Bowland it is clear this is an occupation requiring dedication and a great deal of skill.

Born and raised in Slaidburn in the heart of Bowland, Reuben took a Youth Training Scheme course in walling and masonry when he was just 16 and since then has honed that and many other useful skills by working on farms across the area; he has run his own business as a waller and general contractor for more than twenty years now.

Above: Sheepfold at Cross of Greet

131

Above: Drystone waller Reuben Parsons
Right: Wall on Fair Snape Fell

There was a brief time when Reuben worked away in other parts of the country, but he soon came back to the Bowland area, marrying a girl from Waddington and bringing up three children who are now teenagers. They live in Hammerton Hall, a Grade II listed house which is mainly Tudor but with nearly a thousand years of history in its foundations. Surrounded by green pastures with their iconic stone walls, and bounded by the River Hodder, there is an ancient peace here. Yet Reuben's life is no easy, pastoral idyll. Mostly he works alone, and fortunately he is quite happy in his own company. As with so many who live and work in the Forest of Bowland, he enjoys the quiet times, watching and listening to all that surrounds him. He works in all weathers, regardless, though walling is impossible in a frost as the stones stick together, so on those days he may be hedge-laying, building, or doing any number of other essential maintenance jobs on one of the local farms. He enjoys the variety of his work, commenting dryly that he would go crackers if he was constantly walling! Still, he has many tales to tell of his working life. Once, when out walling, he describes how he watched an approaching storm, smelling the charged lightning in the air. Gradually the lightning came closer and closer, and still he watched, enjoying the elements, until without more warning the lightning struck the wet wall directly beside him, blowing him off his feet. He remembers lying, vaguely stunned, on his back for over half an hour, smelling chamomile, where the lightning had burnt all the moss from the wall. On another occasion he was persistently threatened by a bull approaching him through the broken wall, and decided the only way to discourage it was with a tap from a spade. On his return to the farm the lady of the house asked him whether he had liked their new bull, telling him 'he likes his head tickled!' Oops!

The beautiful stones that make up his walls come from a number of sources; he can buy from farms where a wall is no longer needed or an old building has been demolished; sometimes he gets stones from reclamation yards, or even directly from one of the local quarries. He handles the stones with love, showing me some that have fossils, others where there is a subtle blend of colour from greys to browns. Usually when he is walling he has a plan in his head about how he will tackle the job and what he will do with his material, depending on the location. Each area has its own vernacular style; most walls in Bowland are 'coursed', that is, an outer layer of stone on either side with rubble in the middle to support the structure. In other areas stones may have lime or earth in between them, or, even in Bowland, a lime mortar fill. Further east in the heart of the Yorkshire Dales, tar is often laid on top of walls to prevent the theft of the interesting knobbly topstones that are as much decorative as useful.

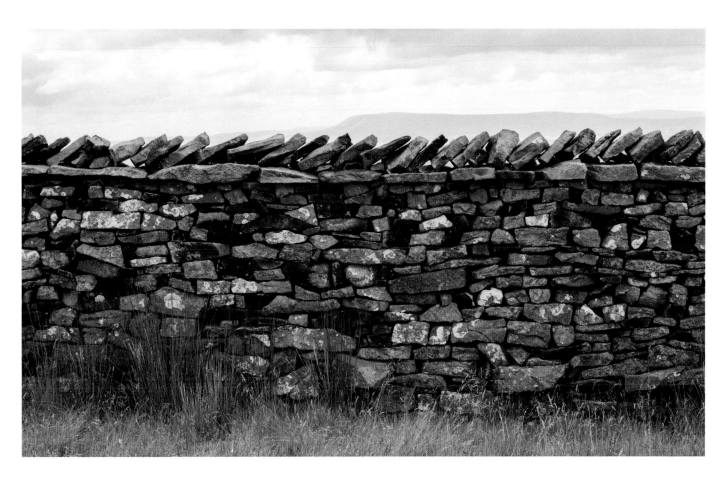

When talking about Bowland, Reuben uses just one word to describe it: 'green', reminding me that the old word 'Bolland' means cow pasture. Yet his favourite area is the uplands, the land of bog and rushes, which may be green, brown, or purple with heather. On a day off in Bowland he would choose to take the road over the Trough of Bowland, climbing up from the green inbye pastures in the valley to the heather and rush-clad tops before dropping steeply down to join the wooded valley of the Marshaw Wyre, buried between the fells: a classic Bowland journey.

Below: Ingleborough from Roeburndale

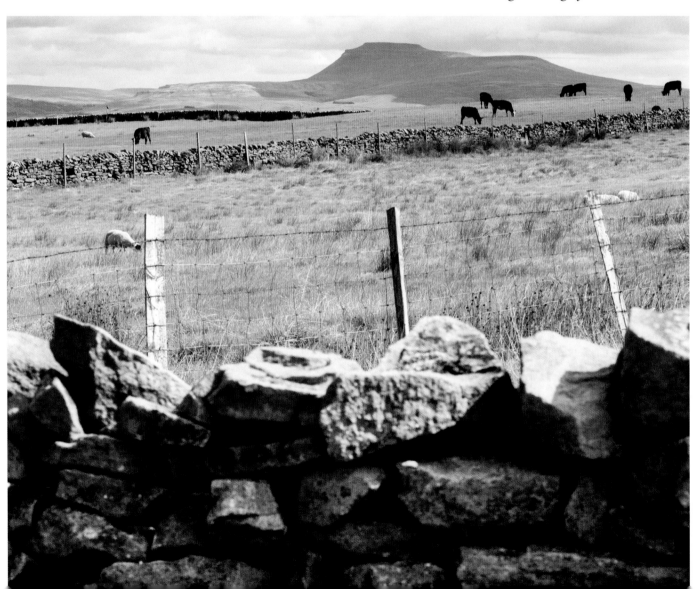

THE AUCTIONEER

The auction ring is surrounded on three sides by steep, scuffed wooden terraces which require some clambering to get onto; the ring itself has sawdust on the floor and a complicated system of metal gates to allow the animals to enter from one side and egress from the other. There is a constant background noise of sheep bleating on sheep days or cows lowing on cattle days. On a hot afternoon in August many of the farmers and buyers are eating large ice cream cones from the van positioned in the car park. Everyone is calm and unemotional.

A loudspeaker announces that the auction will start in five minutes and gradually the space fills up. Some choose to sit on the lower reaches of the terraces and chat to companions, whilst those who are serious about buying choose their own strategic place to stand. One man chooses to lean on the rails directly opposite the auctioneer and places bids by a swift, barely noticeable flick of his wrist. Another stands in the ring itself, directly beside the auctioneer's rostrum, so that the auctioneer has to twist his head a little to check bids, but most buyers

Above: Senior Auctioneer, Stephen Dennis

135

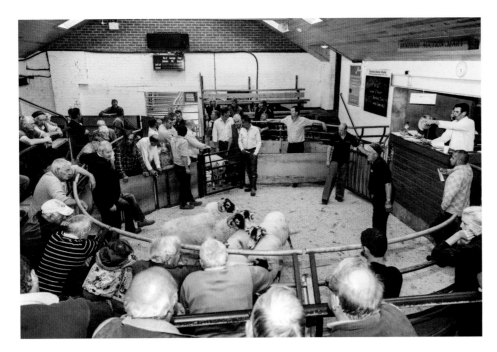

Left: Bentham Auction Market

Right: Fell sheep on the Cross of Greet road – the one in the foreground is a Lonk

stand either side of the entrance gate to the ring and frequently lean over to test the haunches of the animals entering. Of these buyers, one holds up a number of fingers to indicate his bid, another merely raises an eyebrow. Several are using their mobile phones, acting for other buyers and bidding on the phone.

The first group of animals enters the ring and each one looks around for escape. Occasionally a particularly lively sheep will try to leap the barriers, but there are handlers there to make sure all is well and the animal is unharmed.

Instantly the auctioneer begins his seemingly indecipherable patter; it is possible here and there for the uninitiated to catch the odd number being called out but on the whole the entire process is swift and utterly incomprehensible. An electronic board records the number of animals and their weight, but in moments the animals are ushered out as the next batch enters, and the gunfire patter begins again. The auctioneer, the buyers, sellers and the observers all seem to know how much the animals were sold for and to whom, but I have no idea. It seems impossible that the auctioneer can tell who is bidding at such great speed, but he does. Beside him a woman writes furiously in a notebook, apparently recording all bids and the final outcome. Her wrist and hands must ache at the end of the day; and surely the auctioneer will be hoarse!

The Auctioneer

Stephen, the Senior Auctioneer, laughs when I describe my bewilderment. 'It's all experience,' he comments, and he should know, having been almost bred into the role. With grandfather a cattle trader and father an Auctioneer during the 1950s, and farming in his blood, his ambition was always to be a farmer or Auctioneer. He completed a course in Rural Estate Management in Cirencester and became a Chartered Surveyor so that he is able to do property valuations as well. It is clear that Stephen loves his life. He runs his own smallholding with sheep and cattle and hens, and it is the farm animals that he loves. He particularly likes selling dairy cattle which he says each have an individual character; and Bentham auction is one of the very few markets where there are still weekly dairy cattle sales, a fact of which Stephen is very proud. Not for Stephen the auctions where bric a brac is being sold!

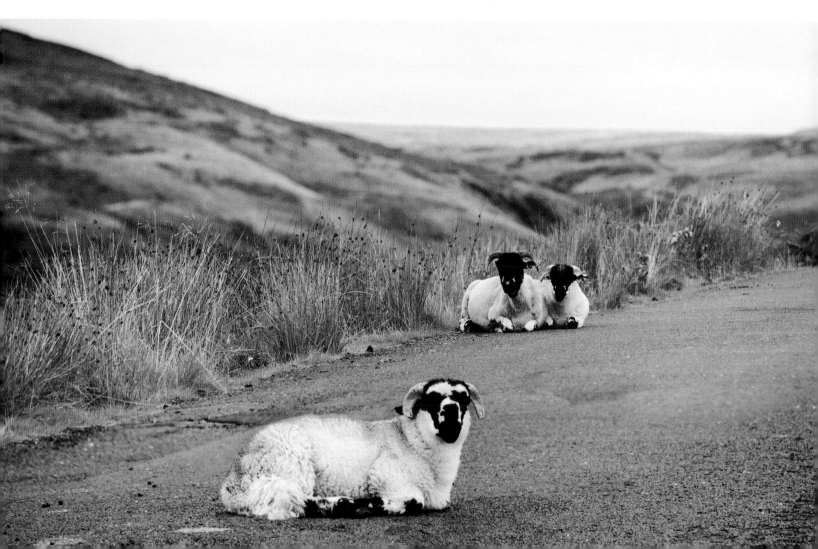

So much of his job now is persuading buyers and sellers to use Bentham Auction Market. He visits farms across the region and even further afield, building relationships, seeing the outcome of his work in the auction ring, and it is here that he finds the greatest buzz of his job. He says perhaps he should have been an actor, as he steps onto the rostrum to begin the auction ritual, and it is his skill in these moments that determine the success of the market, for he must ensure that his sellers achieve good prices for their animals, and that there are buyers there in sufficient numbers to get those prices.

The downside of his job, which Stephen describes with a rueful acceptance, is chasing the money. Sellers pay commission on the animals sold, usually 3% on the auction price, but often it is difficult to obtain the money due from the buyers, (who are often reliant on lines of credit), and this is his biggest headache. As with all businesses, bad debts are never welcome!

Despite this, the traditions of his trade, and particularly of Bentham Market, are a source of great satisfaction to Stephen. The family firm of auctioneers for whom he works, Richard Turner & Son, was established in 1803 and were instrumental in the establishment of Bentham & District Farmers' Auction Mart Co. Ltd. in 1903, having previously been involved in auction sales of livestock in the area, so there is a great history here. He loves the fact that at Bentham there are the original sheds and stalls, that there is still a distinct atmosphere in the place, and countless characters! For many of the farmers the auction is not simply a place of business but a social gathering too. The farming life is essentially lonely but here they can meet to hear the latest news, gain support from others who may also be having trouble with bad weather or animal disease, or even, on occasion, they may meet a future wife or a husband here.

For Stephen one of his favourite places in Bowland, as with others who live and work in this area, is the summit of the road between Bentham and Slaidburn, at Cross of Greet, which he feels typifies the area, with its broad sweep of vista from the high fells and moors down into the fertile Lune valley. But it is the individual people of Bowland, with their livestock, who make this area come alive for Stephen, every day at the auction.

THE ARTIST

John Hatton's stone house and studio sit in a sheltered, secret green hollow below the surrounding Bowland fells from which he draws inspiration for his stunning variety of artistic output ranging from pencil sketches to oil, watercolours and linocuts of the wild birds and animals he observes every day from his studio window.

His studio is a wonderful place. Unsurprisingly, paint, brushes, and canvases are everywhere, whilst piled and propped against every surface are drawings, sketches, prints, books, works in progress; a treasure trove

of skill. On shelves and rafters stand kestrels, grouse, owls, and other Bowland birds, caught forever in their feathered beauty. Binoculars sit beside John's sketching chair, and a huge camera lens waits to capture an image that John may use for reference, as he never paints from photographs, always from life. A computer and printer are on a desk but so far are not often used. More well worked is a litho printing press which John used to print his stylised linocuts.

The view from the studio is of John's wild garden merging onto the fields and fells beyond. Here John can watch the subjects that appear before him undisturbed in their natural environment; here he can work from life. Buzzards circle overhead, a pheasant pads in stately fashion across the grass, a stoat dashes from cover, a flash of foxy red and a black tail tip, before disappearing as rapidly into the hedgerow. In spring hares leap, chase and box in the field beyond. John's hand moves swiftly across his sketchbook. Lines, light and shadow, forms are created by deft fingers and a sure eye.

On some mornings, when the light is striking the fells and clouds are chasing shadows across the swelling hills, he will go up onto the high places of Bowland to draw or paint there, watching the grouse dodge in and out of the heather avoiding the hen harrier searching overhead. It is here John breathes in the sense of place, where he feels the forms of the birds and animals and fells and reproduces that in whichever medium he is inspired to use. The sun on the hillside, the wind brushing and rushing through leaves, a glint of light on water, these are physical manifestations of Bowland, but John also captures the soul of the place, Bowland's peace, its secretive, hidden beauties. He calls Bowland a secret world waiting to be discovered; a land of open skies and dramatic sunsets, expansive, open and yet shy all in one moment of revelation.

This appears to be an idyllic life, going out onto the fells to draw and paint, but nothing is easy. Intense concentration is required, sometimes much trial and error, yet John knows that the more he works, the more

fluid and genuine his art becomes. The start and finish of any work is exciting, but John admits that sometimes the middle of the process can be a bit of a slog, when perseverance is required! Sometimes though, when his mood and skill and desire coincide with a moment in nature, a painting can be started, perfected and finished in only a couple of hours and then stands complete; Bowland alive and living in colours, shapes, and brush strokes.

John has always been an artist, although it is only recently that this has become his full time occupation. He began as a child by copying the pictures on Brooke Bond tea cards (only some of us are old enough to know what a delight these were!). Later he studied Graphic Design in Stockport, but his interest in animals led him into a career as an agricultural merchant, and it was this that brought him from Cheshire to Bowland where he has now lived for more than twenty years.

Retirement from his career gave him the chance to return to his first love of art and now people from across the country visit him in his rural studio to admire and buy his work. The advent of B4RN (Broadband for the Rural North), a community project which brought super-fast broadband to remote farms and villages, allows John to achieve much wider attention through a new website and business selling his images, cards, and commissions online. Previously it was word of mouth, exhibitions, and the Lunesdale Studio Trail, an open studio circuit that takes place every year, that were John's main ways of achieving public notice.

Yet however famous or obscure John may be, it is Bowland that inspires him and draws him back to its secrets; and there is still more in Bowland that John wants to bring to life. He aims to draw the farm animals, as important to Bowland as its wildlife, to capture their essence and personality in fluid form; and last but not least are the character studies of the people who share the fells with him: perhaps a mole-catcher, a shepherd's hand on a crook, those locals who know, and love, and are part of Bowland.

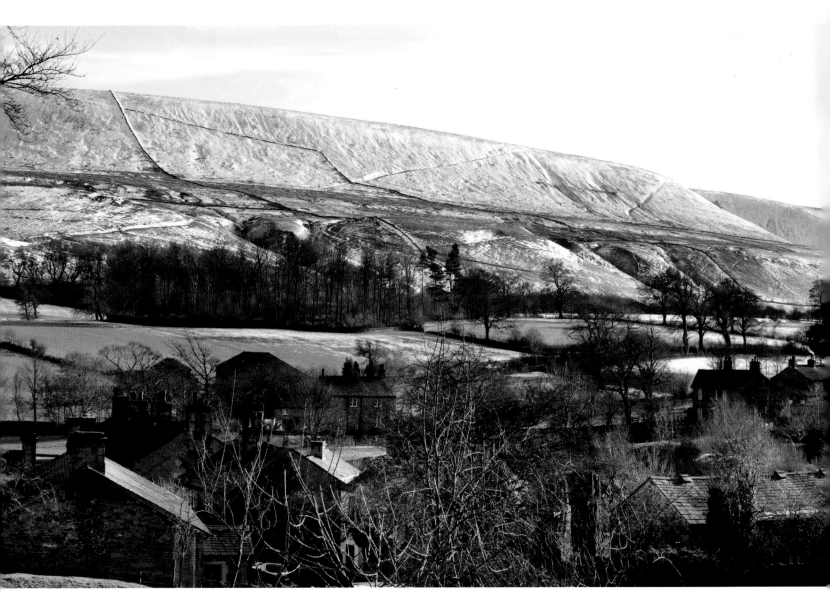

Above: Pendle from Downham

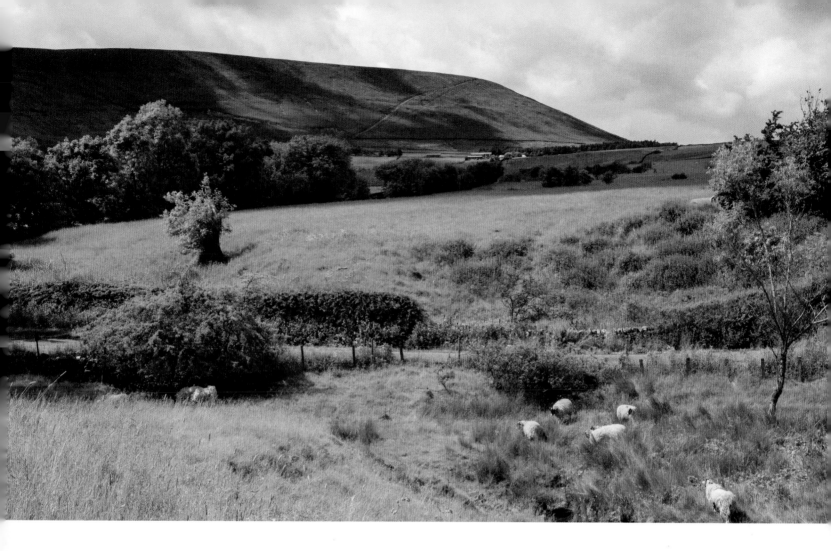

PENDLE

Pendle Hill, with its immensely powerful presence, resonates strongly with native Lancastrians. Not strictly part of the Forest of Bowland, Pendle contributes only twenty square miles to the total of three hundred of the AONB's whole area, but the bold, whaleback outline of this great isolated hill casts a commanding influence over a wide swathe of north-west England, somehow putting many higher hills to shame. It is no surprise that Pendle's true height (1827ft, 557m) was often exaggerated, sometimes grossly, in early writings. Pendle cannot be

Above: Pendle from Barley

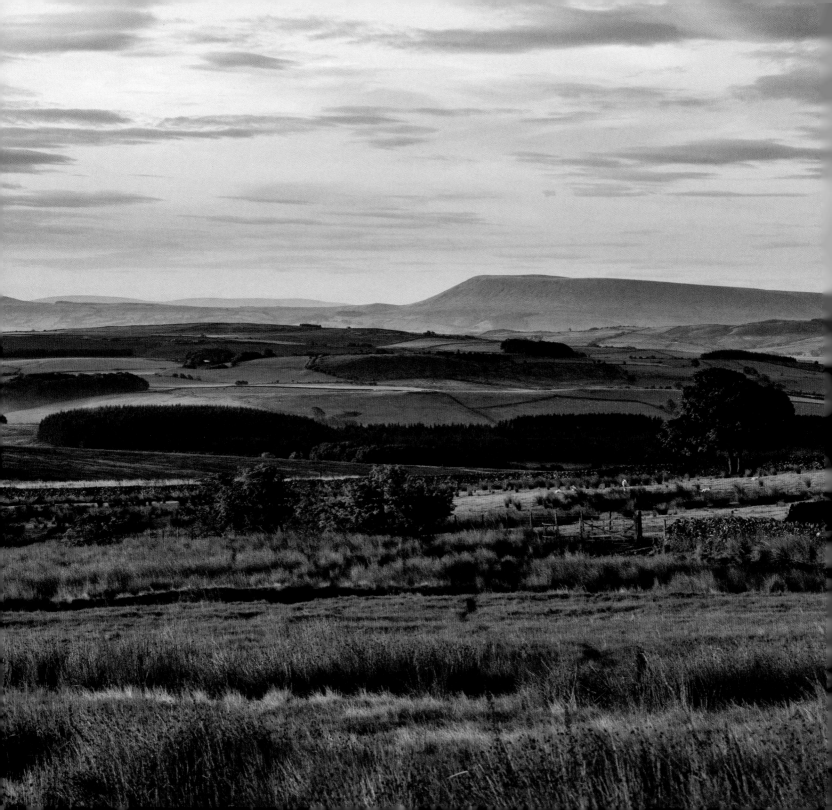

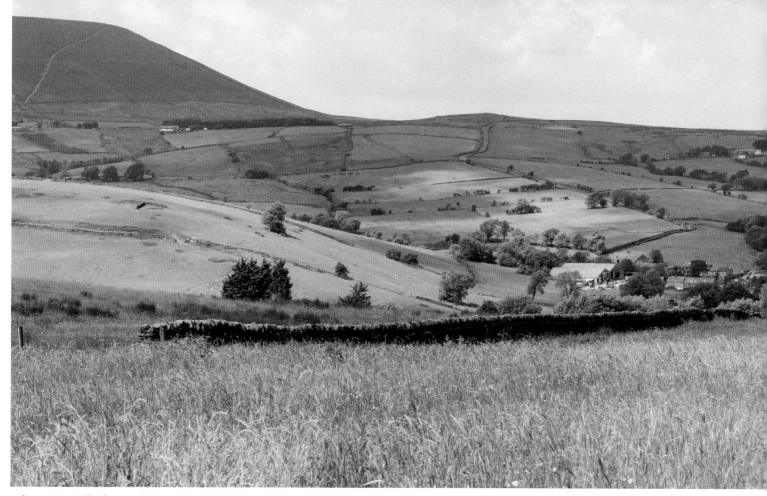

Above: Pendle from above Newchurch

Right: Dawn over Pendle

ignored, and it is hard not to feel the inviting challenge of climbing to its summit (1,827ft or 557m). Most walkers attain the summit from Barley: the most direct way, short but decidedly not sweet. For some time the path has been stone-flagged, allowing some walking rhythm up the steepest section. On reaching the summit plateau, turn back through a hairpin bend and gently climb the last rise to the trig point.

Do select a clear day because the view can be breathtaking! In particular, the Three Peaks district of the Dales offers a superb prospect of almost Alpine appearance in winter, with Ingleborough as usual stealing the show. Further west, the sweep of the Bowland fells from Parlick Pike to Ward's Stone and White Hill shows most impressively; while the Ribble estuary may offer a soothing prospect towards the sunset. On exceptionally clear

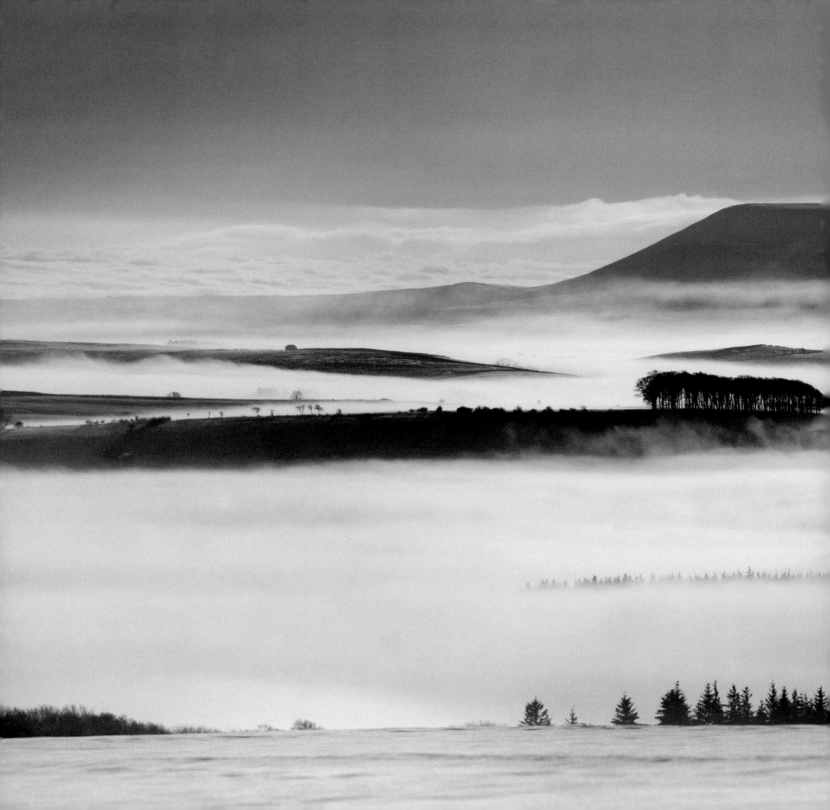

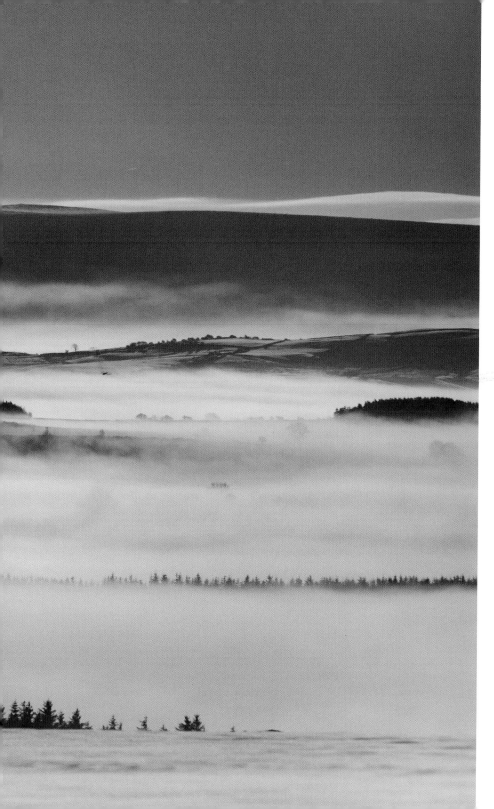

Pendle

days, the Lakeland fells and the Howgills may both be seen behind the Bowland fells: it is about 55 miles from Scafell Pike to Pendle as the crow flies. To the south, there are views across the South Pennines reaching almost to the Peak District, with Black Hill, so familiar (not to say notorious) to Pennine Way pilgrims, visible in good weather. Finally, on the very clearest of days you may catch a glimpse of Snowdon in the south west, 95 miles distant.

Views of Pendle Hill itself are impressive from anywhere within a fifteen-mile radius, or even further. For those seeking photos, however, there are a few especially fine views worth a mention. There is the view of Pendle from Mitton Bridge, where the mature Ribble, looking upstream, leads the eye to the summit. Undoubtedly one of the best prospects is from Kemple End, a higher viewpoint, looking towards Pendle across the greenery of the mid-Ribble valley. A lesser-known but dramatic view of Pendle from the south-east is to be had from the Abbot Stone on Boulsworth Hill, as the ground suddenly drops away before you. After a few visits,

Left: Pendle from Merrybent Hill

you will quickly appreciate the strong contrast between the lush, green westerly aspect of Pendle, where much limestone is exposed, and its rougher, bleaker east side, the Forest of Pendle as seen from Burnley or Nelson. The ancient title, 'Forest of Pendle' is just as historic as 'Forest of Bowland': it was a royal appointment granted by William the Conqueror, mentioned in the Domesday Book. The De Lacys of Clitheroe Castle were lords of the estate for centuries.

Within a few miles of Pendle's summit are a number of interesting and historic villages, which make an appealing short tour. Pendleton, about two miles from Clitheroe, is a good starting point for a splendid circular walk including the Nick of Pendle and the hill's summit. The village itself features a lovely clear stream that divides the main street in two, and the popular *Swan With Two Necks* inn is adjacent.

Downham is probably the best known of all Clitheroe's surrounding villages, and like Slaidburn it remains a classic estate village to this day; the present Lord Clitheroe, of Downham Hall, is a direct descendent of the medieval Assheton family. Its attractions have been recognised in film and TV: *Whistle Down the Wind* was filmed nearby in the 1960s, and more recently the village was used, with sets, for the TV series *Born and Bred*. When you reach the top of the main street, with the *Assheton Arms* to your left, the ground dips sharply in front of you and Pendle dominates powerfully ahead. It looks particularly impressive as you emerge from St. Leonard's parish church into the churchyard, 'filling half the sky'.

Take the Barley road from Downham, an attractive run of about four miles which takes you to the high crossroads at Annel Cross, said to be the site of the last public execution in Lancashire and an excellent viewpoint.

Right: The Witches Galore shop, Newchurch
Opposite page: St Mary's Church,
Newchurch in Pendle

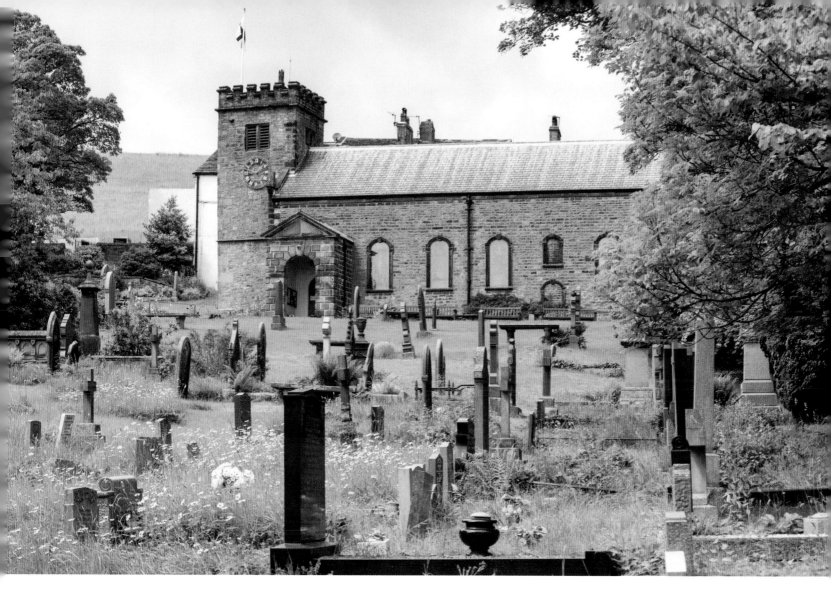

Barley is a charming village, with a substantial car park and local information centre, and makes an excellent base for a number of walks of varying length. In particular, the two Black Moss reservoirs, elevated above the village, afford excellent views of Pendle and the clear path which serves them can easily be extended into a circular route from the village. The well-trodden route to Pendle's 'Big End', mentioned earlier, starts opposite the Methodist church at the north end of the main village street and is clearly signposted.

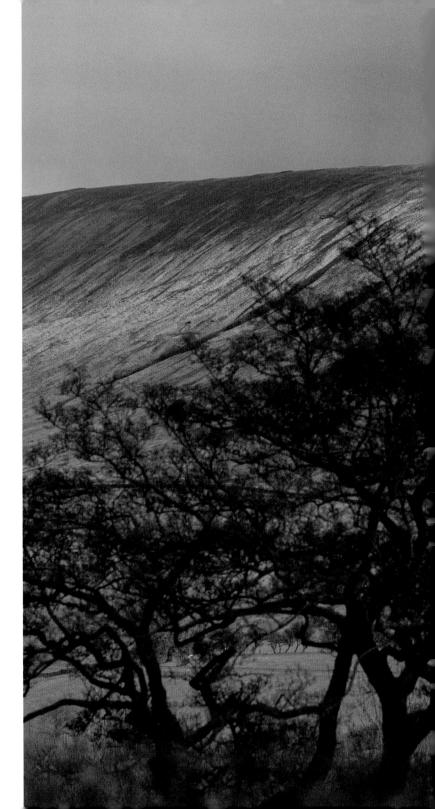

Roughlee, less than two miles east of Barley, is the natural next port of call and makes a very pleasant short stroll from Barley. You can avoid road walking almost entirely, and the stretch along the sparkling Pendle Water beyond White Hough is a delight. Roughlee has traditionally been strongly associated with the Lancashire Witches story as it was the home of Alice Nutter. Alice was long thought to have lived at Roughlee Old Hall, but recent investigations have linked her with Crowtrees, just outside the village.

The dramatic events of the Lancashire Witches story, culminating in the trial at Lancaster in 1612, came to prominence on its 400th anniversary. A number of memorial posts have been erected, claiming to trace the route taken on that fateful journey to Lancaster. Interestingly, it is suggested that the accused witches were taken along the Hornby Road, not along the more familiar Trough road. What was the trial really about, though? Perhaps, above all, feuding families caught up in the wrong place and time. The Puritanical fervour of the day, fuelled by superstition, made a potent brew when combined with accusations of witchcraft. The supposed involvement of Alice Nutter – a gentlewoman and landowner – seems remarkable, until you note that she was from a Catholic family.

The location of Malkin Tower, where the witches were said to have met, is uncertain; possibly in the fields near Sabden Fold. The prominent tower near Blacko, commandingly visible for miles

Right: Pendle, viewed from Clitheroe

150

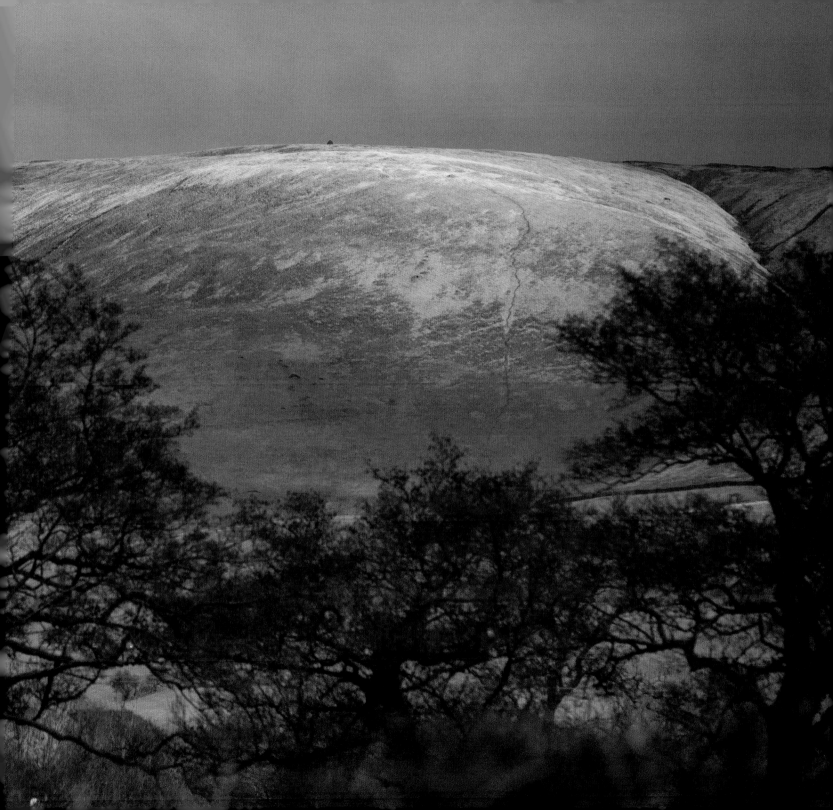

around, is not connected with the witches' story: it was erected by a builder named Stansfield in the late 19th century. Sabden village is a recommended next destination on your tour, until quite recently an industrialised village and now a popular residential spot. At one time there were seven working mills in the village, which was a noted centre for calico making. From here a steep road leads over the Nick of Pendle, a natural cleft in the ridge going south-west from the summit and an excellent viewpoint. Drop down on the west side and you reach Clitheroe in a further two miles, alternatively taking in Pendleton again if you wish.

Finally then, we come to Clitheroe, and although this much-loved market town is not administratively within the AONB, it is high on many people's list of favourite destinations for a day out and makes a splendid

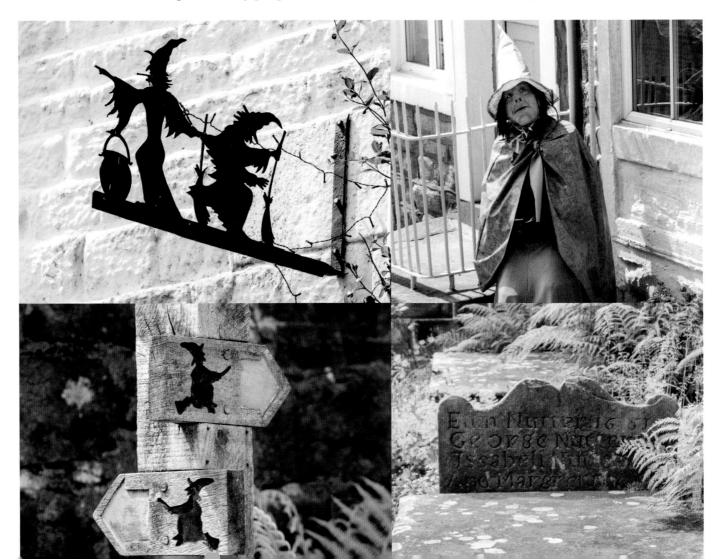

Above: a cottage with the looming profile of Pendle behind it

Opposite page: various witches adorn the village of Newchurch and an original 17th century witch's gravestone

base for the exploration of the district. Pendle is commandingly dominant from Clitheroe, and has a significant effect on local weather. Walk round the streets of the town, and soon enough an alleyway will open up, showing the steep slopes of Pendle Hill, seemingly no distance away. From the keep of Clitheroe Castle, which the visitor should certainly take in, Pendle can be seen in some detail – the road leading over the Nick, the Big End, the Scout Cairn, the deep indentation of Mearley Clough. Look west, on the other hand, and the Forest of Bowland dominates, not powerfully in the manner of Pendle, but enchantingly, especially as you get to know its landmarks.

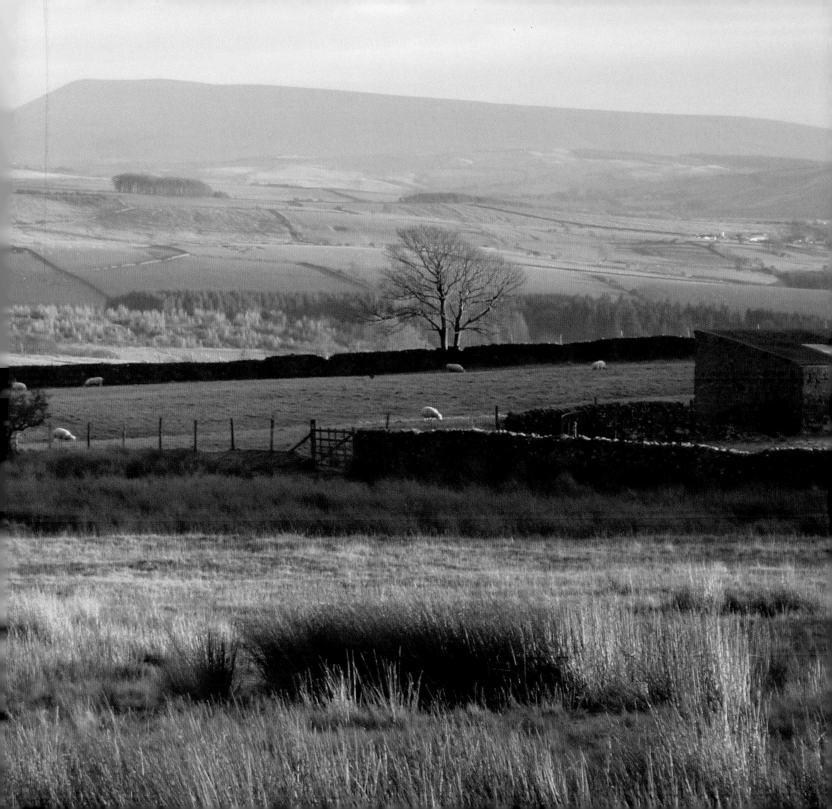

Previous page: Pendle from Merrybent Hill

Left: The Barley Water, Barley

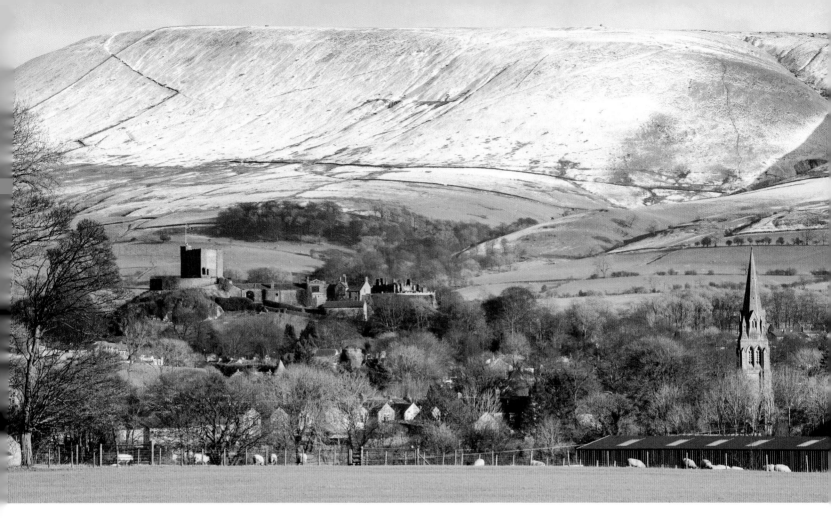

GATEWAY TOWNS TO BOWLAND

Clitheroe

Clitheroe, dominated by its Norman castle keep, is a lively and historic market town with a population of about 15,000. Its wide catchment incorporates the Forest of Bowland, Pendle and environs and the Ribble valley. The town was an independent borough from 1147 until the local government reforms of 1974. Pendle Hill is a looming presence dominating the town to the east, revealing itself suddenly as you pass the many narrow alleyways. Its situation between Bowland and Pendle makes Clitheroe an ideal base to explore the AONB.

Lancaster

The ancient county town of Lancashire, a city since 1937, is another gateway to the Forest of Bowland and the natural terminus of the Trough road. It is dominated by its castle, which stands on the site of a Roman fort. Nowadays the castle is especially remembered for the Lancashire Witches trial of 1612. Lancaster is strongly linked with the monarchy, for the Duchy of Lancaster holds large estates on behalf of the Queen, who is currently Duke of Lancaster. The University of Lancaster was founded in 1964 and has quickly risen to become one of the top ten UK universities.

Skipton

Skipton ('sheeptown') is a lively market town in north Yorkshire and has been the administrative centre of the Craven district since 1974. The castle dates from Norman times and is extremely well preserved. During the Civil War a Royalist garrison was situated here. Compared to Settle, Skipton is much closer to industrial west Yorkshire and stands on the Leeds-Liverpool canal. The town is ideally situated for the southern part of the Dales, notably Wharfedale, and is well placed for access to Bowland too, via either the A59 or A65 which lie to the west.

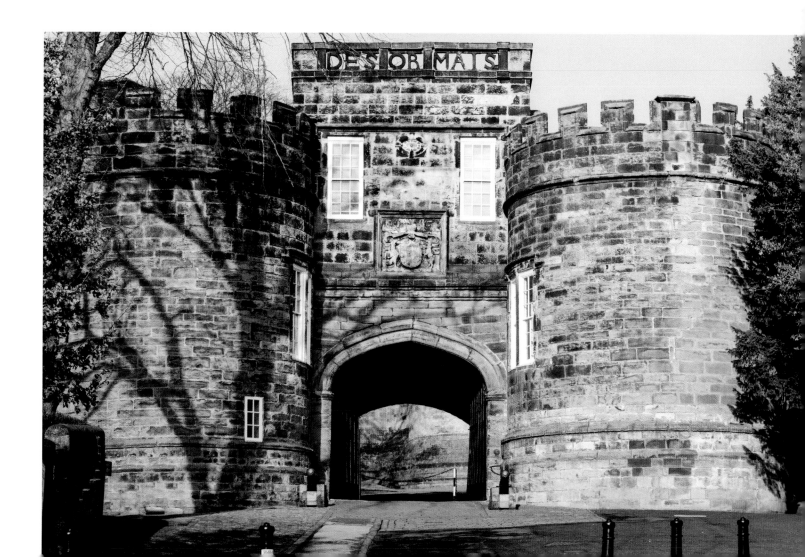

Preston

Preston is the administrative centre of Lancashire and became a city in 2002: England's 50th city in the 50th year of the Queen's reign. Like Skipton, it is linked with the Civil War: Cromwell's forces had a victory over the Royalists here in 1648. The Harris Museum and art gallery *(below)*, opened in 1893, is a fine building with the largest gallery space in Lancashire. Preston offers good access to the Forest of Bowland, either from the east on the A59 or more directly via the pleasant B6243 to Longridge, from where Chipping and the Beacon Fell visitors' centre are easily reached.

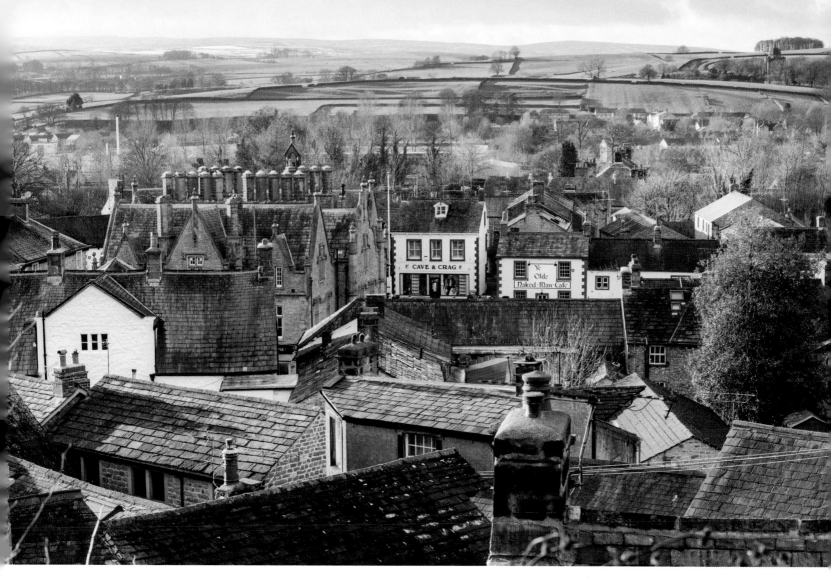

Settle

Settle is traditionally nominated as the gateway to the Dales, but it also has a strong claim to be regarded as a gateway to Bowland. Roads into the AONB are readily accessed from Long Preston, Clapham and Bentham, all within a few miles of Settle. Despite its modest population of just under 3,000, Settle is a bustling market town and a popular destination for day visitors from West Yorkshire or Lancashire. It has given its name to the Settle–Carlisle railway, rightly regarded as one of the UK's great railway journeys with the Ribblehead Viaduct the highlight.

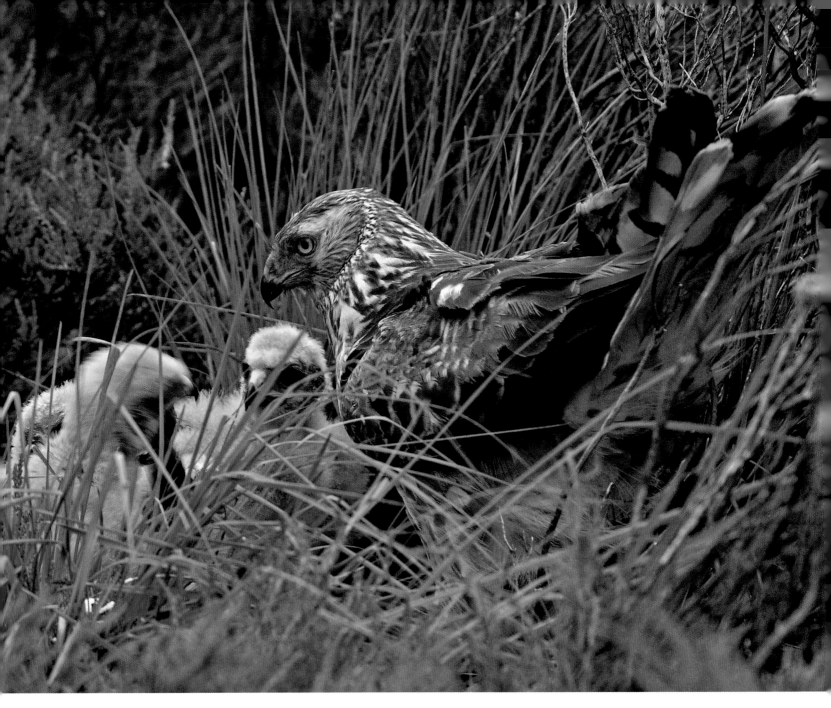

Above: The hen harrier has become the iconic symbol of the Forest of Bowland. Photo © Peter Guy

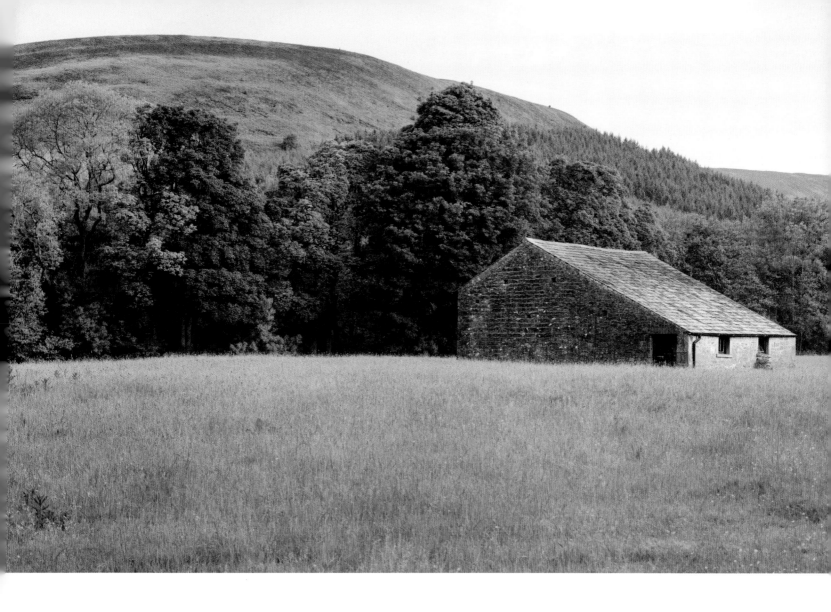

WALKING IN BOWLAND

OS 'Explorer' map no. 41 (Scale: 1:25000) is recommended for all the walks

Slaidburn, Newton and Easington

4 miles

Slaidburn is an ideal base for a wide range of walks of different lengths. Here is a short and charming ramble, enabling you to make a circuit combining Slaidburn itself with two independent and interesting settlements, both within two miles of the village.

1. From the main car park by the village green, opposite the village hall, go towards the Hodder and climb the little bank behind to a junction of paths. You may either follow a permissive path by the river, a delightful stretch, or strike across open fields, then through St. Andrew's churchyard to the B road. Turn left, and after about a quarter-mile turn left in front of the house, leaving the road, which turns right and climbs.

2. Follow the easy track, and soon you rejoin the alternative path beyond a small sewage works. Keep below the attractive steep wooded height on the right through a section which may be wet in season. Continue through a gate onto slightly higher and usually drier ground and follow a clear path with the river initially close on the left. Continue on a clear path through this park-like ground, soon crossing a wall on your right.

3. Turn left, and you soon come close by the river again as Newton Bridge approaches. Regain the B road briefly through a gate and turn left over the bridge.

4. Newton village is now close to the right and easily explored: Newton Hall, a fine 18th century building, is seen directly ahead almost at once and the *Parkers' Arms* is just across the road. Return, cross the bridge and take a signposted path on the left, keeping close to the river at first.

Above: Hodder Bridge, Slaidburn

5. When it bends away left, keep on the clear track, cross a small stream and soon pass by a copse on your right. When you reach a junction of paths ahead, Easington is readily visited by turning right for a short distance, then left when you meet the minor road. Easington was recorded as an independent settlement in the Domesday Book and has a fine old manor house overlooking the charming Easington Brook.

6. Return to the junction of paths and turn right along another clear rutted track, soon passing a pond on your left. Keep straight on through a small copse, crossing a side stream, then cross a bridge over the Hodder itself. You may glimpse Dunnow Hall on the bank behind the river: an imposing building which was used to accommodate evacuated children during the Second World War. You are now definitely back in the park-like grounds visited earlier in the walk.

7. Turn right, and when you reach the divergence of the two paths mentioned earlier, an attractive plan is to use the alternative path on the way back. Aim to be back by 5pm if you intend to patronise the village green café!

Right: The War Memorial at Slaidburn

Dunsop Bridge, Mellor Knoll and Burholme Bridge
7½ miles

This is a delightful walk of moderate length starting from Dunsop Bridge, which lays claim to being at the geographical centre of the United Kingdom. Within a few miles you will experience some of the very best of Bowland – lovely river scenery, soaring fells and some splendid views, including possibly the finest section of the Trough road. The summit of the walk is around 1100ft, with one significant climb to negotiate. At one point, on entering the Whitemore forestry, there is a dramatic glimpse of the Three Peaks area when clear.

1. From Dunsop Bridge, follow the private road running east of the River Dunsop. Beyond the cottages upstream, cross the footbridge, then turn left briefly along the road. Just before Closes barn, leave the road and proceed through fields until you meet the Trough road, with glorious views along the Langden valley.

2. Follow the road right, then leave by the Hareden intake and pass through the yard of the fine old farm (1692). Leave the farm track and take the steep, clearly signed bridlepath that climbs to the col west of Mellor Knoll. You will admire a lovely retrospect of the sinuously winding Trough road on this section.

3. The next section is clear but usually heavy underfoot: in about half a mile you drop towards a wall and shortly enter a wooded section, a delightful terrace with a view of the Hodder valley below and the impressive Totridge Fell on your right. Wind your way along the terrace, then climb slightly to enter the forestry area at a gate. Here is the viewpoint for the Three Peaks area. You may need to pick your way carefully through the forest, which is exposed and vulnerable to fallen trees.

4. Emerge from the forest and soon meet the farm road coming from Whitmore. Follow it left, entering an interesting area of limestone knolls and outcrops. Watch carefully for the point to branch left off this road, soon going steadily downhill through fields until you reach the minor road from Chipping.

5. Follow this left until you reach Burholme Bridge and one of the finest sections of the Hodder valley with excellent views both ways. Cross the bridge, then turn left along the track leading to Burholme farm. Beyond the farm, take the lower path, clearly signed, soon approaching the river once more. You pass the fine confluence of the Hodder with Langden Brook, and a little further on you meet the aqueduct which bears water from the Lake District en route to Manchester.

6. As you approach Thorneyholme, keep left of the buildings. Just after the confluence of the Hodder and the Dunsop, cross the bridge and very soon return to Dunsop Bridge.

Left: Dunsop Bridge where this 7½ mile walk begins and ends

Ward's Stone from Tower Lodge or Tarnbrook

10 miles

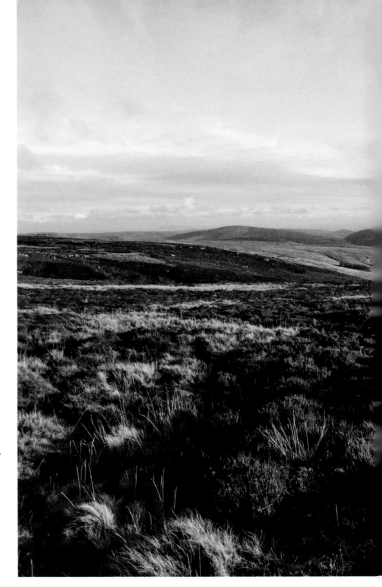

Ward's Stone is the highest of the Bowland fells (1,839ft or 561m) and it also overtops Pendle Hill by a few feet. It presents a demanding climb to the visitor, especially in poor weather, and both fell-walking and navigational experience are desirable. Your reward on a clear day will be the wonderful summit view, looking west over Morecambe Bay towards the Lake District.

1. Tower Lodge is a lovely starting point, along the tree-lined fringe of the Marshaw Wyre. Follow the path, initially north, soon striking across fields north-west where careful navigation is called for over a sequence of fences.

2. Turn back to the north again after crossing the low hill ahead, then descend to the Tarnbrook Wyre by Gilberton farm. Continue on this section of the Wyresdale Way until you meet a path emerging from the secluded hamlet of Tarnbrook. Tarnbrook is another possible starting point but parking is strictly limited.

3. At this point, turn right by a wall and begin a long stretch of permissive path, which leads eventually to Ward's Stone's summit. The route is a straightforward Land Rover track for two miles, though increasingly steep until you turn the shoulder of Long Crag with the Tarnbrook Wyre ever closer on your right. The motorable section ends near a stone hut by the stream, offering excellent shelter.

4. Cross the stream ahead, with care when it's in spate, at a height of around 1,450ft. Another stretch of fairly easy track follows until you reach a fence with a clear access sign at the Wyre-Lune watershed. There are spectacular views of the Three Peaks area.

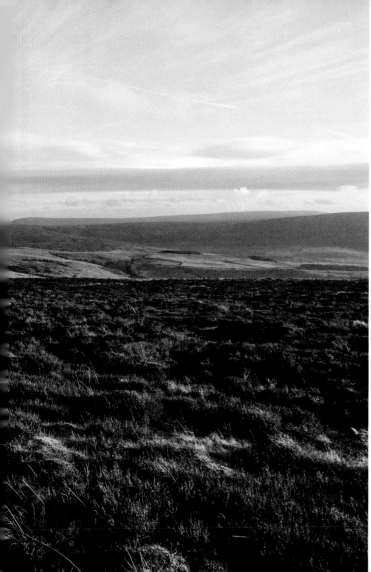

5. The most demanding section follows, especially in wet weather with some heavy peat to negotiate. Turn left and follow alternate sections of fence and wall until you emerge onto open fell a few hundred yards from Ward's Stone's higher (eastern) summit. Note the remarkable little rock formation, the Queen's Chair, at this point. Beyond the east summit (trig point), in mist, take a bearing of 250° which will lead you in about half a mile to the marginally lower west summit. There is a faint but improving tread on this section. You can climb the big stone outcrop, which gives the fell its name, but better still take in the splendid view.

6. There are many possible ways to return, including simply retracing your steps, though that significantly increases the mileage. If you can arrange a two-car walk, the simplest way is to continue west to the lesser height of Grit Fell (1,476ft or 450m), over relatively easier ground than the preceding section.

7. From Grit Fell's summit, proceed north-west initially, cross a fence and turn to the south-west soon, proceeding steadily downhill with a fence close on your left and some possibly wet stretches to negotiate. You emerge by the Jubilee Tower (1887), also a former bus stop on the 'Trough Road' and an excellent viewpoint: the parapet takes in a wide sweep of the Bowland fells, coastal plain and sections of Lakeland. This finish corresponds to the mileage given earlier.

If you have a moment, take in the fascinating story of the Quernmore Burial on a plaque in the adjacent car park. Another possible way to complete a circular walk is to turn left precisely at the col between Ward's Stone and Grit Fell. Follow a clear track, which eventually reaches the Trough Road at Higher Lee. Tower Lodge is then about four miles' road walking away, or again you may arrange to be met at this point.

Above: Looking south to the Trough of Bowland and beyond, from the fells above Tarnbrook.

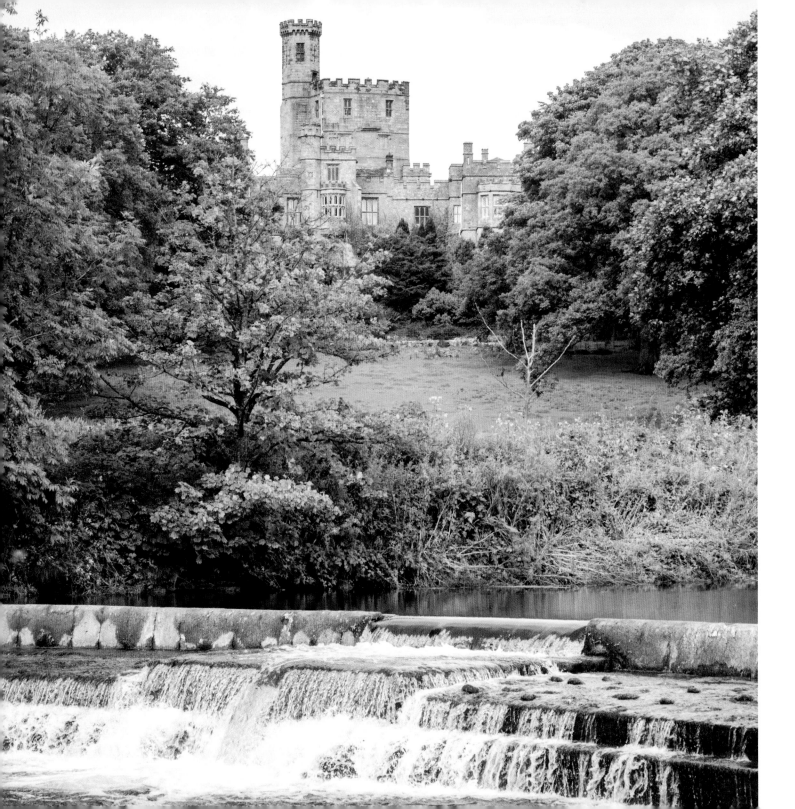

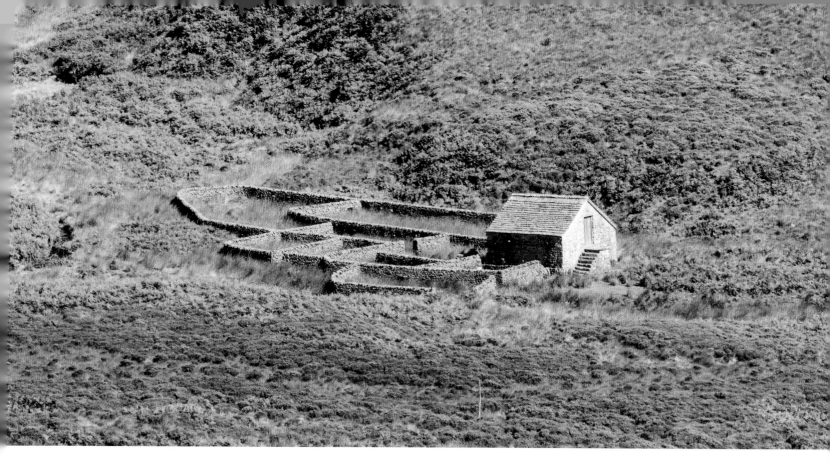

WALKING THE SALTER TRACK

a personal account by Bob Shelmerdine

If I were on the run, this is where I would hide out. It's a wild moorland landscape, dissected by a Roman road, one of the ancient trackways used by our ancestors to cross the Forest of Bowland.

The plan for today's walk is a circuit from Slaidburn, cutting across farmland paths to pick up the Salter Track, walking some 10 miles on the track itself, then across access land to meet up with the Bentham to Bowland road, and back over the 1,400 foot high Cross of Greet pass, down to Bridge of Greet, and home again.

Above: A sheepfold at Croasdale
Left: Hornby Castle above the River Wenning

171

It's a fabulous August day, although it feels a bit autumnal. Plenty of blue sky, fluffy white clouds and a fairly strong wind. This should be a breeze: a walk in the park. First mile is on the road as will be our last 4 miles, but it's a very quiet lane and soon we strike off over fields heading for Croasdale House Farm. We've done this bit of the route before, so we don't get lost, but we do get wet from the long grasses. At this stage it's mostly downhill too, (before we turn north westwards and start the climb to the Salter Track summit). The route from Croasdale onto the Salter Track is not a path at all. There is a line of yellow posts sunk into the morass, but 'sunk' is the operative word.

This is where the 'Belties', (Belted Galloway cattle) reside. They must be a hardy breed as the grass is wiry and sparse and the ground is like a pincushion of round hoof holes half filled with water. It's a place to tread very carefully, or ideally not tread at all. Flying would be a much better option, but we have to teeter perilously with each timid step. Will it hold my weight? Is it a deeper hole than it looks? Why is there so much water? It is just like a slightly overgrown World War One battlefield. Our speed has dropped to 4 miles a fortnight. Will we ever get to the Salter Track proper?

Late morning sees us having coffee and feeling like all the hard work is over. All that's left is a simple walk up and over a path that's been here for 2-3,000 years, (you're not telling me the Romans didn't use any existing paths if they could), a bit of a scramble and finding a route through the Thrushgill plantation, then back on the road and we're home and dry! Simple. Only 15 miles to go.

The shooting season has started but other than a Land-Rover and another couple of people on foot, we have the place to ourselves. The head of Whitendale is a great view. To the south, rolling fells lead to Dunsop Bridge; back to the east, past mile after mile of deep purple heather is Slaidburn, and onward to the west is an invisible Hornby. What you can see in that direction are the tips of Caton Moor's wind turbines with a backdrop of the distant Howgill Fells way, way up the Lune Valley.

It's cool in the wind this high up, but the vistas are expansive, so we walk briskly to keep warm enough and try not to argue about which fell on the horizon is which. Finally it's time to strike off the Salter track, just a few hundred yards of lumpy grass and ditches to get to Hawkshead

Left: Croasdale

Above: Croasdale Brook

Right: Some of the horned beef cattle you might encounter on your Bowland walk – don't worry, they're only heifers!

which looks like a slight rise from this side, but drops away sharply to the north west forming the watershed between Roeburndale and Hindburndale. The sky has darkened and the sudden view of the Yorkshire Three Peaks across moor and meadow is startling and dramatic. It's raining hard either side of Ingleborough, but the sun is shining brilliantly on its flat-topped flanks. Not many people get this rewarding view. It feels as if we've blazed a trail to be here. We are now literally 'off the beaten track'.

As we breast the cliff of Hawkshead and look down there's a sight and sound we weren't expecting though: a shooting party of around 15 people scouring the ground below. We certainly can't go down whilst they are there as we don't want to disturb the game. It must be time for lunch however as they settle down for a bite to eat. We follow suit and stop for lunch too. If they'll head off to the south we might sneak round to Thrushgill plantation without being seen.

The weather cools down even more while we stop. Waterproofs go on to keep the wind out, and as we eat, the weather races past our faces. Without getting wet ourselves, shower after shower moves like a barcode from right to left. It's like watching a play. The rain showers are the curtains, Ingleborough the backdrop. The sun and shadows chase one another up, down and over the fells. One minute everything looks rosy with the afternoon sun paling the cropped grass fields, the next, dark waves of gloom plummet into the valleys. Winter seems to be arriving, and getting off the fell becomes really important, before things get serious.

It's a hard slog finding a way across the heath and into the plantation. It's not quite as bad as the Croasdale path, but wet and reedy and there's a danger of twisting an ankle. It takes longer than we thought (OK, I thought!), to locate a way

into the recently harvested section of Thrushgill Plantation, but we do and then it just gets easier and easier as we head downhill. The route should be easier now. We're going to make it. The Roman Road is now visible back over the fell, the scar of it clear, straight and direct. It just lies on the hillside with the start invisible and the end out of sight. It's a monument to the persistence of the Romans. You can see it from space. In fact it looks like it was made thousands of years ago by spacemen. As it lies there it pulses with history. The more you look, the more you imagine. I can hear the clatter of wood and metal, and Latin curses, foreign soldiers surveying the bleak horizon and longing for their sunny homelands.

Horned beef cattle inhabit one of the fields and they are very skittish. When they see us they race over, all 40 of them. We flee through a gate. Now we are stuck again, but this time within striking distance of the road home. Bravery and necessity take us back into the field with the beasts. A quick wave of the hands sees them flee en masse while we make for our route through another gate in the corner. Nearly there and they return for a further look, racing like stampeding bison, until, like superheroes from a film, we halt them with raised palms. They stop in a sea of dust and saliva, turn and flee again. Phew!

Turning right for the last 500 yards to Botton Head Farm we are on the route once more of the Roman Road. Swords, shields and sweat lie under our feet where the green, green grass now grows. And it is dazzling green. We pass a well-kept farm and it feels great finally to make the road with its welcome smell of tarmacadam.

Thirsty now and tired-limbed, a long climb still lies ahead. With one stop to dip our feet in an ice-cold stream, it is head down and keep going. A 10-minute drive undertaken in the car nearly every day becomes over an hour's labour of love on foot. Walking home is a treasure and a pleasure following the very new Hodder river after passing the Cross of Greet, (no cross and no greeting), but a great view of our valley and Stocks Reservoir and distant Pendle Hill. This is a beautiful place.

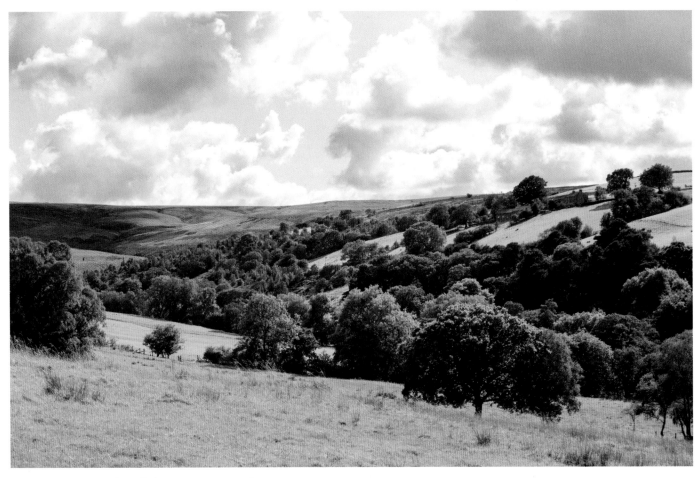

Above: Greenbank Fell from Botton Bridge

The Photographer – Helen Shaw

The beck (yes, we're far enough north here to call it that, but south enough for it not yet to be called a burn) roars through the night, sweeping before it the alder leaves and the twigs from the ash trees, pushing the rushes flat. I lie awake, the darkness absolute, hearing the wild night exercising the trees in the wood, rain slashing the windows, and I am safe inside my sanctuary.

Above and around this huddled stone house, the fells stand firm, solid, sheltering. Only on their tops does the wind tear the breath away, the squelchy peat sponging up the rain only to squeeze it out again in rich brown liquid, drowning an unwary step. Trickles from the mosses drip out and down, coursing with others until they reach the beck, rushing headlong down the clough to form and join the river below.

Next morning, all is quiet. As I slept, the west wind had shepherded the clouds east and the noisy beck subsided as quickly as it rose. It has a happier, less urgent note now, the water clear, and as I look out a bird lands on the stones and bobs, bobs, bobs its white chest as if in a dance with the water. It's a dipper, searching out its breakfast.

On the bank behind the house, the new lambs are daring to discover their world now that the storm has passed. The farmer will be by soon to check that no tiny body was snatched by the raging water in the night; sadly, it happens. If the weather is cold and wet, the lambs may be given colourful little raincoats to wear: strange to see the bright pink dots chasing about on the green terraces above the beck.

A couple of walkers pass the house, enjoying the pale spring sun that has now appeared. Only a few pass this way, through our secret valley, for although the narrow road leads up over the tops to the towns beyond, this is still a hidden place, to be discovered and loved by those who take the time to stop and look and listen. There is a particular point on the top of a hill when this little valley is finally revealed and I know I am coming home, dropping steeply, past the wood, over the beck, down the track, greeted only by the silence, or the sheep.

Just three of us share this quiet valley - on either side of our house but sufficiently distant that we cannot see or hear each other, there are two farms. We are 'off come'd uns', and always will be, but after a decade we are just about accepted as belonging, I think. We support each other, when needed, during illness, floods, snow, and tragedy. We laugh together at the antics of the lambs, admire the genius of the working sheepdogs, and sometimes, during a 'gather' when I get the chance to help with shepherding duties, I feel at one with the life and the land of this most special of places.

We are our own tight community, yet I know that all across Bowland the people in its remote valleys are the same; it is just that our valley feels the most special to me! For any visitors who come to walk or cycle or simply sit and stare, the fells wait with a quiet welcome.

And no matter where I go in the future, this sanctuary will be held forever in my heart: my Bowland.

All the images in this book are available for sale from Helen Shaw via her website
www.malkinphotography.co.uk 07733 010915

BOWLAND INFORMATION FOR TOURISTS

Ribble and Hodder Valleys/Central Bowland

SLAIDBURN

Riverbank Tearooms 23 Chapel St Slaidburn BB7 3ES www.riverbanktearooms.co.uk 01200 446398
Hark to Bounty Inn www.harktobounty.co.uk BB7 3EP 01200 446246
Houses the original Moot Courtroom of the Forest of Bowland. Has accommodation.
Stocks Reservoir Fly Fishery & café www.stocksreservoir.com BB7 3AQ 01200 446602
 Tackle shop and café, boat hire
Gisburn Forest Hub and Café www.stephenparkcentre.com and www.forestry.gov.uk/gisburn
 Dale Head, Slaidburn BB7 4TS 01200 446533 / 01200 446804 (café)
There are also a couple of gift shops in the village: Vanilla Angel Handmade Chocolates and Gifts, Flowers from the Heart, and Slaidburn Village Stores and Post Office
Village Heritage Trail walkingbritain.co.uk/walks/walks/walk_b/2216/
St Andrews Church Grade I Listed 15th century

Below: Looking towards Pendle in winter

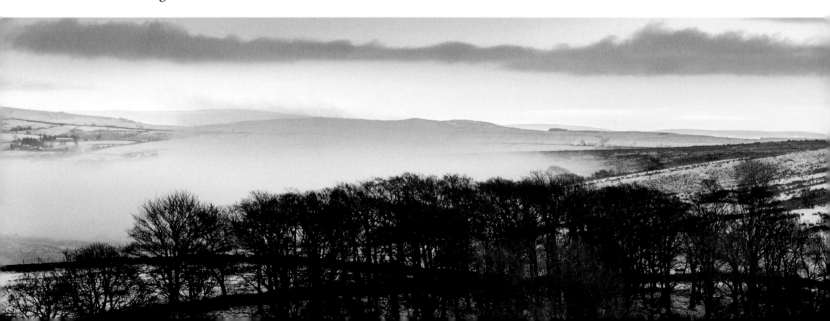

NEWTON-IN-BOWLAND

The Parkers Arms www.parkersarms.co.uk/ BB7 3DY 01200 446236 Inn with rooms, delicatessen shop
Clerk Laithe Lodge and *The Bowmans Rest* www.clerklaithe.co.uk/ BB7 3DY 01200 446989 B&B with tearoom open afternoons

GRINDLETON

Duke of York Pub www.dukeofyorkgrindleton.com BB7 4QR 01200 441266 Gastro Pub
Village heritage trail www.grindleton.org/heritage_trail.pdf
St Ambrose's Church Grade II* Listed

WADDINGTON

Country Kitchen Café Clitheroe Rd Waddington BB7 3HP 01200 429364
Waddington Arms www.waddingtonarms.co.uk BB7 3HP 01200 423 262 Bistro pub with rooms
The Higher Buck www.higherbuck.com BB7 3HZ 01200 423226 Bistro pub with rooms
The Lower Buck Inn www.lowerbuck.co.uk BB7 3HU 01200 423342
Waddow Lodge BB7 3HQ 01200 429145 National Gardens Scheme open garden
St Helen's Church Grade II* Listed part 16th century
There is also Melt at Backridge Farm BB7 3LQ 01200 443412 which is worth a visit

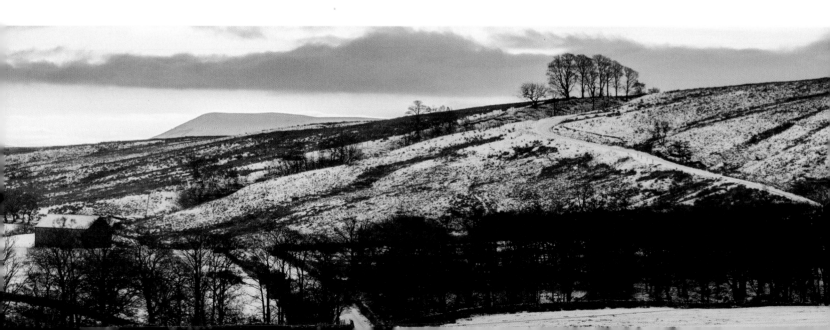

BOLTON BY BOWLAND

The Garden Kitchen, Holden Clough Nursery - www.holdencloughnursery.comhcl.aspx?pg=garden-kitchen Holden BB7 4PF 01200 447447

Bolton-By-Bowland Tea Rooms and Shop 2 Main Street BB7 4NW 01200 447201

Hindelinis Café www.ribblesdalepark.com/hindelinis BB7 4LP (in between Gisburn and Bolton-By-Bowland) 01200 445227

Varley Farm BB7 4NZ 07887 638436 National Gardens Scheme open garden www.ngs.org.uk

Church of St Peter & St Paul Grade I Listed 13th and 15th century

SAWLEY

Spread Eagle Inn www.spreadeaglesawley.co.uk BB7 4NH 01200 441202 Coaching inn with rooms

Sawley Abbey www.english-heritage.org.uk/daysout/properties/sawley-abbey/

HURST GREEN

Millie's Café, 2a Whalley Rd Hurst Green BB7 9QJ 01254 826039

Shireburn Arms www.shireburnarmshotel.co.uk BB7 9QJ 01254 826678 17th century inn with rooms

Bayley Arms www.bayleyarms.co.uk BB7 9QB 01254 826478 Pub, restaurant and hotel

Stonyhurst College www.stonyhurst.ac.uk and www.visitlancashire.com/things-to-do/stonyhurst-college-p7125 - BB7 9PZ 01254 826345 Historic house and gardens, open when the college is closed

Walk in the footsteps of JRR Tolkein www.visitlancashire.comdbimgs/Tolkien_Trail.pdf

Dutton Hall www.duttonhall.co.uk PR3 3XX 01254 878254 National Gardens Scheme open garden

Lower Dutton Farm PR3 3XX National Gardens Scheme open garden

GREAT MITTON

The Three Fishes www.thethreefishes.com BB7 9PQ 01254 826888 Gastro restaurant
The Aspinall Arms www.brunningandprice.co.uk/aspinallarms BB7 9PQ 01254 826555 Pub/restaurant
Mitton Hall www.mittonhallhotel.co.uk BB7 9PQ 01254 826 544 Luxury country house hotel and restaurant
All Hallows Church Grade I listed 13th century

WHITEWELL

The Inn at Whitewell www.innatwhitewell.com BB7 3AT 01200 448222 Luxury country inn by the river with amazing rooms and food.
St Michael's Church, C1400, Chapel of Ease Grade II Listed

CHIPPING AND SURROUNDING AREAS

The Cobbled Corner Café www.cobbledcorner.co.uk PR3 2QH 01995 61551/61216
Brabin's Tea Garden and Shop PR3 2QT 01995 61221 Also has an art gallery
The Tillotsons Arms thetillotsonsarms.co.uk PR3 2QE 01995 61568
The Sun Inn PR3 2GD 01995 61206
The Dog & Partridge www.dogandpartridgechipping.co.uk PR3 2TH 01995 61201
The Gibbon Bridge Hotel www.gibbon-bridge.co.uk PR3 2TQ 01995 61456 Luxury Hotel, Restaurant, stunning gardens
The Derby Arms seafoodpubcompany.com/locations/derby-arms PR3 2NB 01772 782 379 Gastro restaurant and boutique rooms – between Chipping and Longridge
Ferrari's Country House Hotel and Restaurant www.ferrariscountryhouse.co.uk PR3 2TB 01772 783148 Country house hotel and restaurant – between Chipping and Longridge
The Newdrop www.thenewdrop.co.uk/ PR3 2XE 01254 878338 Gastro pub on Longridge Fell
Bowland Wild Boar Park www.wildboarpark.co.uk/ PR3 2 QT 01995 61554 Also has a café
Beacon Fell Country Park www.lancashire.gov.uk/leisure-and-culture/country-parks-and-nature-reserves/beacon-fell-country-park PR3 2NL 01995 640557 Also has a café
Bowland Visitor Centre Beacon Fell Country Park PR3 2NL 01995 640557
St Bartholomew's Church Grade II* Listed Dates from 1506

DUNSOP BRIDGE

Puddleducks Café and store BB7 3BB 01200 448241
Dunsop Village Hall serves teas on Sundays

BASHALL EAVES / COW ARK

Red Pump Inn theredpumpinn.co.uk BB7 3DA 01254 826227 Bistro pub with rooms
Bashall Barn www.bashallbarn.co.uk BB7 3LQ 01200 428964 Food visitor centre, restaurant, coffee shop, retail
Browsholme Hall www.browsholme.co.uk BB7 3DE 01254 827166 Hall/gardens/tearoom – open Wednesdays and Bank Holidays in summer

East Bowland/Yorkshire Dales Borders

TOSSIDE

The Old Vicarage Tearoom www.facebook.com/TheOldVicarageTeaRoom 07809 489282 BD23 4SQ
 07809 489282
The Dog and Partridge www.gisburnforestbikes.co.uk BD23 4SQ 01729 840668 Inn with rooms
Crowtrees Inn www.bowlandfellpark.co.uk/facilities BD23 4SD 01729 840278 Just outside Tosside

CLAPHAM & AUSTWICK (on the fringe of the AONB – actually in the Yorkshire Dales NP)

Dalesbridge Outdoor Centre www.dalesbridge.co.uk LA2 8AZ 015242 51021 B&B, self catering, bunkhouses
The Old Manor House www.claphambunk.com LA2 8EQ 015242 51144 Bunkhouse and café/bar
Croft Café LA2 8EA
New Inn www.newinn-clapham.co.uk LA2 8HH 015242 51203 Coaching Inn with rooms
The Game Cock Inn www.gamecockinn.co.uk LA2 8BB 015242 51226 Pub with restaurant and rooms
The Traddock www.thetraddock.co.uk LA2 8BY 015242 51224 Hotel & restaurant
Austwick Hall austwickhall.co.uk LA2 8BS 015242 51794 Luxury country house hotel, amazing gardens

PENDLE

Pendle Heritage Centre Colne Road, Barrowford, BB9 6JQ 01282 661701 www.visitpendle.com

BARLEY

Barley Tea Rooms www.facebook.com/pages/Barley-Tea-Rooms/132171506891158?sk=timeline
 BB12 9LA 01282 694127
Barley Mow seafoodpubcompany.com/barley-mow BB12 9JX 01282 690868 Restaurant and rooms
Pendle Inn www.pendle-inn.co.uk BB12 9JX 01282 614808 Inn and rooms

NEWCHURCH-IN-PENDLE

Clarion House Tea Rooms www.clarionhouse.org.uk BB12 9LL Open on Sundays
There is also the famous Witches Galore gift shop in Newchurch
St Mary's Church Grade II* Listed Dates from 1544 – home of the 'Witch's Grave'

DOWNHAM

The Assheton Arms www.seafoodpubcompany.com/the-assheton-arms BB7 4BJ 01200 441227 Grade II listed
gastro pub and boutique rooms
Village was used for filming *Whistle Down the Wind* and the TV series *Born and Bred*
St Leonard's Church Grade II* Listed Part 15th Century

ROUGHLEE

Bay Horse Inn www.bayhorse.eu BB9 6NP 01282 696558 Gastro pub
Oak View Fishery www.oakviewcoarsefisheries.com BB9 6NR 01282 541898

PENDLETON

Swan with Two Necks www.swanwithtwonecks.co.uk BB7 1PT 01200 423112 Village pub and restaurant

WORSTON

The Calf's Head www.calfshead.com BB7 1QA 01200 441218 Country House Hotel & restaurant

SABDEN & NICK OF PENDLE

The Wellsprings www.thewellsprings.co.uk BB7 9HN 01200 427722 Restaurant
The White Hart Inn www.thwaitespubs.co.uk BB7 9EX 01282 777862
The Pendle Witch pub BB7 9DZ 01282 779317
Higher Trapp Hotel www.bw-highertrapphotel.co.uk BB12 7QW 01282 772781 Country House Hotel
There is an interesting **Antiques Centre** in Sabden
St Nicholas's Church Grade II listed c 1846

CHATBURN

The Brown Cow BB7 4AW 01200 440736
Shackletons Garden Centre and Pavilion Coffee House/Brasserie www.pavilioncoffeehouse.co.uk BB7 4JY
01200 440760

Lune Valley area

WRAY

Bridge House Farm Tearooms www.bridgehousefarm.co.uk LA2 8QP 015242 22496
 Also has a garden centre and craft shop next door
The George and Dragon pub www.wrayvillage.co.uk LA2 8QG 015242 21403
Clearbeck House open garden www.clearbeck.wordpress.com LA2 8PJ 01524 261029
St James the Less Church Grade II* Listed Dates from 13th & 15th century – situated in Tatham nr Wray
Church of the Good Shepherd Tatham Grade II Listed c 1888

HORNBY

The Castle Inn www.thecastleinnhornby.co.uk LA2 8JT 01524 222279
 Bistro and boutique bedrooms, open for coffees etc
Hornby Tearooms LA2 8JR 015242 2237
St Margaret's Church Grade I Listed Dates from 1514
Hornby Castle www.hornbycastle.comabout-hornby-castle (private but visible from road) is Grade I listed –
gardens open for special events

CATON

The Ship Inn www.ship-caton.co.uk LA2 9QJ 01524 770265 Pub & Restaurant
Station Hotel LA2 9QS 01524 770690
The Black Bull www.theblackbullbrookhouse.co.uk LA2 9 JP 01524 770329
Gresgarth Hall www.arabellalennoxboyd.com LA2 9NB 01524 771838
 Gardens open on selected dates
St Paul's Church Grade II* Listed part 16th Century
St Peter's Church Quernmore Grade II Listed c 1860

Wyre area

SCORTON

The Priory at Scorton www.theprioryscorton.co.uk PR3 1AU 01524 791255 Hotel/Café/Bar
The Barn at Scorton www.plantsandgifts.co.uk PR3 1AU 01524 793533 Gift shop/garden centre/tearoom
The Apple Store Café, Wyresdale Park wyresdalepark.co.uk PR3 1BA 07740 111331
Church of St Peter Scorton Grade II Listed C 1878

CLAUGHTON ON BROCK

Cobble Hey Farm www.cobblehey.co.uk PR3 0QN 01995 602643 Gardens and tearooms

Gateway Towns

CLITHEROE

Clitheroe Visitor Information Centre Platform Gallery & Visitor Information Centre, Station Rd, Clitheroe, BB7 2JT 01200 425566 www.visitribblevalley.co.uk
Must see – Norman Castle, museum and grounds. Lots of restaurants, cafés, and pubs, independent shops.

LANCASTER

Lancaster Visitor Information Centre Storey Gallery, Meeting House Lane, LA1 1TH 01524 582394 www.citycoastcountryside.co.uk
Must see – Castle, Priory, Judges Lodgings, Ashton Memorial and Williamson Park, Lancaster City Museum, Lancaster Maritime Museum. Lots of restaurants, cafés, and pubs.

SKIPTON

Skipton Tourist Information Centre Town Hall, High Street, Skipton BD23 1AH 01756 792809 www.cravendc.gov.uk
Must see – Castle, Craven Museum and Gallery, Canal Basin, Holy Trinity Church dates from c 1300. Lots of restaurants, cafés, and pubs, independent shops.

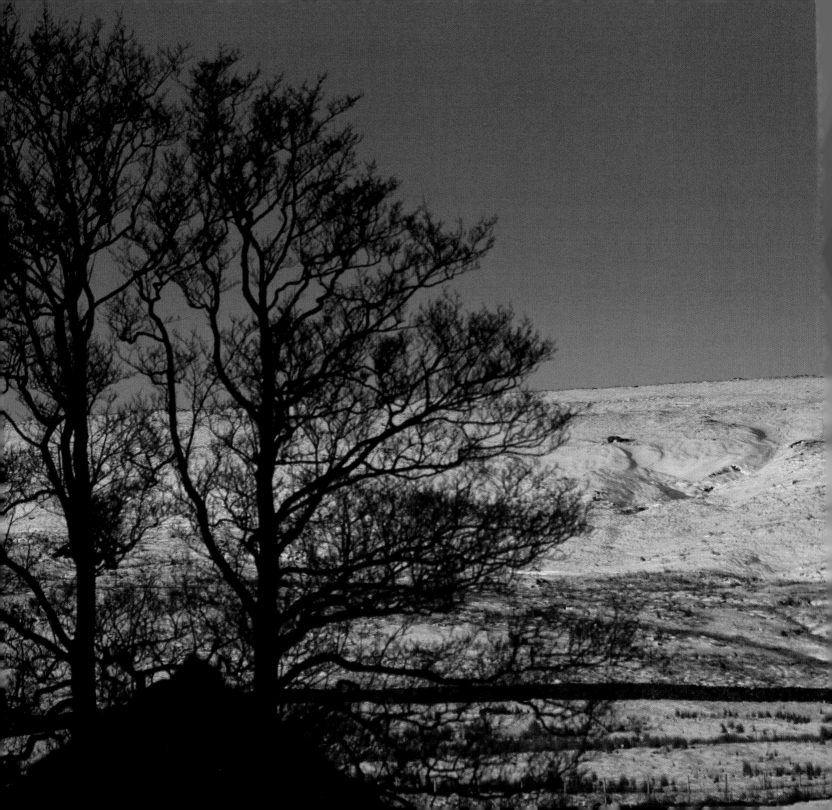

Lamb Hill Fell

SETTLE/GIGGLESWICK

Settle Tourist Information, Town Hall, BD24 9EJ 01729 825192 www.settle.org.uk
Must see – Market Place, Castleberg Hill, Settle-Carlisle Railway. Some lovely cafés, restaurants and independent shops.

GARSTANG

Visit Garstang Centre, Cherestanc Square, Off Park Hill Road, Garstang, PR3 1EF
01995 602125 www.visitwyre.co.uk
Must see – Greenhalgh Castle, medieval weinds (alleys), market cross, river and canal. Nice cafés, independent shops.

HIGH BENTHAM

Bentham Tourist Information Point Town Hall, Bentham LA2 7LF 015242 62549
Must see – Big Stone, Bentham Heritage Trail. Cafés and pubs, some small shops.

LONGRIDGE

Must see – Longridge Fell, nearby Roman town of Ribchester. Several cafés, pubs, shops.

Tourist Information Centres

Bowland Visitor Centre Beacon Fell Country Park PR3 2NL 01995 640557
Clitheroe Visitor Information Centre Platform Gallery & Visitor Information Centre, Station Rd, Clitheroe, BB7 2JT 01200 425566 www.visitribblevalley.co.uk
Visit Garstang Centre, Cherestanc Square, Off Park Hill Road, Garstang, PR3 1EF
01995 602125 www.visitwyre.co.uk
Lancaster Visitor Information Centre Storey Gallery, Meeting House Lane, LA1 1TH 01524 582394
www.citycoastcountryside.co.uk
Pendle Heritage Centre Colne Road, Barrowford, BB9 6JQ 01282 661701 www.visitpendle.com
Settle Tourist Information, Town Hall, BD24 9EJ 01729 825192 www.settle.org.uk
Skipton Tourist Information Centre Town Hall, High Street, Skipton BD23 1AH 01756 792809
www.cravendc.gov.uk
Bentham Tourist Information Point Town Hall, Bentham LA2 7LF 015242 62549

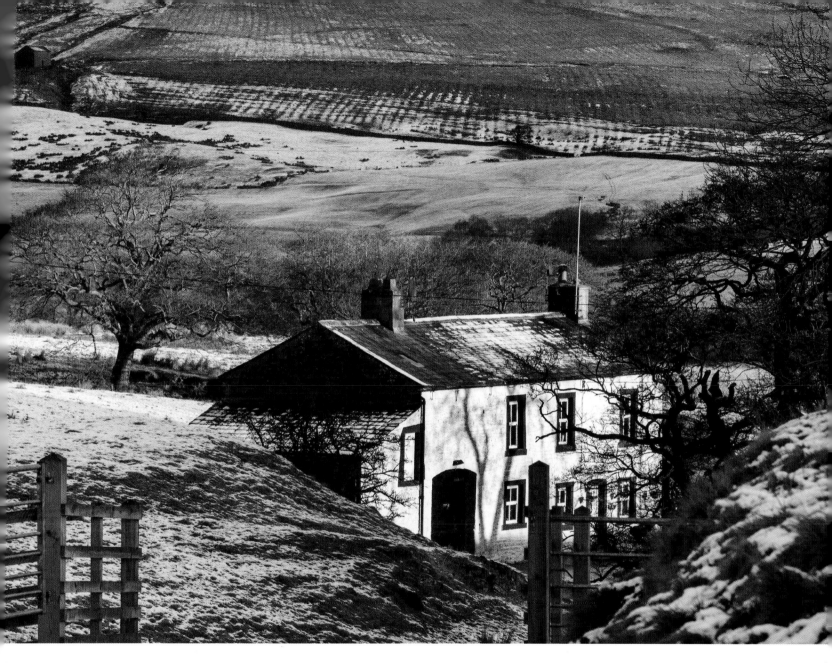

Above: Kenibus

Author's note

I grew up in Great Harwood, a short distance from the Forest of Bowland, yet for me it remained a mysterious, largely unexplored area during my youth. It was declared an Area of Outstanding Natural Beauty in 1964, but at the time we had no family car. Only slowly, by undertaking more ambitious walks and using the few buses available – especially the private service around Dunsop Bridge – did I become aware of this true wonderland. It was the beauty of the Hodder valley and the charm of Bowland's villages, especially Bolton by Bowland and Slaidburn, which first enchanted me, but in those earlier years, the high fells remained almost wholly unexplored by me. They were in any case largely closed to public access in those days.

After a long period of absence, I returned to the north in 1991 and my knowledge and appreciation of Bowland grew quickly in my avid eagerness to discover more. The high fells were definitely on the agenda now, even before the steady opening up of the district, culminating in the 'right to roam' legislation of 2000. I relished many hours and days of solitude spent immersed in the high fells and hidden valleys of Bowland, remarkably close to industrial east Lancashire but in a different world. Certain walks became great favourites: I loved to walk the entire Hornby Road from Slaidburn to Hornby, using only public transport to its starting and finishing points, making it a full day's expedition. Once I realised the presence of unusual birds in the area, there was an added sense of expectation. The possibility of seeing a hen harrier, a peregrine or a merlin, put an extra spring in the step.

My perspective of Bowland is that of one who lives beyond its fringe but who loves its special character with a passion. Insiders might tell Bowland's story quite differently, but I am proud to serve as a champion of Bowland in this book. Its shy beauty and endearing nature deserve to be far better known, and I hope local residents will forgive any omissions. It has been a pleasure to work with many friends inside the AONB: I should like to acknowledge especially Chris and Joanne Bosonnet, Geoff Bowker, Robert Parker of Browsholme, David Kenyon and Linda Blakeman. Finally, I thank Helen and Bob most warmly for their support throughout this project: it has truly been a pleasure to work with Helen and to share ideas regularly, as the book took shape.

Andrew Stachulski

Left: Haymeadows at Bell Sykes Farm looking towards Fell Side.

INDEX